The Professional Photographer's
Guide to Shooting & Selling
Nature & Wildlife Photos

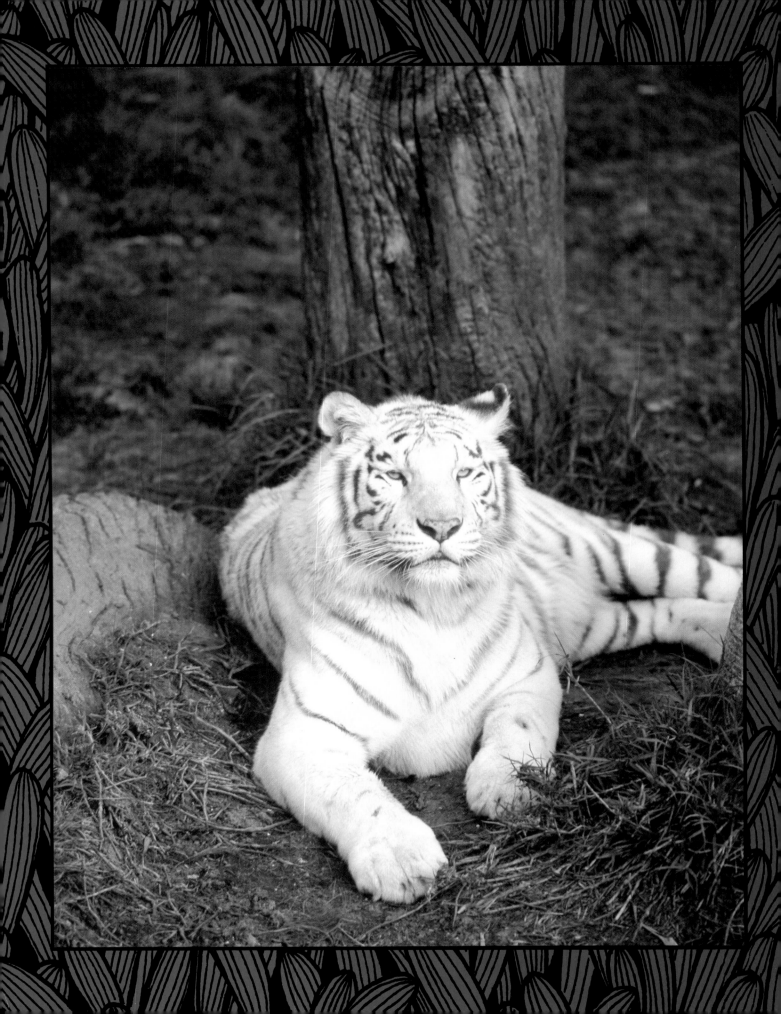

THE PROFESSIONAL PHOTOGRAPHER'S
GUIDE TO SHOOTING & SELLING
NATURE & WILDLIFE PHOTOS

JIM ZUCKERMAN

Writer's
Digest
Books

CINCINNATI, OHIO

**The Professional Photographer's Guide to Shooting
and Selling Nature and Wildlife Photos**. Copyright ©
1991 by Jim Zuckerman. Printed and bound in Hong Kong. All
rights reserved. No part of this book may be reproduced in
any form or by any electronic or mechanical means including
information storage and retrieval systems without permis-
sion in writing from the publisher, except by a reviewer, who
may quote brief passages in a review. Published by Writer's
Digest Books, an imprint of F&W Publications, Inc., 1507 Dana
Avenue, Cincinnati, Ohio 45207. First edition.

95 94 5 4 3

"Snow Comes to the Southwest," *Westways*, December 1989
issue, © 1989 Automobile Club of Southern California, repro-
duction by permission, courtesy of *Westways*.

Library of Congress Cataloging in Publication Data

Zuckerman, Jim.
 The professional photographer's guide to shooting and sell-
ing nature and wildlife photos / by Jim Zuckerman.
 p. cm.
 Includes index.
 ISBN 0-89879-460-9
 1. Nature photography. 2. Photography, Freelance. 3. Sell-
ing—Photographs. I. Title.
TR721.Z83 1991
778.9'3'0688—dc20 91-16200
 CIP

Edited by Mary Cropper
Designed by Carol Buchanan

I wish to dedicate this book to my family, who loved and supported me even during the darkest part of my life.

ACKNOWLEDGMENTS:

I want to thank my dear friend, Bert Eifer, for appreciating my work from the very beginning and for introducing me to Writer's Digest Books.

I also wish to express my gratitude to David Lewis, who as editorial director saw my pictures and enthusiastically supported this project until its conclusion.

And to Mary Cropper, I am in debt for her sensational job of editing this book. Without her analytical thinking and remarkable sense of organization, my text probably would have been incoherent.

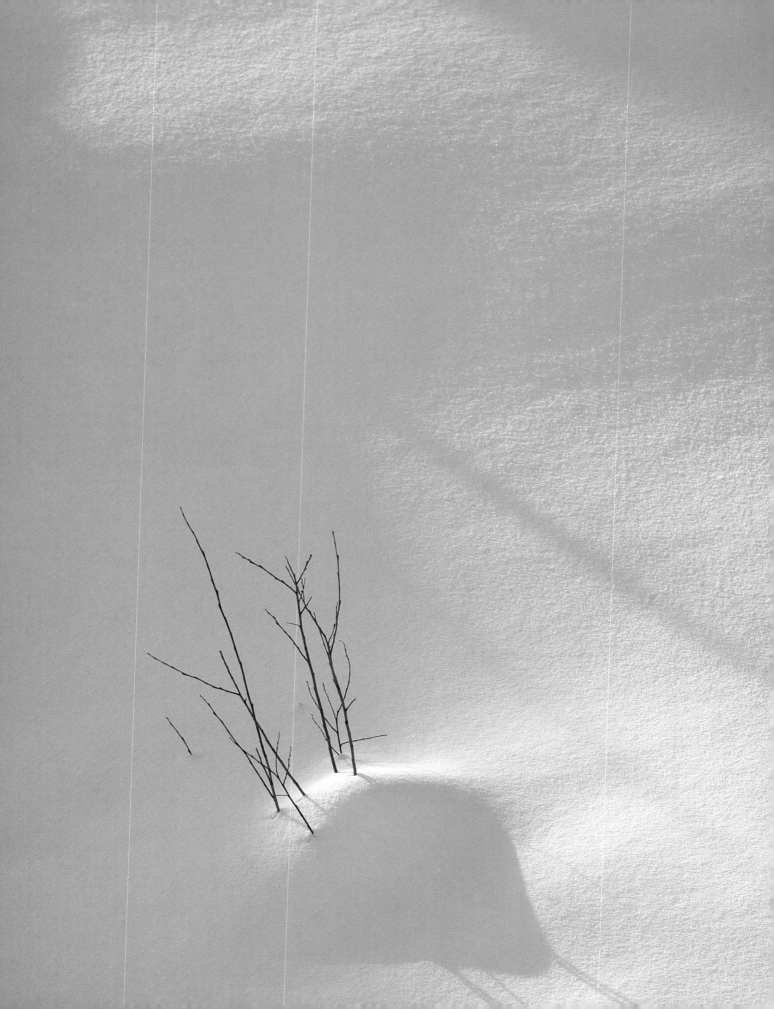

PREFACE:

More than anything else in life, I love taking pictures of nature and wildlife. It's my greatest joy. It would be impossible for me to have a nine-to-five job sitting behind a desk. It's not just that I wouldn't do it—I couldn't handle it at all.

My decision to pursue a career in photography was a matter of following my heart. I felt that I was put on this earth to capture beauty on film, and that to do anything else would be going against what I knew to be the Truth. I don't think it's possible to be happy if you betray your purpose. It only took me twenty years to realize this.

You must want very much to succeed to be able to make it as a nature and wildlife photographer. It's not a matter of saying to yourself, "I think photography would be more fun than plumbing or accounting." You must make a total commitment, keeping all your energy focused on your goals. Your success will be proportional to this commitment.

By David Pavol

ABOUT THE AUTHOR:

Jim Zuckerman left his medical studies in 1970 to pursue his love of wildlife and nature photography. He has taught creative photography at the University of California, Los Angeles and Kent State University in Ohio, but he now prefers to teach seminars and to also teach in the field on international photo tours.

Zuckerman is a contributing editor to *Petersen's Photographic Magazine*. His images, articles and photo features have been published in both books and magazines including several Time-Life books, publications of the National Geographic Society, *Outdoor Photographer*, *Outdoor and Travel Photography*, *Condé Nast Traveler*, *National Wildlife*, Australia's *Photo World*, and Greece's *Opticon*. He is the author of two other books, *Visual Impact* and *Shoot Early, Shoot Late*.

His work has been used for packaging and for advertising. Zuckerman's images have appeared in calendars and are used on posters. His stock photography is represented by Westlight in Los Angeles.

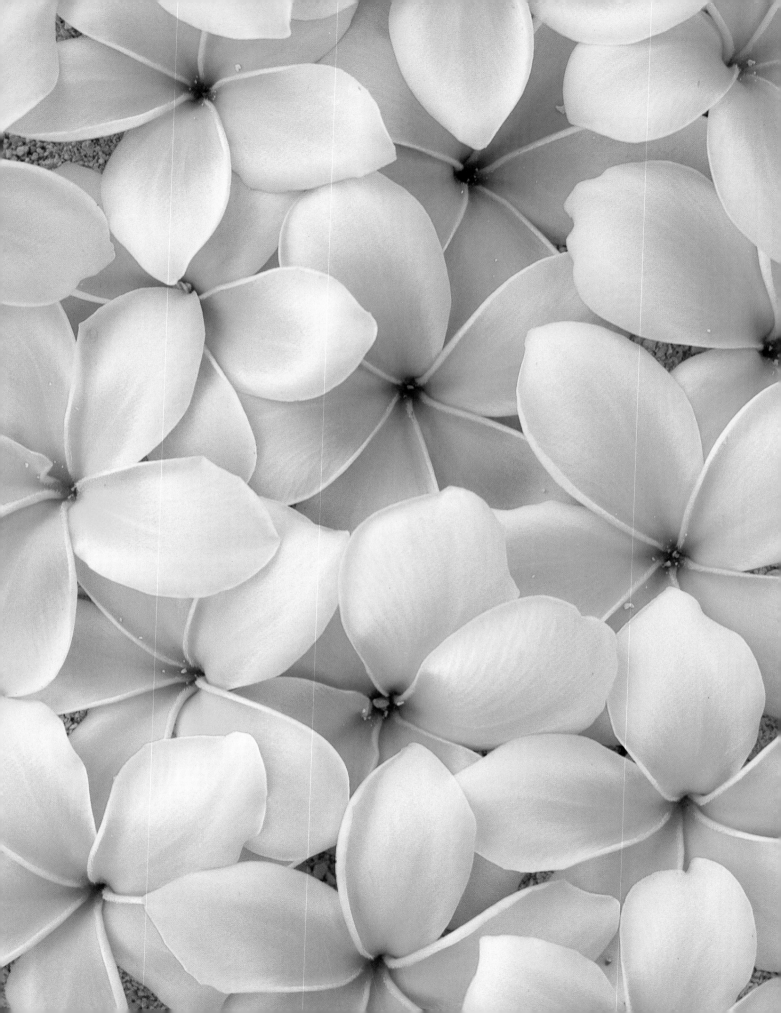

MAKING GREAT PHOTOS

Great photographs begin with personal vision. This vision, which develops gradually, will enhance your images with sensitivity and artistry that is solely your own. But expressing that vision requires learning the fundamentals of photography first. I personally don't like rules that restrict artistic expression, and I tend to break them as often as follow them. My ability to break them successfully, however, comes from having learned them in the first place.

Following the accepted standards and principles of photography will give you guidelines for evaluating and improving your work. Study the work of the great masters of photography and analyze how they've utilized the basic elements of composition such as dominance, balance and

unity to create striking images. Is there a strong center of interest? Look at how they have used color and light to capture a particular effect. Try to decide when they broke the rules and, more important, *why*.

You get to be a better photographer the same way you get to Carnegie Hall in the old joke: practice, practice, practice. Thousands of pictures will end up in the trash along the way, but don't ever let that discourage you. Even after taking pictures for twenty-two years, I still find my reject pile growing by leaps and bounds. A lot of that is the sign of my growth as a photographer. I've gotten more and more demanding of myself as my work has matured. Images that would have pleased me five years ago are no longer good enough. If it's not already true for you, it will be.

PRETTY ISN'T ALWAYS GREAT

I think the toughest part of photography is learning that a pretty scene won't always yield a great photograph. This is most obvious when you try to capture a beautiful panorama. Every time I take the Palm Springs Aerial Tramway (Palm Springs, California) to the top of a cliff that's a mile and a half above the desert floor, I want to put on a wide-angle lens and capture the whole expanse of desert. But I

know that the resulting image would only document what I saw; it wouldn't be a great photograph because the panorama has no strong graphic shapes. Also there's no illusion of depth or any rich texture to the ground. You'll encounter the same problems

when you try to capture an expanse of forest or waves rolling across a wide beach.

Unfortunately, we usually don't realize the difference between pretty and great until we get our pictures back from the lab. Scenes with dynamic shapes, a strong center of in-

As a general rule, you get a better composition if you have a focal point, something that immediately draws the viewer's attention. But there are exceptions to every rule, as this photograph demonstrates. There is no one center of interest, but the arrangement of flowers within the frame, the bright spots of color, and the interesting texture of the petals provide enough interest to draw in the viewer. Experiment with breaking the rules of composition occasionally and see what results you get.

Technical Data: *Mamiya RZ 67, 110mm lens, #1 extension tube, 1 second, f/22, Fujichrome 50D, tripod.*

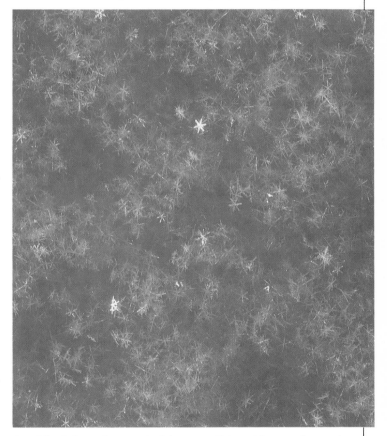

I could only have photographed these snowflakes with a very low angle of light. The sunrise illumination just skimmed across the ground, catching a few flakes and providing the textural quality necessary. If the sun had been overhead, the light would have been too flat to get this shot because there wouldn't have been the highlights and shadows that clearly define each flake.

It was fifteen degrees below zero when I shot this, and the extreme cold kept the flakes from melting into each other as they would at warmer temperatures. Although my fingers ached from the piercing cold (despite three layers of gloves), I had to get this rare shot.

Technical Data: *Mamiya RZ 67, 110mm lens, #2 extension tube, 1/4, f/22, Fujichrome 50D, tripod, cable release.*

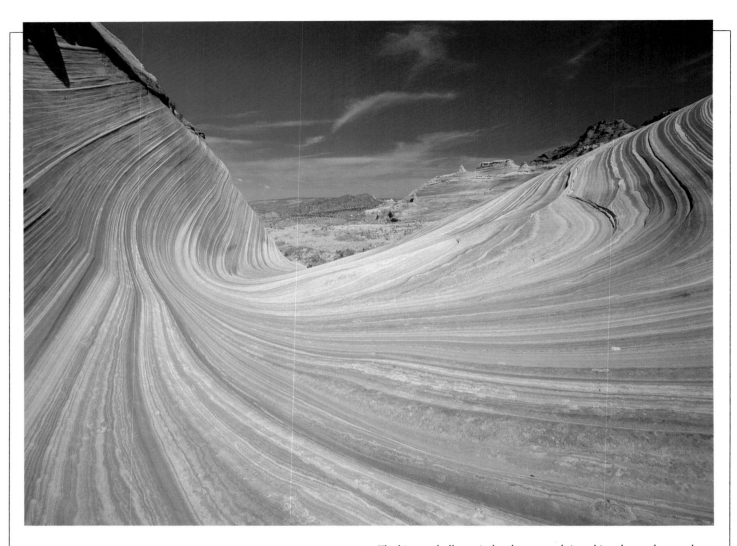

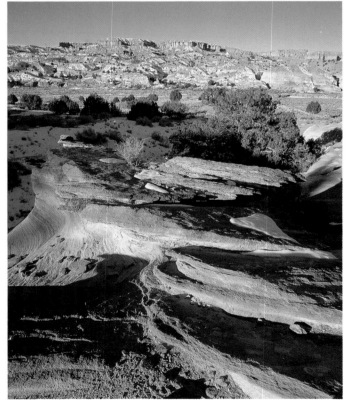

The biggest challenge in landscape work is seeking shapes that produce beautiful photos. Study the mountain ranges, the courses of rivers, the vegetation, and the cloud patterns to determine which point of view will give you the most artistic design of lines and shapes. In the left-hand photo, although I followed most of the rules of landscape composition — beautiful lighting, interesting textures, division of the frame — the image doesn't work because it lacks striking shapes. The lines are ordinary. I didn't choose a place that exhibited special beauty.

I took the photo on the top perhaps a hundred yards from the other. It works because the sandstone formation has fluid, artistic shapes that add a strong graphic element to the composition. Your peers and photo buyers will recognize time invested in searching for dynamic shapes like this.

Technical Data: Desert photo on left — Mamiya RZ 67, 50mm lens, 1/8, f/22, polarizing filter, Fujichrome 50D, tripod, cable release. Desert photo at top — Mamiya RZ 67, 180mm lens, 1/8, f/22, polarizing filter, Fujichrome 50D, tripod, cable release.

terest, rich texture or patterns and striking lighting always stand out. Without these basic elements, a pretty scene simply looks boring or flat, making us wonder why we bothered to take it in the first place. As you analyze your slides or prints, compare the shots that stand out to those that don't, and decide what makes the difference. Keep those elements in mind when you shoot, and you'll soon begin separating pretty from great *before* you snap the shutter. To help you evaluate your work, we'll review in this chapter the basic principles of photography and see how to apply them for better images.

WHY SHOULD I TAKE *THIS* SHOT?

All truly compelling images have two things in common: They have a center of interest that draws the viewer's eye, and they hold the viewer's attention. Some aspect of the scene—an unusual rock formation, an animal, or a cloud pattern—or its overall arrangement must capture your eye immediately. If it doesn't, you won't catch the viewer's attention, either. There must be a shock of recognition, an emotional response, or a sense of intrigue to persuade a viewer to look further. Once you've captured the eye of those elusive viewers, you must *keep* their attention. In other words, the whole image must work to deliver on the promise of that first glance. It should convey a sense of a shared experience or should

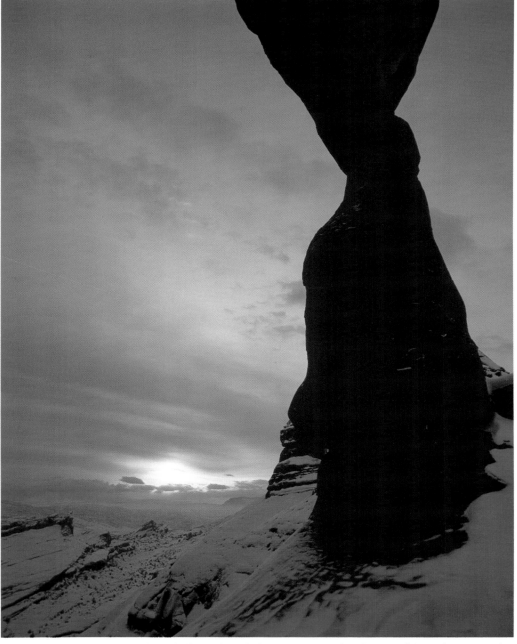

I hiked for an hour in the predawn darkness through deep snow to reach Delicate Arch in Arches National Park, Utah, hoping for the beautiful morning light. No such luck. It was completely clouded over, and I thought the trip was going to be wasted. Instead, the sun peeked out from behind the cloud cover, giving me a dramatic silhouette of the huge sandstone monolith. It lasted for only a few seconds—not enough time to mount the camera on a tripod. This is my favorite of the few shots I got. Even if you don't get the sunrise or sunset you wanted, the chances are still good that you can find something worth photographing. It might be a gentle streak of pink in the sky, a striking silhouette, or the sky's reflection in a pool of water. That's what makes those times of day so special for photographers.

 Technical Data: *Mamiya RZ 67, 50mm lens, 1/60, f/4, Fujichrome 50D, hand-held.*

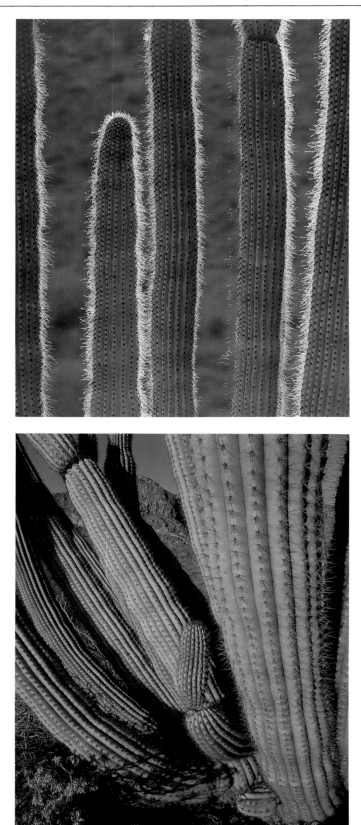

charm through sheer beauty. This is why details are such a critical part of every photograph—one small element that detracts from the overall image can ruin the whole thing.

Something to consider if you want to earn your living with your photography is what you plan to do with an image. Often you'll take a photograph simply because it's aesthetically pleasing and decide on an appropriate market for it later. On the other hand, you'll sometimes have to consider where you plan to market the image before you shoot. For example, I often finance shooting trips by selling photo essays about the location when I return (see pages 72-73 for more on this). That means I must make sure that at least some of my images will work for a certain magazine audience rather than shooting just what pleases me. If I see a scene or encounter an animal that I think will make a shot with cover potential, I try to use a vertical format because that's more likely to fit easily on a magazine cover.

LIGHT

Light is one of the most important components of an outstanding image because it determines how the subject will look in terms of contour, form, texture, tone and color. The hardness or softness of the light will affect the highlights and shadows, which will change the emotional impact of a scene. The direction of

When the sun is low on the horizon, you can take two very different kinds of photographs. If you face the sun, objects in front of you are either backlit or silhouetted against the brilliant sky. If you have your back to the sun, objects in front of you are illuminated with a warm, frontal light. Both shots of this organ pipe cactus were taken only minutes before the sun sank below the horizon. The backlit image (top) is made dramatic by the halo effect created by the light shining through the needles, contrasted with the darker barrels of the cactus. In the frontlit image (bottom) the drama comes from the warm colors of the cactus accented by the unusual angle of the shot. Same subject, same time of day. The only difference is the effect of the lighting.

__Technical Data:__ Backlit photo—Mamiya RZ 67, 250mm lens, 1/60, f/11, Fujichrome 50D, tripod. Frontlit photo—Mamiya RZ 67, 50mm lens, 1/8, f/22, Fujichrome 50D, tripod.

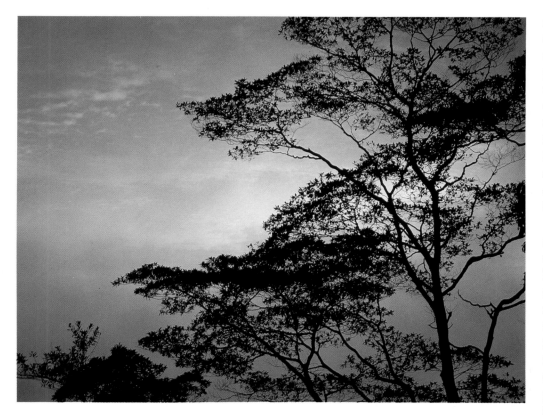

The soft lighting and pastel colors at sunrise or sunset transform any outdoor subject. This tree in the Amazon would have made a very dull photograph during midday, but at sunset it creates a delicate silhouette against a lovely sky.

Although sunrise and sunset provide beautiful colors anywhere, I believe they're especially dramatic in the American Southwest—and not just because I live there. Look at the photos in this chapter, such as the ones on page 2, and see how the orange and rust tones of the earth are made more brilliant by the atmospherically filtered sunlight.

Technical Data: *Mamiya RZ 67, 180mm lens, f/11, Metz 60 T-2 strobe, Fujichrome 50D, handheld.*

the light can create dramatic effects or wash out a picture entirely. Even the time of day can make the difference between a good shot and a great one.

You must become a sensitive observer of natural light to create dramatic shadows, a strong feeling of dimension, or rich or subtle colors. Return to the same place at different times of the day and in different light or weather conditions. You'll discover that each hour has its own mood or atmosphere and that some lighting conditions produce more effective photographs of a certain place or subject than others do.

SUNRISE, SUNSET

Sunrise and sunset are the best times to shoot nature and wildlife photos. Including the sunrise or sunset itself in a shot automatically gives the image extra punch. Depending on the weather conditions, the half hour or so after sunrise and the half hour or so before sunset can provide especially dramatic lighting effects. Shadows are long and textures and colors are extremely rich in the warm, gentle light at these times of day. You'll often find exciting contrasts between light and shadow areas and between brightly colored and more subdued areas. It's very easy to achieve lighting effects such as silhouettes, transillumination, rim lighting and backlighting when the sun is low on the horizon.

Dawn and dusk—the half hour or so before the sun rises or after it sets—fill the sky with magical, rapidly changing light. The cool, blue/purple hues of night mix with the golden tones of daylight, creating a cosmic palette of dazzling intensity. Trees, rock formations, and animal silhouettes framed against this spectacular backdrop of color can give you many of your best pictures.

These moments, however, are short lived. The deepest color saturation in the sky lasts for just a few minutes (unless you are in the extreme northern or southern latitudes), so you must shoot fast. Be in position, with your tripod and camera already set up, *before* the sky reaches its peak color. With the composition already framed, all you need to do is take a meter reading and make the shot. If you look for a good place to set up *during* the brilliant color display, you'll be too late.

Although exposures are tricky when shooting into a bright sky, you'll get a proper light reading by analyzing the brightest part of the glowing clouds. This can be done with a spot meter or by using a telephoto lens in conjunction with the TTL meter in your camera. Once you get the reading, compose the shot and make the exposure. If the sun itself is above the horizon, take the light reading from the area of the sky *next to the sun*, without including the sun in the frame as you make the reading.

These readings will give you

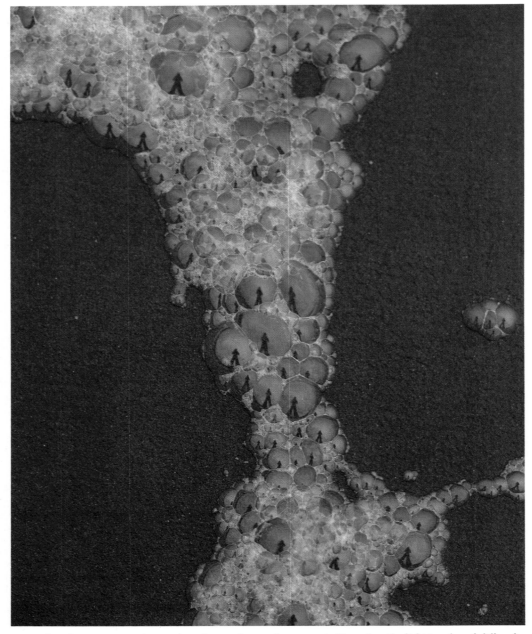

Some of my favorite nature images have been taken under overcast skies, when the light is soft and diffused. These iridescent ocean bubbles, reflecting me as I leaned down to compose the image, were photographed on a black sand beach in New Zealand. Note that there are no shadows and no modeling. The colors are muted rather than bold, and the texture of the sand isn't pronounced. I could only have gotten this particular look and mood on an overcast day. Although the light level was very low, I couldn't use a tripod because the composition kept changing, each design lasting only seconds. It was vital that I keep the film plane parallel with the bubbles to maintain maximum focus. I was shooting wide open, trying to gather as much light as possible.

I spent two hours trying to get this image. The wind was blowing quite hard, breaking the bubbles constantly and making my eyes water. The surf kept destroying whatever composition I was trying to frame. In addition to these hazards, a dog on the beach desperately wanted someone to play with. Since I was the only person around, he would bring me a piece of driftwood and drop it right under my camera in the middle of my composition. I'd throw it as far away as I could, but fifteen seconds later he would be back with his pleading eyes and the same piece of wood.

Technical Data: *Mamiya RB 67, 180mm lens, 1/30, f/4.5, Ektachrome 64, hand-held.*

a dramatic, properly exposed sky with a very dark foreground. If you expose for the ground, the rich color in the sky will be overexposed and virtually lost. That type of treatment rarely produces a good picture when shooting in color.

Overcast Conditions

An overcast day is an excellent time to take nature photographs. This surprises many photographers who become discouraged when they see the sunlight blocked by a heavy cloud layer. The light on an overcast day is even and diffused, similar to that produced by a softbox in the studio. Contrasts are soft and subtle.

Colors under these conditions are rich and fully saturated — perfect for flowers or autumn foliage. The soft light can also give your photographs an ethereal quality. It's ideal for shooting a high-key image of a light-colored subject against a light-colored background, because it creates an even, diffused light with a minimum of dark, shadowed areas.

The soft, hazy atmosphere that fog and mist create can be especially effective; many of my favorite images were taken in dense fog or winter white-out conditions when the natural light was at its maximum softness.

Be careful when shooting a landscape with a lot of sky on an overcast day. Often the sky is uninteresting — a washed-out gray or white. You may get

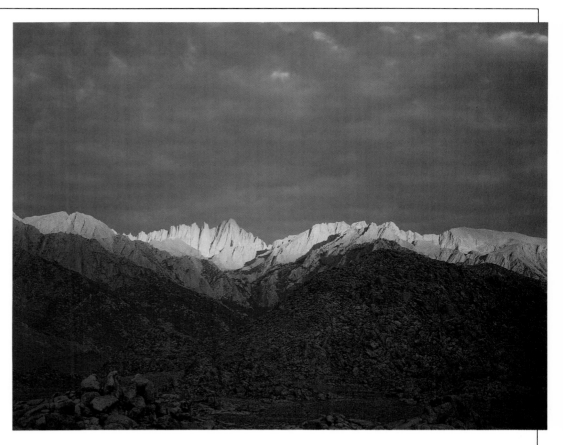

better results by keeping your horizon line relatively high or using the sky as a contrast to a very interesting foreground.

STRONG COMPOSITIONS

I spend most of my time looking for powerful compositions—the biggest challenge that nature photographers confront. You can't just point your camera anywhere, even in spectacular settings such as Bryce Canyon or Yellowstone, and expect to get a great shot. You must be extremely selective, studying each scene with an artist's eye. The composition you choose will make or break the photo.

There are always many ele-

A sunrise peeking through clouds illuminated the face of the eastern Sierra Nevadas near Lone Pine, California. The contrast between the warm tones in the highlighted portions of the mountains and the cooler hues of the shadows and sky promised a beautiful shot. But beautiful lighting isn't enough. In the first photo (top), the horizon line cuts the frame exactly in half, leaving the picture static because there is equal weight above and below it. In the second picture (bottom), the composition follows the Rule of Thirds. The ridge of the mountains follows the upper horizontal third, while the upper portion of the unusual rock formations outlines the lower horizontal third. The highest peak in the photo was placed along the left vertical third. Although the Rule of Thirds, like all rules, can be broken at times, you can rely on it for consistently good compositions.

Technical Data: *Both photos— Mamiya RZ 67, 180mm lens, 1/15, f/16, Ektachrome 64, tripod, cable release.*

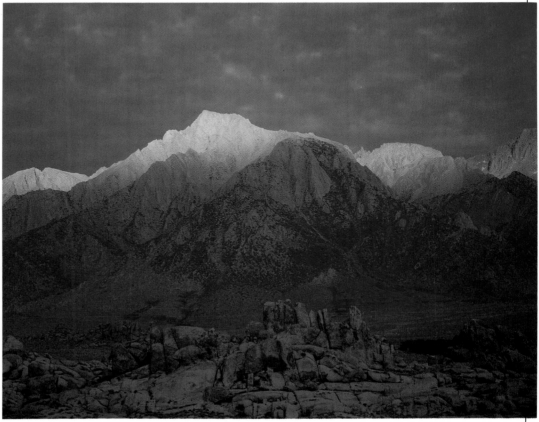

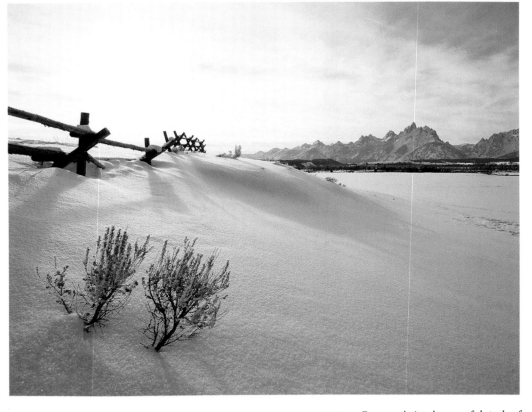

ments to consider when composing a picture. Although every rule of composition can be broken with effective results, you must know the rules and be able to follow them successfully to break them without inviting disaster. Take a few minutes before you shoot to decide what impact you want the image to have on the viewer; then find the composition that best achieves your desired result.

I could devote the rest of this book to composition and still not discuss it all. So I'm going to concentrate on just a few critical issues, followed by a quick review of some of the special problems inherent in wildlife photography.

THE RULE OF THIRDS

One of the most important aspects of photographic design is the Rule of Thirds. Although this rule can be broken successfully in some cases, you will get good photographs if you follow it in most instances.

The Rule of Thirds means that you mentally divide the area of your composition into thirds along the horizontal and vertical edges of your viewfinder. Then position the dominant element(s) — a tree, mountain range, animal or flowers, for instance — along the horizontal or vertical thirds of the frame.

In other words, imagine your viewfinder is divided into a tic-tac-toe board with two vertical lines and two horizontal lines. A single tree should be composed along one of the

Frequently it takes careful study of the scene to determine the best composition. I sometimes take several shots, moving around to different locations and experimenting with lenses before I find the shot that's eluded me. These two images show the difference that changing your format can make to your composition. I shot a vertical first (left), but it lacked a dominant foreground. The two small bushes in the center are too distant, and their shapes are lost because a portion of the split rail fence intersects the top of the plants. In the horizontal format, the shrubs are a dominant foreground element, and the background is strong and graphic. It also includes more of the mountain range and less of the fence. I moved closer to the plants to get the composition from this angle and had to stand in snow up to my hips, but it was worth it.

Technical Data: *Both images — Mamiya RZ 67, 50mm lens, 1/4 second, f/32, Ektachrome 64, tripod. Incident light reading determined by Minolta III flash meter.*

vertical lines, while the horizon is best positioned to coincide with one of the two horizontals. The four points at which the lines intersect are frequently reserved for important objects such as the sun or a bird in flight.

While the Rule of Thirds helps you get consistently well-composed images, don't be afraid to break it. There are times when the best place for the horizon is smack in the middle of the photograph. When photographing a single tree in winter, I've sometimes flouted the rule successfully by placing the tree in the middle of the frame. Because it counters the viewer's expectation of how a photograph should be arranged, not placing an element in a third sets up an interesting tension. For example, centering a single element in an image can heighten the viewer's awareness of its isolation.

HORIZONTAL VS VERTICAL FORMAT

Some scenes lend themselves to horizontal compositions, while others demand a vertical treatment. Sometimes both work well, and you'll have to choose the one that best enhances the mood you want to convey. If you're not sure, try several shots with both vertical and horizontal format to improve your chances of getting the best version.

Unfortunately, commercial considerations must play a role here. Magazine covers and full-page ads are generally

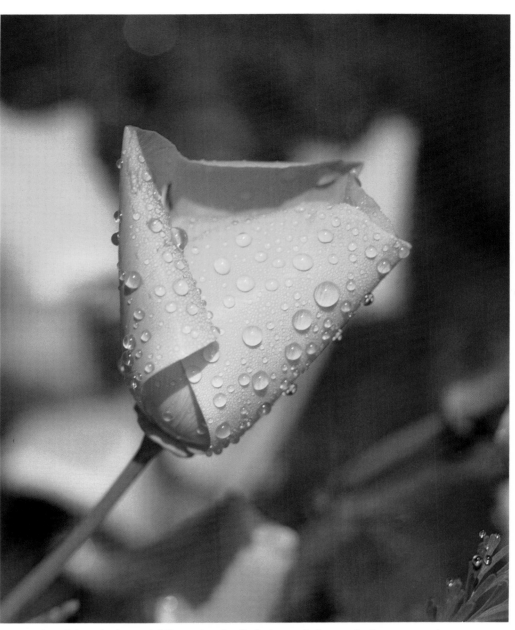

Capture the subtlety of color and delicate, tiny details during and after a rain that most people never even notice. I photographed these raindrops on an orange poppy at the end of a shower, when the sun was just starting to break through the clouds at 6:00 A.M. I wanted an out-of-focus background to make my subject prominent against the soft color. Since the flower was relatively close to the foliage behind it, I couldn't use apertures in the range of f/22 or f/32. If I had, the background elements would have come into focus.

Technical Data: *Mamiya RB 67, 127mm lens, #1 extension tube, 1/15, f/11, Ektachrome EPR 64, tripod.*

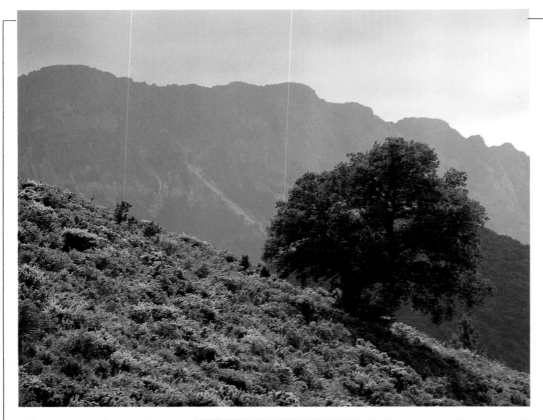

verticals, and those photo buyers prefer verticals because they fit design and cropping needs. Sometimes I'll shoot a vertical to make an image more salable, even though a horizontal may be more attractive. Most calendars and double-page magazine pictures are horizontals (posters can be either), so I try to shoot specifically to fill this need. The best way out of this dilemma is to take both formats of a particularly great scene if time and conditions permit. When there's time for only one shot, try to think of where you'll have the best chance of selling the image, and go with that format.

SHAPES AND LINES

Some lines are more visually dynamic than others. The S-curve has contributed to the success of many superb pictures. That's probably why the Snake River as seen from the Snake River Overlook in Grand Teton National Park has been photographed so often. You can also find sinuous S-curves along shorelines, among tree branches, or in the contour of an animal's body. The C-curve is also quite attractive when used, for example, in shooting rock outcrops or doing macro work. Diagonals add more excitement than straight vertical lines, which tend to be static. I frequently angle my camera simply to emphasize a diagonal line.

Simple, strong shapes help create exciting pictures. Think of all the classic images with

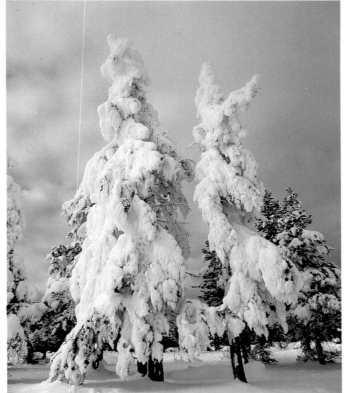

Balance is one of the most important rules in composition. Imagine the center of the frame is a fulcrum with a seesaw balanced on it. All the elements in a shot must be balanced around a central point. This photograph (right) taken from cross-country skis in Yellowstone demonstrates this principle. Both snow-covered pines are composed around the central point within the 6×7cm format.

But balance doesn't mean that all compositions must be centered in the frame. If a single, strong element is placed off center in the right or left third, for example, then it is balanced by the negative space on the opposite side of the picture. This photograph (top) of a tree in the Cadiz Mountains of southern Spain shows how this type of asymmetrical balance works. The tree was positioned in the right third of the shot, and the balancing element on the left is the upward slope of the foreground hill.

Technical Data: *Snow-covered pines—Mamiya RB 67, 127mm lens, 1/125, f/5.6, Ektachrome 64, hand-held. Single tree and mountains—Mamiya RZ 67, 180mm lens, 1/30, f/16, Fujichrome 50D, tripod, cable release.*

a single rock outcrop or cliff standing against the sky. A close-up of an animal's face against a very soft background is another example. For maximum impact, there should be a strong contrast between the shape and its background—lightness and darkness or contrasting colors. Unusual or partial shapes, such as a section of a leaf, can also have great impact.

ORDER OUT OF CHAOS. How do you begin to choose which of the many elements in the scene before you to include in an image? I usually think in terms of lenses—wide-angle and telephoto (I seldom use a 50mm lens). With a telephoto you isolate a particular element from the rest of the picture. Think of it as cropping within the camera. You can include only one part of a mountain or single out a tree branch.

Because you get a very shallow depth of field with long lenses, the soft background further helps isolate your subject by focusing all of the attention on it. The characteristic compression of perspective associated with telephotos also makes the subject in focus stand out against the background. Isolate an animal from its surroundings (especially handy in zoos, see pages 31-32) by framing the picture in a tight composition with a long lens. Make sure that your background is totally out of focus, not just a little blurry, when you want to isolate an animal or other element against it. If the background is too recognizable, it will be distracting.

On the other hand, wide-angle lenses elongate a scene by giving the illusion that the horizon is farther from, and foreground closer to, the camera than it really is. The secret to creating classic landscapes is to find an interesting foreground very close to the camera position—perhaps three to five feet away—and use a wide-angle lens and a small aperture for maximum depth of field. I prefer a 24mm wide-angle for 35mm format and the 50mm wide-angle for shooting medium format. You must have a tripod when you're using small apertures because your shutter speeds will be too slow to hand-hold the camera.

The way an animal looks and moves can completely change its effect on a viewer. As this bobcat approached my camera, I photographed it in many positions. When it was standing at the base of the tree, fully stretched, it looked wild, alert and stealthy. But when I captured a tight shot of its face in the tree, it appeared more like a cuddly pussycat. It's the same animal, but the feeling of the picture is totally different.

Technical Data: *Both shots— Mamiya RZ 67, 500mm lens, 1/60, f/8, Fujichrome 50D, tripod.*

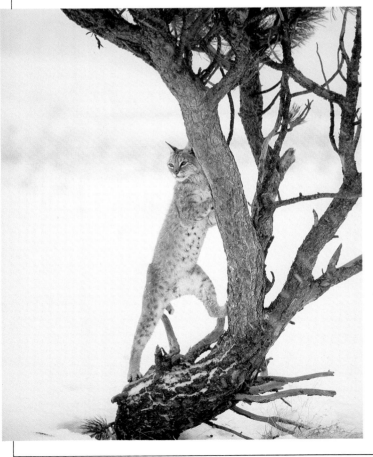

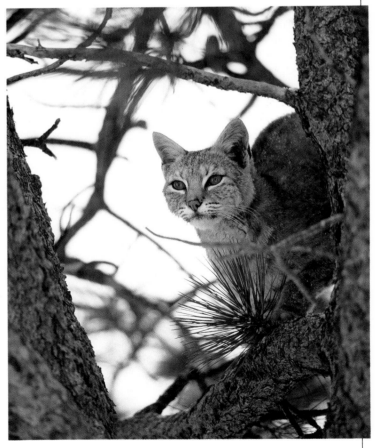

Balance

Balancing a composition is much like balancing a seesaw. The fulcrum is the center of the viewfinder, and you have to position the elements on either side of it so the whole image, like the seesaw, is balanced and even. This doesn't always mean dividing your image so the weight falls absolutely evenly; you don't have to split two tall trees so that one falls on each side of the center. If you do that your image *will* be in balance, but it may *not* be very exciting.

Instead you could put your two trees on one side and a group of many small rocks on the other. If the rocks are small relative to the trees, then position the trees closer to the fulcrum. Children know to do this on a seesaw, so a larger child will sit closer to the center while the smaller child sits way out at the other end. A large expanse of negative space—sky, grassland, ocean or white beach—has weight and can therefore be used to balance objects on the other side of the composition.

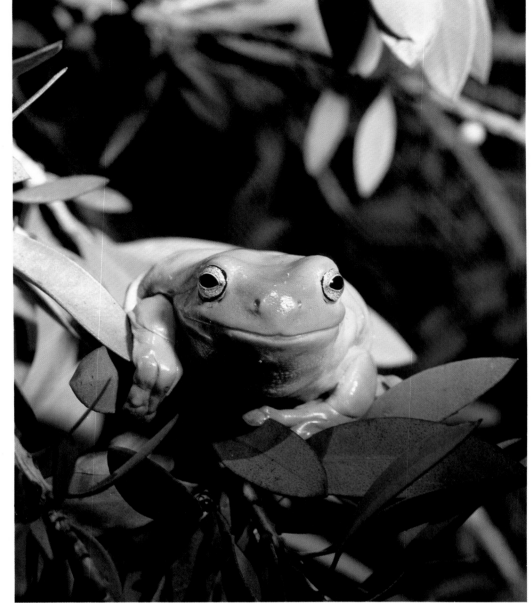

Facial expression is just as important in wildlife photography as a person's expression is in portrait photography. This White's tree frog must have smiled for the camera—or maybe it was just enjoying a private joke. But the comical expression makes the shot.
Technical Data: Mamiya RZ 67, 180mm lens, 1/250, f/5.6, Fujichrome 50D, hand-held.

Wildlife Composition Problems

Because animals move suddenly, it's hard to get a beautifully composed shot of one. To improve your odds of getting a strong composition, get close enough to the subject to have it fill a significant portion of the frame. That means using a long lens, at least 300mm in 35mm format; lenses in the 400mm to 600mm range are common. The longer lenses also improve your chances of keeping the background soft so it's not distracting. That alone can make the difference between a good and a great image.

Use a blind whenever you can. This will let you get much closer to your quarry, especially if you also use food bait. You'll also be able to use a much shorter lens. This blind and bait technique works best in winter when food in the wild is in short supply.

Wildlife Movement and Expressions. The most challenging aspect of photographing wildlife is to capture interesting expressions, poses and movements. Animals move suddenly and swiftly; something startles them and they're gone. An animal's expression is as fleeting as a person's. Qualities such as alertness, surprise, fear, aggression, curiosity and affection can turn a mundane shot into one that has magic.

You can't capture an animal's expression by photographing just the eyes. It's the attitude of the ears, the tenseness of the neck, the baring

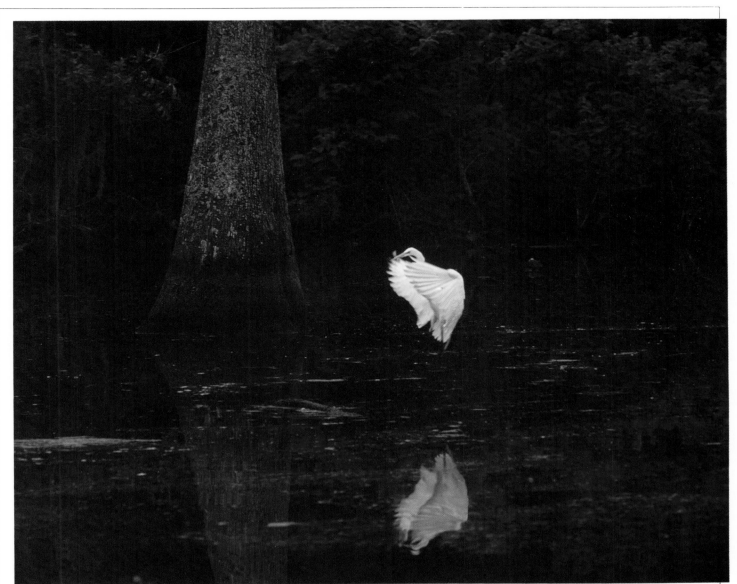

of the teeth. How an animal moves and stands is critical to effective shots of mammals, birds, and even some reptiles. Grazing animals such as deer or wild horses can be especially challenging to shoot because they stand there eating, heads down, for hours. You must often wait until these animals sense the possibility of danger. Then they stand erect, bodies tense and ears up, and turn their heads to investigate—and that's the moment to shoot.

To capture these special moments, know your equipment thoroughly and be able to shoot quickly. Autofocus and autoexposure systems are invaluable in these instances, because they let you concentrate your total attention on framing the subject and choosing the perfect moment to shoot. With a manual system you must preset your exposure and focus as quickly as possible. In those few brief seconds when you're not quite ready to shoot you can lose a once-in-a-lifetime image. I can remember too many pictures that I lost because the equipment I used when I was starting out wasn't fast enough to keep up with the

I was photographing egrets and herons in Louisiana's Atchafalaya basin from the deck of a boat provided by Chevron Oil Company. It was much darker than I had expected, so I was forced to push process my Ektachrome 64 to 400—not the best situation. When film is pushed that much, you'll get increased grain, loss of the rich blacks, and a picture that tends to look muddy. With that large an increase in film speed, I was stuck with an exposure of 1/60th of a second. That's not fast enough to freeze moving wings, but the shot is surprisingly effective as it is.

Technical Data: Mamiya RZ 67, 500mm lens, 1/60, f/8, Ektachrome 64 pushed to 400 ISO, tripod. A tripod on a boat isn't stable since the boat isn't; however, it did help take some of the weight of that hefty 500mm lens off my neck.

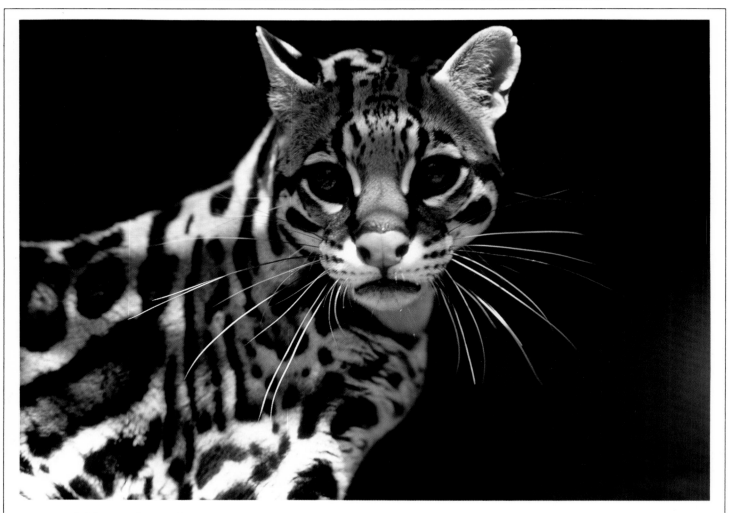

action unfolding in front of the lens.

When shooting with manual systems, fast lenses such as a 300mm f/2.8 or an 85mm f/1.2 help you focus in record time because they allow so much light into the viewfinder. It's easy to judge when you're in focus. Slower lenses, such as the 300mm f/5.6, permit much less light. By the time you turn the focusing knob back and forth, trying to get it right, the moment may have been lost forever.

You must also know your quarry — their habits and responses to situations. You'll have an edge if you can anticipate when an elk will have an alert expression or a wolverine will move into an aggressive posture. You can't afford

a moment's distraction, even if your hands or feet *are* freezing. I've missed many shots because I was thinking about something else and recognized a great photo too late to get it on film.

SELF-CRITIQUE

The most important skill you need as a photographer is also the hardest to develop: the ability to judge your own work objectively. That means checking your ego and emotions at the door and analyzing your work as if it's that of a complete stranger. The only way we can improve as photographers is appraising our work honestly and then working to improve those areas in which we're weak. It's a process that never ends, no mat-

It's tough to photograph wildlife in the tropical rain forests, because it's dark on the forest floor and the animals won't get close enough for a good shot. Many are also extremely elusive. I've only once seen an ocelot in the wild. It ran across the road in front of my car when I was leaving the Mayan ruins of Tikal in Guatemala. Once past the car, it stopped, ran back to the edge of the jungle, stared at me for about five seconds, and was gone. But that was long enough.

Patchy sunlight presents a challenge to photographers, because it's tricky to get the right exposure. If you expose for sunlight, the shadows are too dark. If you expose for shadows, the highlights end up overexposed. Because I had only one chance to photograph this ocelot, I went for a point in the middle, hoping to keep my highlights from losing detail while still holding the shadows.

Technical Data: Mamiya RZ 67, 500mm lens, 1/125, f/8, Fujichrome 400, hand-held. I rested the lens on the window frame of the car door.

ter how many years you've spent taking photographs.

The three criteria by which you must judge your work are technical excellence, artistic merit, and choice of subject matter. It's easy to determine whether your photographs meet tough technical standards. The images must be absolutely sharp when seen with at least an 8X loupe. The exposure must be correct, the color should be rich and saturated, and the surface of each slide or negative must be free of scratches and other imperfections.

Artistic merit is harder to determine. These judgments are always subjective, but try to be as unemotional as possible. Examine the composition and graphic qualities of each image. Will the mood or atmosphere of each elicit an emotional response from your viewer? Will they draw and hold a viewer's interest? Have you shared a moment? Are your wildlife shots action-packed, humorous, adorable or poignant? Do all the elements blend together harmoniously? Is the use of lighting effective?

Finally, review your choice of subjects. Not all rocks or trees are equally photogenic. Butterflies may have tattered wings. It's your job to choose carefully the subjects you capture on film. For a tree to become an effective silhouette, it must have a beautiful shape. The mountain range that dominates the horizon must have a dynamic crest that draws the viewer's eye.

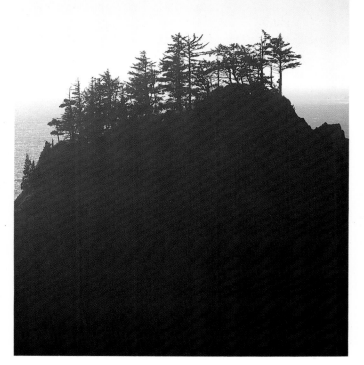

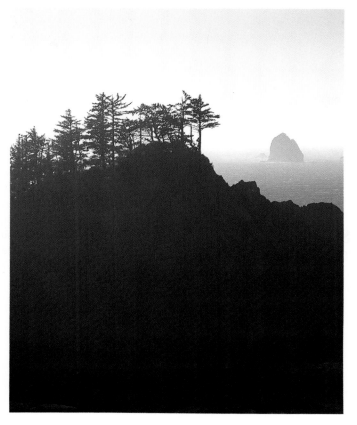

Sometimes it takes only a small change to make a good picture better. I framed this graphically attractive stand of trees on the Oregon coast against the brilliant late afternoon sky, which gave me beautiful lighting and a good design element. I thought I had framed the perfect composition. But when I studied the scene again after my initial shot, I noticed that a distant sea stack could add beautifully to the design. I turned the camera to the right an inch or two and took advantage of a dip in the ridge, which framed the sea stack to help increase the visual interest.

Technical Data: *Both photos — Mamiya RZ 67, 360mm lens, 1/30, f/22, Fujichrome 50D, tripod.*

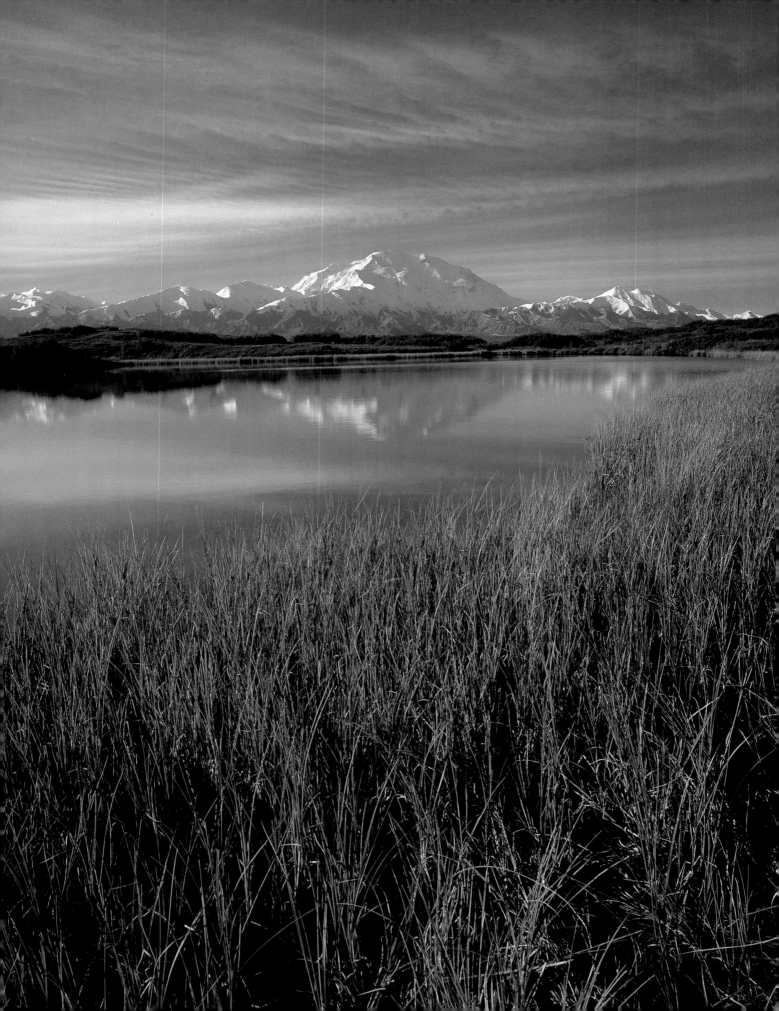

TAKING GREAT, SALABLE PHOTOS

Chapter one addressed the fundamental concepts behind the art of taking great pictures. But even if you produce outstanding images, you have no guarantee that the marketplace will embrace your photography. Indeed, your first few sales may be few and far between.

Let's examine what the obstacles are in making initial sales. This will help you identify the solutions in overcoming those stumbling blocks.

GREAT PHOTOS DON'T GUARANTEE SALES

The biggest reason excellent images don't sell is that the marketing strategy is targeted in the wrong direction. Perhaps a magazine needs a group of photos for a layout, and you've only submitted a

A great shot may be rejected because it doesn't meet a photo buyer's specific needs. This photograph of Mt. McKinley and Reflection Lake in Denali National Park, Alaska, was submitted to a magazine that had requested images of mountain peaks. Although they loved the image, it didn't fulfill the photo editor's preconceived cover shot concept. He wanted a mountain filling the frame, so that it looked huge and powerful. This wide-angle view of McKinley places the mountain in a subordinate relationship with the foreground marsh grass.

Technical Data: Mamiya RZ 67, 50mm lens, 1/8, f/32, Fujichrome Velvia 50, tripod.

single image. Or maybe your image is better suited to advertising, yet you submitted it to fine art poster dealers. Photo buyers are frequently very specific in the types of photographs they use. If your imagery doesn't fit, that doesn't mean it isn't good. It just may not belong in a particular area of sales.

Competition is intense, too. Wildlife and nature photography is the most popular type of shooting. That means that dozens of photographers who shoot as well as or better than you do are trying to fill the same slots with their images. Your images must be extraordinary to stand out in the pile—they have to have something a little special and different. And sometimes you still won't make the sale.

Your work should reflect a personal style, and your images should be fresh. Don't shoot the same subjects the same way that others have. No matter how sharp, well exposed, or brilliantly composed your image is, it won't be as salable because we have all seen that view before.

Finally, many of your great photographs may not sell as you anticipated because of bad timing with submissions. A magazine may reject a story because they just ran such a piece—or they have one in the wings about to be published. A publication may not tell you this is why your work

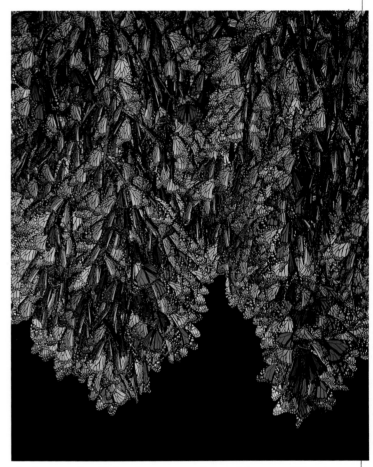

I had previously sold this photo as part of an article to two different publications. But when I showed my collection of shots of the monarch butterfly migration to California and Mexico to California Scenic, they told me I was too late. Just a couple of weeks earlier they had bought another photographer's pictures of the same event, and even though they liked mine better it was too late to do anything about it.

Just because a publication rejects you doesn't mean your work isn't professional or every bit as good as—or better than—what you see in print. Other circumstances can, and do, prevent sales. But the more times you push your work out into the market, the more times you'll succeed in making sales.

Technical Data: Mamiya RB 67, 180mm lens, Metz 60 T-2 strobe, f/8, Ektachrome 64, hand-held. You are looking at a tight cluster of monarchs covering a branch of a pine tree. The low light level of the forest forced me to use a portable strobe.

is rejected, but it is common. Three or four years ago I showed my portfolio to a photo editor at *California Scenic* (they've since folded). I suggested a number of themes, one of which was the monarch butterfly migration, which occurs on the West Coast every autumn. The photo editor saw my pictures and lamented that mine were better than the ones she had seen—and bought—only two weeks earlier.

There are some ways you can maximize your chances of selling your photos. Thinking before you shoot, looking for shots of new places, finding different ways to shoot the same places or animals, and developing a specialization will help you stand out in the crowd. In the rest of this chapter, we'll look at some ways to do all this.

CHOOSING SALABLE SUBJECTS

When I first began taking pictures, I took whatever suited my fancy. Some were good. Most weren't. When I finally decided to turn my love of photography into a vocation, I still retained my passion for the medium. But instead of simply capturing everything I felt was beautiful or exciting on film, I started looking through the viewfinder and thinking about sales. What markets would most likely use this image? Is this a possible cover, or should I shoot it horizontally for a calendar sale? It's still difficult, even after many years of shooting, to

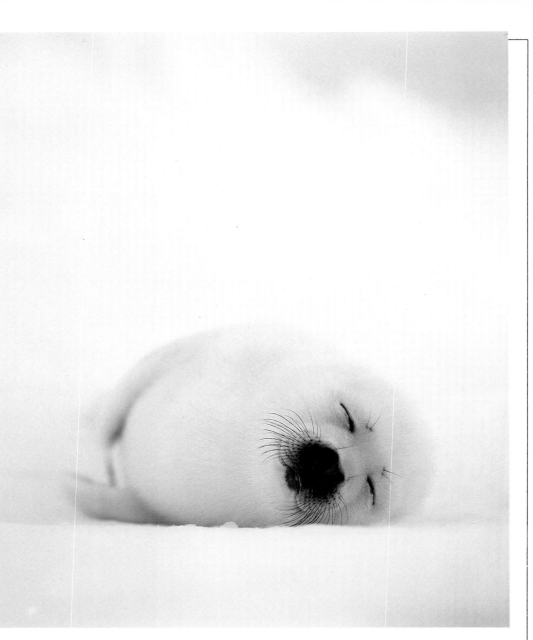

predict what qualities a photo should have to be salable. There are, however, certain patterns one sees time and again in pictures that sell. Let me list some for you.

Cute and cuddly. Right or wrong, people find some animals more lovable than others. Since photo buyers are people too, they respond to adorable little faces just like everybody else does. When I filled the frame with a close-up portrait of a baby harp seal on the pack ice in the Gulf of St. Lawrence, I knew I had a very marketable image. And,

in fact, within ten months the shot appeared on two magazine covers.

Strong design elements. Dynamic or graceful lines and shapes in nature—tree branches, mountain ridges, shorelines, rocks—are compelling to photo buyers. These compositions often end up in calendars, magazine covers, and fine art posters.

Mood. Fog, light rain, falling snow, and low cloud patterns are very salable. People respond strongly to photos that offer to share a feeling.

Sunrises and sunsets. The

Cute and cuddly animals are always big sellers. People see a baby harp seal and all they can think about is hugging it and taking it home. Animals that are less lovable to people, like reptiles, may be interesting, but they don't stimulate the same emotions and thus don't sell as many times for magazine covers, posters, calendars and note cards.

Technical Data: *Mamiya RZ 67, 250mm lens, 1/125, f/5.6, Fujichrome 50D, tripod. Exposure was determined by a hand-held incident meter because an in-camera TTL reflective meter would have incorrectly read the whiteout conditions.*

light guarantees you'll get great photos and the time is considered romantic, making such shots almost irresistible to photo buyers. Including the sun itself in the composition, peeking from behind a branch or rock, perhaps, adds even more sales potential.

Thematic groups of photos. Sometimes a single image is less salable than a group of images around a common theme. One beautiful picture of the Atchafalaya Swamp in Louisiana may generate a few sales, but a group of twenty related shots could mean not only a cover sale but a photo essay, an article, and perhaps even the concept for a book on the swamp.

PLANNING A TRIP WITH MARKETING IN MIND

When you go on a photography trip, every day you're away from home costs money. Therefore, carefully plan all aspects of the photo shoot so that you can return with a maximum of salable pictures and a minimum of expense. When I travel domestically, I usually drive. True, time is money, and days spent driving means several no-income days. But in the end, I reason that by driving I'm saving cash, as opposed to losing money I never had in the first place. Besides, there can be many photo opportunities along the way.

Another advantage to driving is that I can easily sleep in my own vehicle, which is a pickup with a camper shell. This not only saves money,

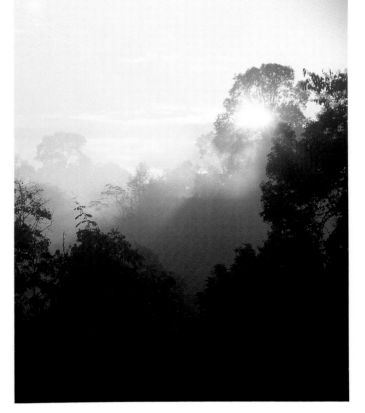

You'll sell more verticals than horizontals for magazine covers because of the magazine's format. This is one of the few horizontals I've sold that was cropped vertically. The photo editor liked it so much he just made it work.

Technical Data: *Mamiya RZ 67, 127mm lens, #1 and #2 extension tubes, flash on-camera positioned just off lens axis, f/22, Ektachrome 64, hand-held.*

Traveling to other countries is an expensive proposition when working on speculation. Some subjects, however, are more lucrative than others. Photos of the rain forest are always in demand, especially since the destruction of our tropical rain forests is so often in the news. This ethereal sunrise was photographed in northern Thailand, where much of the area has been logged for teak.

Technical Data: *Mamiya RZ 67, 360mm lens, 1/125, f/6, Fujichrome 50D, tripod. This tricky exposure situation was interpreted not with a meter, but by knowing the "Sunny f/16 Rule": At sunrise, open up one and a half to two f/ stops from bright sun.*

but it allows me to comfortably be at the right place and right time for sunrise or sunset. Sleeping in a rental sedan is extremely uncomfortable.

Most of the research I do in planning a trip is visual. I study photo books, postcards, local guidebooks, maps and calendars that pertain to the area I will be shooting. These images give me a clear idea of precisely where I want to go and the kinds of images I can expect. Not to prepare yourself in this way means a loss of valuable time when you arrive. I also speak to park rangers and other local residents concerning the best vantage points, specific areas of wildlife sightings, and so on.

Just as important as planning your photography is letting photo buyers know before you leave what your destinations are. I will call the editors or photo editors of several magazines that have used my work and let them know, for example, that I'll be spending a couple of weeks during January in the Grand Tetons and Yellowstone. I ask if they'd like to review my shots when I return and whether they'd like any special angle covered. They usually won't commit to using your photos or article until they see the results, but they may give you some ideas. Follow up on them. Shoot your scenics but add shots of a particular ghost town, if an editor suggested it. If you haven't been published before, call anyway and introduce yourself. Tell them you understand

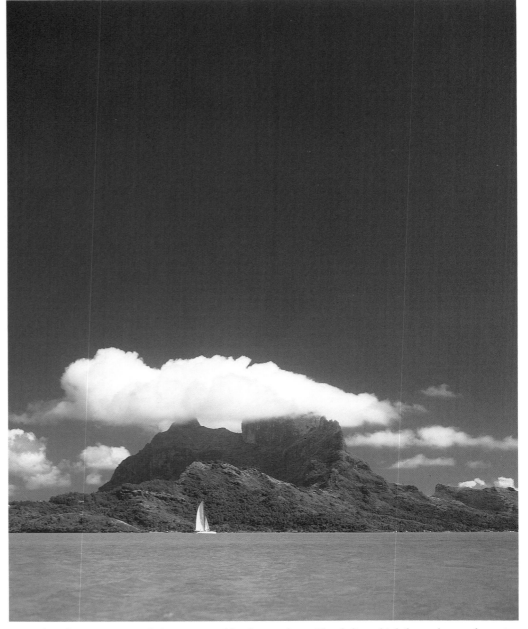

Many photo buyers want people in nature and landscape photos. They believe this helps to show scale or give perspective, or that people just relate better to people pictures. I feel including people often ruins a nature photograph. The subject is no longer nature or the scene; it's become the person included in the frame. But there are exceptions. This sailboat drifting by Bora Bora in French Polynesia fits perfectly with the otherwise pristine environment. Commercially, the shot is much more salable because the human element entices and invites in a very seductive way. Everyone looking at this picture wants to be on that boat!

Note how much negative space I allowed for the sky. I did this purposely for future sales so a magazine logo or ad copy could easily be superimposed over the large expanse of blue.

Technical Data: *Mamiya RZ 67, 250mm lens, 1/125, f/5.6, Fujichrome 50D, polarizing filter, hand-held in small, rocking boat.*

any shooting is strictly speculation on your part, but you thought they might like to get the first crack at seeing your work.

As you shoot during a trip, think about how your photos might be used. Cover shots are usually vertical format, while double-page spreads and calendars are usually horizontals. Also think thematically. Tell a story with pictures around a central theme. At a camping site, in addition to the landscape shots and macro work, document hikers on the trail, and people sitting around a campfire. Magazines whose specialties range from travel to backpacking can use this series. You'll have a complete visual story an editor can easily lay out, and you will have greatly increased your sales potential.

It's also a good idea to keep in the back of your mind larger projects, such as books. By filling holes in your stock library, you can work toward a long-range goal. I want to have a book of my butterfly shots published, so I photograph these beautiful insects everywhere I go.

INVOLVING THE VIEWER

A strong center of interest draws a viewer into a picture. Photo buyers look for this kind of composition. A single, bold tree silhouette, a jagged mountain peak, or a bull elk against the setting sun are examples of very strong centers of interest. True, these pictures don't present themselves at every turn on the

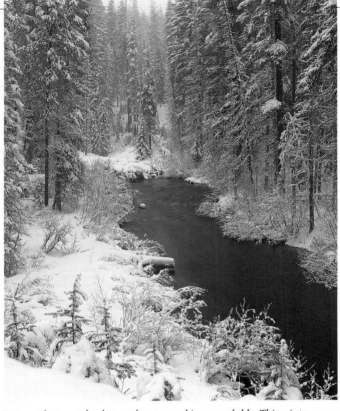

Nature photography that evokes a mood is very salable. This winter scene near Crater Lake in Oregon was actually taken in dim twilight, but the long exposure enabled me to lighten the overall shot. The moodiness of the cold snowy river, seen here with the bluish cast, can sell for many different markets: greeting card, calendar, magazine cover and so on.

The blue in this image is the result of a color temperature reading around twelve thousand degrees Kelvin. Daylight film is balanced for fifty-five hundred degrees, and any color temperature above this gives a bluish picture.

Technical Data: *Mamiya RZ 67, 110mm lens, 20 second exposure at f/22, Fujichrome 50D, tripod. It was snowing during the time the film was exposed.*

trail, but it should be a constant goal of every photographer to seek out these salable shots, record them on film, and let clients know you've got them.

Many travel publications like people in the shots they publish, even when they use landscapes. The editors think viewers need to relate to the picture by seeing people in the scene. I rarely shoot like this myself and have lost sales as a result. Recently I was asked by a travel magazine for nature photos of Thailand. I sent a beautiful selection, and

they were turned down because no tourists were in the shots. If you tend to think, as I do, that a person in a landscape ruins the image, then follow your heart and leave them out—*most* of the time. Every now and then, include two or more people interacting in some way with their natural environment. You will definitely find a market for these shots.

MAKING A PERSONAL STATEMENT

There are many niches in wildlife and nature photogra-

phy. Some photographers specialize, becoming known for a particular aspect of the business, such as macro work, large format color landscape, large format black-and-white landscape, wildlife portraits, photomicrography or aerial landscapes. Some photographers become known for their work with a particular species or group of animals, such as wolves or owls.

Photographers who have a certain agenda they wish to communicate can leave indelible impressions on the public consciousness. Showing the destruction of the environment, for instance, through intimate close-ups—oil-soaked marine mammals, or hawks electrocuted by high-voltage lines—elicits powerful reactions. Publications such as *Animal's Voice Magazine* in Culver City, California, uses pictures like these all the time, while most other periodicals shy away from such tragic imagery.

A personal statement or specialty can work both for and against you. In your favor, a specialty singles you out in the public's eye, calls attention to your work, and helps you get published more easily, since few photographers will have the body of work that you do. The disadvantage is that you may get known for a specific field or style, and other assignments that you are fully capable of doing will be given to others because it's assumed they are outside of your expertise. When you do decide to branch out into

other directions in photography, it will be almost like starting a new career.

Whether you specialize will depend on your own emotional and artistic needs. I've never chosen a specialty because I love all aspects of nature and wildlife photography. I just couldn't keep myself from delving into as many areas of it as possible.

FINDING "NEW" PLACES TO SHOOT

Sometimes it seems as if everything has already been photographed. But before you give up on a site just because it's been shot before, look at it in new ways or from different vantage points. Just a change in the weather can produce a unique picture. I have been to Monument Valley at least twenty times, yet it wasn't until the last time that I photographed it during a blizzard. Different lenses, points of view, and times of day affect the types of pictures you get. Don't settle for the familiar; a little effort spent finding the new in the familiar will be richly rewarded.

When you find yourself in a beautiful location, look for points of view that don't look like the standard pretty postcard shot. The "sun at your back" rule and the tree branch framing the picture are so trite that it looks as if you are following a formula rather than being truly creative. Look for more unusual effects, such as the sun peeking out from behind a tree

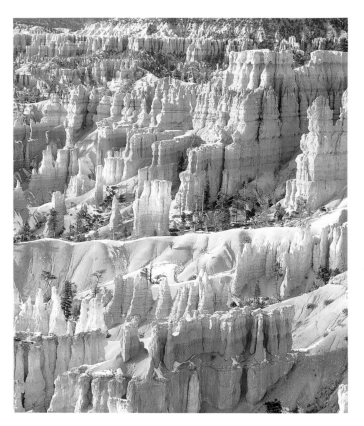

Look for the unusual. Try to avoid the same old way of interpreting a place that everyone knows well. We usually see pictures of Bryce Canyon National Park from the rim, like the top picture. This is indeed a nice shot, with good color, nice graphics, and early morning light.

A very unusual rendition of the canyon, however, was shot from inside the fairyland-like canyon looking upward (bottom). What makes this unusual is the black sky—you never see pictures like this of Bryce. The startling contrast was achieved by using a polarizing filter and underexposing one stop. The cobalt blue sky at an altitude of about eighty-five hundred feet goes very dark when polarized.

Technical Data: *Bryce Canyon traditional shot—Mamiya RZ 67, 180mm lens, 1/15, f/22, Ektachrome 64, tripod. Bryce Canyon black sky—Mamiya RZ 67, 180mm lens, 1/60 (underexposed one stop), f/8, polarizing filter, Ektachrome 64, tripod.*

branch. Or use a wide-angle lens for a close-up study of a starfish. Interpret the scene emotionally, rather than strictly documenting it. A warming filter or a split neutral density filter might yield some interesting results. Wildlife photography also offers infinite variety—facial expressions, poses and movement, composition, environment, lighting and behavior all change.

There are plenty of less famous state and national parks, wildlife habitats, wildflower preserves, backwoods swamps, lovely stands of forests, and other natural environments that offer an endless number of subjects. Get off the beaten track in your search for great photos. Novelty sells.

From tiny salamanders crawling around a forest floor in Virginia to Bureau of Land Management badlands in New Mexico, from songbirds nesting in Idaho to bluebonnets in Texas or poppies in California, so many photographs wait to be taken that you could spend three lifetimes pursuing nature photography and hardly scratch the surface. I often say to my friends when I'm thinking about all the things I haven't yet photographed, "So many pictures to take and so little time!"

How do you find the places to try out these techniques? I subscribe to many travel and photography magazines that highlight unique locations for nature shooting. The entire publication may not be de-

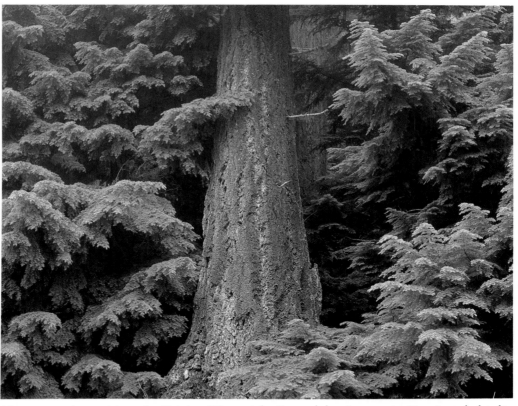

It's easy to analyze a picture after it's taken. When out shooting and choosing a composition, it can be hard to remember all the points that go into a great picture. The various marketing strategies that come into play later may easily elude you because there are many things to take in during the creative process. I tend to compose my shots instinctively now, without a conscious analysis. Marketing, on the other hand, is always a very conscious effort. Sometimes the two come together, as when I'm photographing a scene with a strong center of interest.

Buyers of photography, as a rule, tend to seek out pictures in which elements don't compete for viewer attention. They prefer pictures that are about a single subject, rather than images that confuse the eye. The treatment of a single large trunk surrounded by greenery provides a very strong center of interest. Attention automatically goes to the single subject.

Technical Data: *Mamiya RZ 67, 250mm lens, 1/8, f/16, Fujichrome 50D, tripod.*

voted to this, but if I get one lead per issue it is of great value. Guidebooks also are invaluable, but only get the kind that have color pictures generously spread throughout the book. It is the pictures, not the descriptions, that will help you decide to go to a particular site. Each state has a tourism department that will send information as well, and it is usually free. Much of it won't be relevant, but there's enough valuable information to make obtaining the material worthwhile.

Another superb source of information is the newsletter *Photo Traveler*, published by Nadine Orabona, P.O. Box 39912, Los Angeles, CA 90039. This is a bimonthly publication that is packed full of ideas of what, where and when you can find interesting subject matter to shoot. Nadine has included diverse topics such as horse drives, and the best fall foliage.

Camera clubs are another resource. Photographers are very willing to share information about great locations they've found. Also, environmental groups such as the Si-

erra Club have many outings, including day and overnight hikes, to special places across the United States. Join the group activities, and then if you want to go back for more time to do serious photography you'll know where to go.

I found a particular place to photograph butterflies by contacting the lepidopterist at a large natural history museum. He told me about a place called Fortin de las Flores in Mexico that was teeming with tropical butterflies. It was everything he'd promised. Hundreds of species

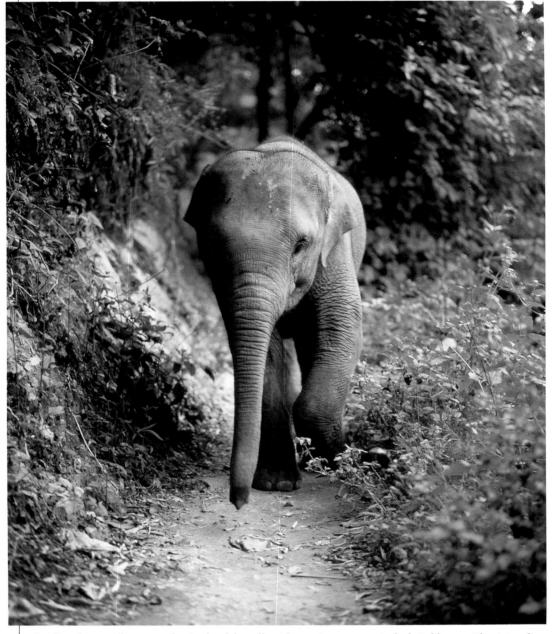

Leading photography tours to foreign lands has allowed me to increase my stock photo library without spending thousands of dollars. In fact, the tour companies pay me to go! I am not as free as I would be if I traveled alone, but I can still return home with hundreds, and usually thousands, of images that may sell for years to come. This baby elephant in the northern Thai jungle near Chiang Rai had been following its mother, who was transporting members of my tour group to a remote tribal village. I got off my elephant, preferring to walk the narrow trail rather than bounce precariously in a wooden seat. It was all I could do to quickly grab this shot before fifteen hundred pounds of baby elephant charged right into me!

When you shoot in the jungle, you will quickly discover it is exceptionally dark—even at midday—under the canopy of trees. If you shoot vegetation, you can afford the luxury of a fine grained, slow film. But you'll need a faster emulsion if you want to photograph wildlife.

Technical Data: *Mamiya RZ 67, 180mm lens, 1/125, f/4.5, Fujichrome 100D pushed one stop, hand-held. I wasn't prepared to shoot a running elephant, and only had 100 ISO film loaded. I used a faster shutter speed than the meter indicated (1/60, too slow for a sharp picture in this situation) and push-processed the film to compensate.*

were flying everywhere, all brilliantly colored from neon blue to fire-engine red to canary yellow.

You may feel that planning photo trips with future sales in mind will take much of the fun out of photography. Shouldn't self-expression, not selling, be paramount? Yes, this is important. But do keep in mind that that irresistible image may be less salable than some of your planned shots. By all means, take photos of what attracts you, but consider the business of photography as well if you want to make a living from it. You can have both—images that are marketable *and* emotionally satisfying.

Perhaps it will help to think of shooting salable photos as a *creative* challenge. Focus on sharing the moment with the viewer. Look for meaning rather than merely recording a scene. Make each photo as special and different as you can while remembering what it takes to make a good photo/ article or cover shot.

In the beginning, thoroughly explore the environs close to home. This may include everything from insects to moose, from fall foliage to the aurora borealis. Staying close to home is certainly the most cost-effective way of generating a stock library of images.

As a local resident, you know when and where to look for ice-covered berries. You are there for the peak of the cherry blossoms and fall foliage. You know the best van-

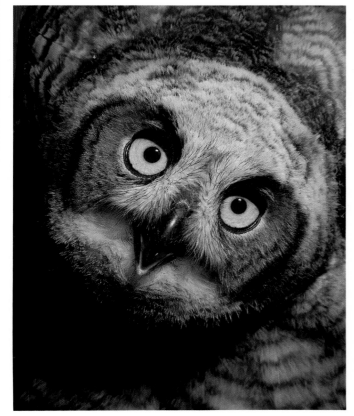

I've had great success with close-ups of wildlife. Many animals have such dynamic faces that these photos are as compelling as portraits of people. Since eyes are the focus of any face, owls have the most intriguing faces. This tight shot of a young great horned owl jumps off the page and grabs you. And that's what it does to photo buyers, too.

Technical Data: *Mamiya RZ 67, 360mm lens, flash, f/22, remote trigger, tripod.*

tage point to shoot lightning and sunsets. You can capitalize on your familiarity with your own neighborhood by always being ready to shoot. Out-of-town photographers won't be able to compete with your more complete stock of images.

MORE AFFORDABLE TRAVEL

Most photographers love to travel. But traveling to distant places is expensive. So you must sell a lot of work from that trip to recover the costs and make a profit. This often doesn't happen immediately on your return, but can take months or even years.

There are some alternatives to paying your own way. I lead photography tours for three companies. This lets me travel all over the world and get paid for it. My only expense is film. Yes, there's a lot of responsibility in caring for and instructing a group of people, but I feel the benefits are worth it.

If you've been published and/or have teaching experi-

ence, you too can lead tours. You can find the major photo tour operators in ads in the back of most photo magazines, particularly *Outdoor Photographer, Outdoor and Travel Photography,* and *Petersen's Photographic Magazine.*

There are other ways of traveling without investing megabucks. Many years ago I put a small ad in a newspaper circulated in an L.A.-area marina. It said, "Young man to crew, anywhere, anytime." I was offering to help crew a sailboat to any foreign destination in exchange for the trip. Did I have experience in sailing? No. But I had read a book on the subject and knew the correct terminology and the theory behind sailing, so I could talk as if I knew what I was doing. I was offered several trips, including one across the entire South Pacific. I chose instead, since this was my maiden voyage, to accept an offer to go to the southern tip of Baja California and into the Sea of Cortez for a six-week trip.

A friend of mine has traveled to Africa, New Zealand and Tahiti as a travel writer. A hotel chain sent him to those destinations free if he, in turn, wrote articles for travel magazines featuring various hotels. He got a letter from the editor of a travel magazine saying they'd use the piece, and once he got his first article published, he used that as a way to get other such trips.

Join several airline mileage clubs. If you fly frequently, you

can earn free flights about every forty thousand to fifty thousand miles (mileage varies for each airline). Earlier this year I took my first complimentary flight to Europe using the mileage earned in the Alaska Airlines Gold Coast Travel Club. I also am a member of the American Airlines and Delta mileage clubs. You can obtain more information on these plans by calling the toll-free number of any airline.

COMPETITION

Competition in the marketplace can be intimidating until you realize how many photo buyers there are. No, not hundreds. Not even thousands. Tens of thousands of people buy photography every month. The numbers of images sold is in the millions. Many of these sales involve wildlife and nature.

The publications with which you are familiar are only the tip of the iceberg. There are thousands of other sources to sell your work to besides *National Geographic* and *Life.* Religious magazines, trade publications, calendars representing nonprofit organizations, small greeting card companies, local newspapers and album covers represent just a few avenues.

It's smarter to get published in numerous small magazines first. Rather than spend two or three years trying to get into *National Geographic,* you can see your work in print many times during the same period in local, regional and national magazines with

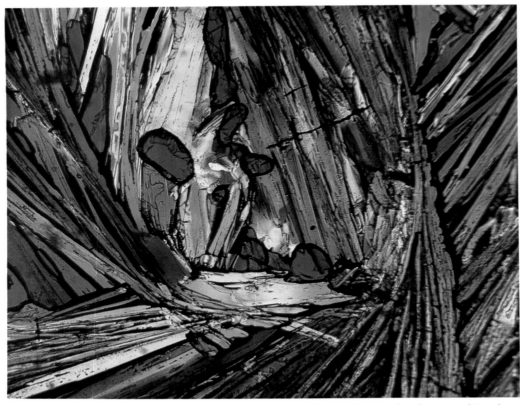

A unique specialization in nature photography is photomicrography. Few photographers know anything about this field, but every textbook dealing with biology, nursing, embryology, genetics, physiology, hematology, botany or entomology uses pictures taken in microscopes. This photo shows the natural crystal formation of vitamin C photographed under polarized light. I took it in my first microscope, which I bought used for two hundred fifty dollars.

Recently, there have been many requests in the marketplace for photomicrographs of the AIDS virus. In this case, because the virus is too small for an optical microscope, the images would have to be generated with a scanning electron microscope (SEM). Examine and photograph dangerous subjects in a microscope, such as contagious viruses, with extreme caution. If you are not familiar with safety precautions, ask people in the medical profession how to protect yourself from contamination.

Technical Data: *Mamiya RB 67, 100X enlargement, Bausch and Lomb microscope, 1/4 second, Ektachrome 50 tungsten. Since this inexpensive microscope did not have a built-in light source, I used a Kodak Carousel projector as my illumination. Over the projector lens I placed a tin can with an opaque end cap. Into this cap I fitted a leaf shutter that allowed the light to pass only when it was open. Rather than risk vibration from the camera's shutter, I could now push the camera shutter button, wait for the vibration to stop, and then make the exposure by opening the shutter over the light source for the specified amount of time.*

knowledgeable in your field. Read authoritative research papers, books and professional journals for extensive background information. Try to work with researchers in the field. Only when you understand the biology, habits and habitats of a particular species or group of species can you develop an exhaustive, excellent collection of photos.

Because you'll spend so much time studying and shooting your specialty, choose one that has great appeal to you. If you've always been fascinated by volcanoes, then this specialty is right up your alley. You'll want to shoot both active and dormant volcanoes, the geology that documents past activity, the plant life that thrives in and around volcanoes, destruction caused by eruptions (such as from Mt. St. Helens or Kilauea in Hawaii), and the wildlife that inhabits those regions.

Let photo buyers know you're a specialist. Generate a significant body of images around your area of specialization. The exact number may vary according to the breadth of the subject, but it should be at least a few hundred excellent slides. Then, send introductory letters and/or sample slides or promotional sheets to prospective buyers (more about this later in the book). If you have a unique body of work, soon you will become known in the marketplace as a specialist in your field, and they will come to you.

smaller circulations. Time invested researching the lesser-known publications will be repaid many times over. (See chapter five for more on the magazine market.) The fine art market is also open to photographers who aren't nationally known (see chapter nine). Once you have a track record,

it's time to target the higher-paying and more prestigious markets.

BECOME A SPECIALIST
One way to beat the competition is to specialize in a narrow aspect of nature photography. Become an expert on a certain species, especially one

that's a little offbeat, such as jumping spiders or rare cacti, and build up a library of thousands of images. Eventually everyone will call you first for images because you know the subject and have the best shots.

To become known as an expert, you must be thoroughly

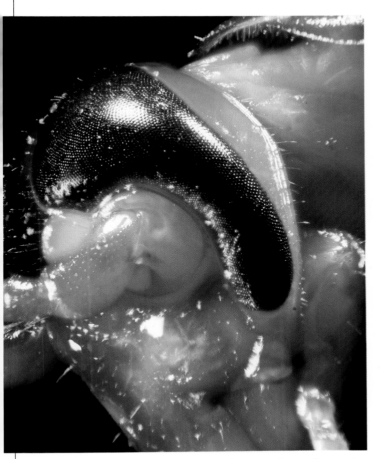

Every time I project this image on a screen for an audience, the reaction is always the same. Without even knowing what it is, people wrinkle their noses and say, "Oooh, that's disgusting!" When I tell them what it is, they can't believe I actually photographed the eye of a cockroach.

However, specialization in nature photography can take all forms, and there is a demand for all aspects of the natural world. One photographer I know only photographs insects that impact agriculture. He constantly gets calls from gardening magazines, pesticide manufacturers, agencies of the government, and farming publications. No one else can compete with his extensive collection.

Technical Data: *Mamiya RZ 67, 12.5mm Minolta micro lens, 10 second exposure, f/2.8, Ektachrome 50 tungsten. To get this kind of incredible depth of field at a magnification of approximately 20 × required the use of a device called the Dynaphot, manufactured by Irvine Optical Company in Burbank, California. The subject is mounted on a stage that moves up through a horizontal plane of light very, very slowly. The camera is positioned above, aimed straight down. The light plane, narrower than the depth of field of the lens, illuminates only a thin slice of the subject at any one time. The camera is focused on the plane of light, so as the insect moves up it records only the section that is illuminated and in focus. Exposure is determined by the speed with which the stage moves up.*

As you take more pictures in an area of specialization, you will have to test the salability of your work. If your images are immediately published, you know you're probably on the right track. However, if you have trouble selling the work, perhaps you should look more closely at what you're doing. Consider these issues:

1. Are you submitting your work to the wrong markets?

2. Perhaps the photography is correct scientifically but it is not artistic. Can you improve this aspect of your shooting?

3. Are you contacting a large enough sample of potential buyers? One or two rejections is too small a number to determine the marketability of your work.

4. Have you found a large number of outlets for your work? Many obscure places buy nature photography. Part of your job is finding them. Study magazine stands and periodical sections in libraries, and speak to teachers and researchers in the field to learn about professional journals and international publications that could want your material.

5. Is your field of expertise too narrow? If you limit yourself, you will also limit your market.

You can also become known for an unusual technique or style. Perhaps your particular niche is "abstract nature," which would be especially popular in fine art photography. Your macro work of flowers suggests the paintings of Georgia O'Keefe.

Your collection of unique designs in rock faces is known for subtlety in texture and animal-like forms. It is this kind of approach that can set you apart from the pack and establish a reputation.

GREAT PHOTOS + GREAT MARKETING = GREAT SALES

Excellent photography plus diligent marketing translates into hundreds of sales over the years. You can penetrate any market with your photography if you focus first on creating beautiful and sensitive images, and then on getting those pictures into the market. You must make sure, of course, that your promotion is targeted to the right people and it's presented in a professional manner. (See chapters four through nine on targeting and presenting your work to specific markets.)

It is also important to know your strengths and weaknesses. I've always done this by comparing my work to that of photographers I respect. If I see someone has done an outstanding series of images in Yosemite, for example, and they're better than mine, I try to figure out why. Lighting? Composition? Season? Camera angle? When I know, I'll go back to the park and produce a new series of images based on my analysis.

Know which photo buyers want which subjects. Spend lots of time in large magazine stands and at libraries that have an extensive periodical section. Study the magazine's

Strong design elements always catch the eye of photo editors. These powerful formations in Nerja Cave on the Costa del Sol in Spain are made even more impressive by the rich texture of the rocky surface. The colors, which come from strategically placed artificial lights, add to the unearthly quality.
Technical Data: *Mamiya RZ 67, 50mm lens, 1 second, f/16, Fujichrome 50D, tripod.*

editorial content and the advertising. What kinds of nature images appear? Browse through calendars and racks of posters. Which markets use photos like yours? How do yours compare for quality?

Your sales will depend on how well you know the market and how effectively you can get your pictures into the hands of the people who buy them. Simply being a great photographer is not enough. You must also be excellent at marketing your work — or hire someone to do it for you.

Earning a living as a photographer is not like working for an employer and getting a paycheck every two weeks. There is no job security. You won't make any money until you sell photographs. You must focus all of your energy on your goals and pursue them relentlessly. Persistence and patience must be cultivated to achieve what you want in photography. This is not just rhetoric. It's true. It's easy to give up after a rejection or two and resign yourself to finding another way to

make a living. But you must learn from the rejections. Study work that is being accepted into calendars, magazines and posters, and compare it to yours. What can you learn?

Consider each rejection letter a learning tool, and then tailor your next submission more to the needs of the client. To quantify how and why your submission failed, make a checklist of possible reasons based on any information in a rejection letter. (Some rejection letters are simply form

letters and won't help at all. In those cases, call the editor and ask — in a way that tells the person that you really want to work with the publication — why he or she couldn't use the material.) This checklist might look something like the following:

- Does the market to which I submitted work use the kind of material I have?
- Is my work too scientific for the consumer audience?
- Is my work too artistic for the scientific community?
- Is the market too saturated with the work I do?
- Is my quality high enough compared to other work I see published?
- Was I rejected due to the timing of my submission or its similarity to other work already in print, or was it because of the material itself?
- How can I improve the professionalism of my presentation?

Many years ago, when I compared my nature photography to the images I saw published, there was something missing in my work. Finally, I realized that a large majority of the material I liked had been shot at sunrise or sunset. When I started doing the same, my photography took a quantum leap forward.

The texture in this dinosaur footprint near Tuba City, Arizona (left), could only have been revealed in such detail when the light was coming from a low angle. The sun had just gone below the horizon, but the bright western sky was providing enough light to be directional. Likewise, the beautiful forms of the Huangshan Mountains in China (top) are much more powerful against a setting sun than at midday. Including the sun itself in the shot, especially one accompanied by such lovely pastels, adds to the impact of the image.

Technical Data: *Dinosaur footprint—Mamiya RZ 67, 127mm lens, 1/8, f/22, Ektachrome 64, tripod. Huangshan Mountains—Mamiya RB 67, 500mm lens, 1/15, f/11, Ektachrome 64, tripod.*

GETTING GREAT PHOTOS—
NO MATTER WHERE YOU LIVE

There are many places in North America where you can photograph wildlife in its natural habitat. Although sightings of animals can occur virtually anywhere, there are well-known spots where certain animals congregate at specific times of the year. For example, bald eagles are frequently spotted in Haines, Alaska, from October through January. Monarch butterflies gather in the Sierra Madre Mountains near Ocampo, Mexico. Horseshoe crabs are prevalent along the Massachusetts coast in May.

I love shooting in the wild. Capturing a shot of an animal in its natural environment is even better than eating chocolate! But time and money often prevent us from taking off to faraway places to search for wildlife subjects. And many animals are difficult to find and almost impossible to shoot in the wild. For exam-

There are many well-known areas where certain animals are regularly found. In the summer you can plan to see black-tailed deer on Hurricane Ridge in the Olympic National Park near Port Angeles, Washington, which is easily reached by car. The deer are often quite approachable, especially around the picnic areas, but this fawn was a little more wary. I used a long lens to photograph it.

Technical Data: *Mamiya RZ 67, 500mm lens, 1/125, f/8, Fujichrome 100D, tripod.*

ple, endangered species such as the snow leopard and the black-footed ferret are so few in number that your chances of seeing one in its natural habitat are slim to none. Trying to photograph nocturnal jungle animals can be an exercise in futility. So what are the alternatives?

I've discovered how to take advantage of sites and resources in my own backyard. Believe it or not, you can find great nature and wildlife pictures without going to exotic places. For example, many zoos feature animals in natural-looking habitats.

The list of alternate sites to shoot nature and wildlife photos is much more extensive than you may think. All you need is a little imagination and creativity. Game parks, aquariums and pet stores offer opportunities to shoot many creatures. Botanic and public gardens and greenhouses offer you access to exotic plants. Macro photography is another option. Hundreds of tiny subjects are just waiting to be discovered—the graceful curve of a blade of grass, the delicate pattern of a lichen, or the artful texture of the roots of an old tree. In this chapter I'll show you some of the places I've taken great photos and pass along some secrets for getting truly natural-looking shots despite some man-made obstacles.

Zoos

Zoos are terrific places to photograph wild animals. Within a relatively small area, you can find hundreds of species—including endangered ones—from all over the world. Many zoos are famous for their in-captivity breeding programs; for example, the Cincinnati

Zoo is noted for its success with gorillas and white Bengal tigers. And they'll often arrange for special exhibitions of animals not regularly on display.

You can find zoos in many major cities, such as Washington, D.C., San Diego and Chicago. And some, such as the

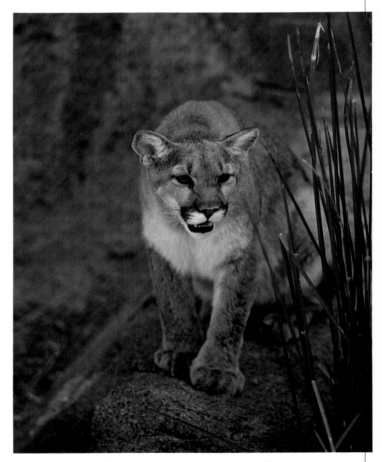

Many zoos now exhibit animals in settings that resemble their native habitats. I feel that one of the best such zoos is the Sonora Desert Museum near Tucson, Arizona, where the exhibits seem designed especially for photographers. The zoo has reptiles as well as many rare animals, including jaguarondi, coyote and mountain lion. Their collection of desert plants is also exceptional.

Technical Data: *Mamiya RB 67, 500mm lens, 1/30, f/8, Ektachrome 64, tripod.*

one in Ashboro, North Carolina, are a little more off the beaten path. Some zoos have spent a lot of time and money building new or converting old exhibit areas that more closely resemble natural environments. You may have to use the longest lens you've got to capture a good image of an animal that's separated from you by a canal—but it's worth it to have that more natural look.

It is true, however, that most zoos present major obstacles to getting the shots you want. Many animals live behind chain-link fences or glass enclosures or are housed in less-than-natural surroundings. But it's not impossible to get great shots even then. I've taken quite a few images in zoos across the country that have sold in a variety of markets. The secret to good zoo photography is patience, persistence and creativity. Here are ways I've found to get around the most common obstacles.

CHAIN-LINK FENCES. I've always thought it would be a nice courtesy to photographers to provide small openings, perhaps three inches square, in chain-link fences at zoos. But I know that's considered dangerous, as someone could carelessly poke an arm or hand through and end up getting badly hurt.

An alternative that works quite well is placing your telephoto lens right up to the fence and shooting through one of the openings between the links. The edges of the frame may be slightly blurry, because parts of the chain link cut across the periphery of the lens, but you can avoid serious vignetting problems by shooting wide open. Long lenses have such shallow depth of field that the large aperture will obliterate any telltale signs of the fence. The decreased depth of field also benefits you by softening an obviously man-made background.

GLASS BARRIERS. Many animals that require controlled-temperature environments, such as reptiles, amphibians and penguins, are placed behind glass. Glass-enclosed spaces also protect animals that may be vulnerable to diseases spread by people.

Although shooting through glass does diminish the quality of an image, you can still take these photos successfully. The biggest problem to overcome is the reflections in the glass. These lower the overall contrast of the picture as well as introduce unwanted elements, such as your camera or people standing behind you, into the scene. If you use a flash, the problems are compounded by the reflection of the strobe into the lens.

The best way to eliminate unwanted reflections is to place a camera lens shielded with a rubber lens hood up against the glass. This will work even when you're using a flash. Because any imperfections in the glass are close to the lens, they become out of

This is an adorable cheetah face, but that's not the only reason I shot this as a close-up. I had to shoot through a chain-link fence at the Los Angeles Zoo to get a shot of the animal at all. The shallow depth of field and the soft background added atmosphere and prevented the fence from showing.
Technical Data: Mamiya RB 67, 360mm lens, 1/60, f/6, Ektachrome 100, hand-held.

focus to such an extent that they virtually disappear. Since something must always cushion and protect both the lens and the glass barrier, I cup my fingers around the lens to act as a buffer between the two glass surfaces when I don't have a lens hood with me.

If you can't put the lens up against the glass, you can still use a flash successfully by having a friend hold the unit at a forty-five-degree angle off to one side. This eliminates the artificial light reflecting back at you, but you'll still have to work to prevent other unwanted reflections. I've found that wearing a black shirt helps keep my image from reflecting into the lens.

OBVIOUSLY MAN-MADE ENVIRONMENTS. Some zoos, such as the San Diego or the Sonora Desert Museum (near Tucson, Arizona), are known for keeping animals in natural-looking environments. Others have concrete floors and artificial rocks that scream "Fake!" a

I really like geckos, although nobody seems to share my enthusiasm for them. I don't think they're as ugly as people say, but I will agree that they're mean. That's why I took this shot through glass—to keep from getting bitten.

Technical Data: *Mamiya RZ 67, 110mm lens, #2 extension tube, Metz 60 T-2 strobe, f/22, Fujichrome 50D, hand-held. I angled the flash to prevent unwanted reflections, and I cupped my fingers around the end of the tube to act as a buffer between it and the glass barrier.*

This large silverback gorilla at the Los Angeles Zoo is one of my favorite zoo shots. Although these great apes live in the rain forest, the rocks that surround the animal here provide enough of a natural setting to work.

You can return to the same zoo many times and continue to find new and rewarding images. Always visit a zoo when you're traveling because each has its own method of presenting the animals for viewing. If you get the chance to travel outside the country, make a special point of visiting the local zoo to look for unique photo opportunities.

Technical Data: *Mamiya RZ 67, 500mm lens, 1/125, f/8, Fujichrome 100D, tripod.*

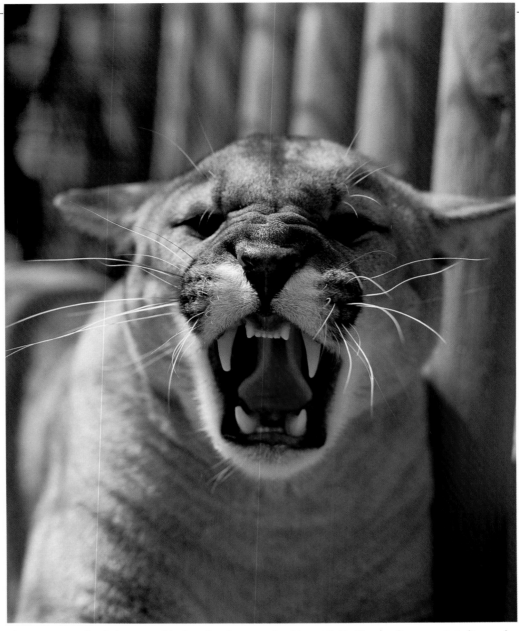

This is an example of what to avoid when shooting an animal in captivity. The snarling mountain lion makes an exciting shot, but the wooden wall behind it ruins the picture by shouting, "in captivity." Most photo buyers won't want the image for that reason. The background is visible because the cat is quite close to it. The wall would have been too soft to distinguish if the cat had been twenty feet away from it, especially if a long lens was used.

Technical Data: *Mamiya RZ 67, 250mm lens, 1/125, f/5.6, Fujichrome 50D, hand-held.*

mile away. Pictures taken in these zoos tend to have an artificial quality, but you can still get effective pictures by shooting close-ups.

Instead of showing the animal in its environment, use a long lens and frame tight shots of the face. If two animals are cuddling or playing together, fill the composition with both of their faces. Expressions are critical for this type of animal portrait, so look for humorous, adorable or bizarre ones. Spend time shooting as the animals play or simply move around the cage. You'll use up more film this way, but it takes just one outstanding image to have a bestseller that'll pay for the day's film.

I'm working on a series of images that focuses on patterns in the fur and hair of exotic animals. These include many of the large cats, giraffes, zebras—even a porcupine. I've taken every one of these shots in a zoo where the animal was not in a natural-looking environment, but I could get a good close-up with my telephoto.

USING YOUR FLASH EFFECTIVELY

It's perfectly all right to use a strobe when shooting in relatively dark exhibit areas at the zoo. Although these shots look less natural, using a flash is fine as long as the scene doesn't look like it's a setup. (Photographers frequently have to use a flash in the wild to get better shots, too.)

Because animals can move suddenly and frequently, I

suggest you use a flash that has an automatic exposure. You won't have time to use a manual unit, because the distance from the camera can change so suddenly. But the automatic flash will compensate for movement as fast as it happens.

If you want to shoot rapidly, one shot every one or two seconds, get an auxiliary power pack. (I use a Quantum that can be worn at my belt.) A power pack produces many more flashes per charge than a set of AA batteries—and the recycling time between pops is very short. After one roll of film, you'll have to wait ten to fifteen seconds for AA batteries to recharge; but, depending on the distance to the subject, you'll be shooting again after only one to five seconds with a power pack. The farther the animal is, the more light required from the strobe, and the longer recycling time you'll have.

GETTING BEHIND THE SCENES

Sometimes I've wanted to get closer to the animals on display than is normally allowed. It's just impossible to get a shot of birds that are protected by wire mesh, and some nocturnal species sleep throughout the day. You can often make special arrangements with zoos to get pictures that aren't possible any other way. Sometimes you can deal directly with the curators who care for the animals. Other times you work with the public relations department. Because zoos always

If you get the chance to visit foreign countries (see page 25 for more on how to afford this), maximize your photo opportunities by learning before you go about the best sites to find certain animals. For example, there are well-known monkey temples in several Asian countries, where scores of primates live because they're fed by local people. Out of a whole roll of film I shot at the temple in Phitsanulok, Thailand, this shot of an elderly macaque monkey was the only one sharp enough to use. It was very dark under the large tree where he was sitting, so I was forced to use a slow shutter speed. Even then, the depth of field is so shallow that only the eyes and beard are in focus. You can sometimes get close-ups similar to this one at the zoo with a good telephoto. Also consider asking permission to get closer to an animal with the help of a curator.

Technical Data: Mamiya RZ 67, 250mm lens, 1/30, f/4.5, Fujichrome 50D, hand-held.

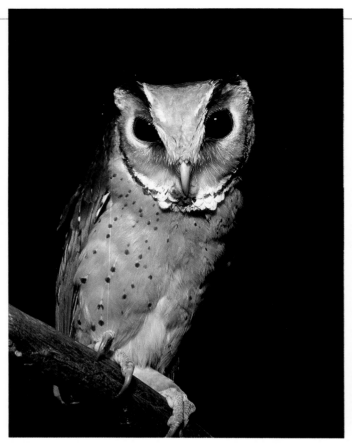

I had been fascinated by this Thailand Bay owl the first time I saw it in the San Diego Zoo. I knew I'd have to photograph it somehow, but it was behind a mesh fence that I couldn't shoot through, and the stucco background looked unnatural. I finally got the shot by arranging with the public relations staff to have a curator take me into the bird's enclosure. I used a flash and angled my shot so the background went black, simulating night. This solution to an unnatural background was fine for an owl, but it would be better to have a lighter background for a bird active in the daytime.

* **Technical Data:** Mamiya RZ 67, 180mm lens, Metz 60 T-2 strobe, f/16, Fujichrome 50D, hand-held.*

I photographed this bison at the Olympic Game Farm in Sequim, Washington, a drive-through game reserve where you can photograph llamas, fallow deer, elk, and other animals that roam freely. I turned off the car's engine to eliminate vibrations and shot with a door-mounted tripod head to help steady the camera. Sometimes animals came right up to the car window, and I had to pull my camera in quickly to keep the lens from getting licked!

* **Technical Data:** Mamiya RZ 67, 250mm lens, 1/250, f/4.5, Fujichrome 50D, door-mounted tripod head. I opened up a half stop from the light reading to prevent the animal's hair from going too dark.*

need good press, it helps your cause if you can get a magazine or local newspaper to feature a story about some aspect of the zoo. Try to develop a good relationship with the curators at zoos where you shoot frequently. They'll feel more comfortable making special arrangements for someone they know and feel they can trust.

GAME PARKS

Game parks are large tracts of land people drive through to see and photograph North American and African wildlife. Although they aren't as common as zoos, a game park can be worth a special trip. If you travel economically and do your homework before you go, you can get enough salable images to repay your investment.

You'll get very natural-looking images from a game park, although you still must watch for occasional man-made elements in the background. You can get very close to some of the animals in these parks,

but I'd suggest that you use a long lens instead. Almost all wildlife photos taken in the wild were made with telephotos, so the background is soft and the image has a compressed perspective. That means any photo shot in a game park will look more authentic than one shot with a normal or wide-angle lens.

With the exception of one or two game parks connected with amusement parks, such as the Wild Animal Safari at Kings Island Amusement Park (Kings Island, Ohio, just north

of Cincinnati) or the Busch Gardens amusement parks, most of these places seem to be in the southwest. The best-known ones are:

Texas Safari Ranch
Rt. 2
Clinton, TX 76634

International Wildlife Park
601 Lion Country Parkway
Grand Prairie, TX 75050

Natural Bridges Wildlife
Ranch
Rt. 20
San Antonio, TX 78218

Wild Wilderness Drive
Through Safari
Rt. 3
Gentry, AR 72734

(There may be other game parks across the country that I've not listed here. These are simply the best known and the ones with which I'm most familiar.)

BUTTERFLY HOUSES

You can find butterflies outdoors everywhere – at the right season. But a butterfly house – a large, enclosed greenhouse in which butterflies fly freely – expands your shooting season to year-round. You'll have the opportunity to photograph all aspects of the butterfly's life cycle in a natural-looking setting.

I have visited the butterfly house at Marine World USA in Valejo, California, just thirty minutes north of San Francisco. You can roam through ten thousand square feet of greenhouse with a waterfall, a jungle of plants, and many species of butterflies. Sometimes a butterfly will even land on your head or camera lens. There's also a butterfly house called Butterfly World (3600 West Sample Road) in Coconut Creek, Florida. Some zoos have similar, if smaller, facilities, such as the Cincinnati Zoo's Insect House.

Although there is enough ambient light from the windows to shoot without artificial light, I recommend you use a strobe. The available light is usually softened by

Butterfly houses such as the one at Marine World U.S.A. in Valejo, California, are becoming more common across the country. Some zoos have similar free-flight areas either standing alone or as part of their insect houses. At this butterfly house there were at least thirty species, mostly from tropical South America and Asia. I photographed this emerald swallowtail from Thailand with a single on-camera flash. Would you have known this wasn't shot in southeast Asia?

Technical Data: *Mamiya RZ 67, 110mm lens, Metz 60 T-2 strobe, f/22, Fujichrome Velvia 50, hand-held. I was only eight inches from the butterfly when I took this.*

I've done a little underwater photography, so I know how difficult it is—moving currents, reduced visibility, and tough technical problems with exposure. Shooting in an aquarium, on the other hand, is relatively easy. With a single flash unit and some patience, you can take photos that look realistic. I photographed this lionfish by placing the lens against the glass to eliminate reflections and waiting until the fish swam into my prefocused target area. A friend held the flash off to one side.

* **Technical Data:** Mamiya RZ 67, 127mm lens, Metz 60 T-2 strobe, f/16, Ektachrome 64, hand-held.*

whitewash on the windows, which keeps the enclosure from getting too hot but makes the light too blue. Without a flash you may get pictures back with a blue cast that detracts from the rich, beautiful colors of the butterflies. The brilliant burst of light from a flash close to the butterfly also lets you use a small aperture to get enough depth of field and have the butterfly completely in focus. It will stop motion, which keeps your subject from looking blurred.

I use a flash mounted on the camera and placed directly above the lens. This makes the shadow behind the butter-

fly fall away from the lens at a one hundred eighty-degree angle so it is blocked from view by the insect. If you mount the flash off to one side, you will get a distracting shadow to one side of the subject.

To determine the correct exposure, shoot a test roll. Prefocus for the estimated distance between subject and lens, set the flash on manual, and then change the exposure in half-f/stop increments. Once you've found the best exposure, focus by moving the camera closer to and farther from your subject until it appears sharp. Your exposures will be accurate and con-

sistent because the flash-to-subject distance never changes. Don't try to use a tripod because it'll limit your freedom of movement. You can get away with holding the camera, since the flash duration is short enough to freeze all but the most rapid wing movements.

Aquariums

You could spend thousands of dollars to shoot exotic fish underwater while scuba diving in the tropics. *Or* you can build an impressive stock of exotic fish by shooting in aquariums. In addition to those in fish and pet stores or those owned by your friends, many cities have large facilities with both exotic and native specimens.

The National Aquarium in Baltimore is justly famous for its displays and is now being copied by facilities in many cities, including Aquarium of the Americas in New Orleans. Visitors to the new aquarium can travel through a Caribbean reef via a transparent tunnel for a scuba diver's view under the sea. Or they can experience the Amazon River basin while walking through an enclosed tropical rain forest teeming with schools of piranha and shovelnose catfish. You can even get a taste of the underwater world at the Oklahoma City Zoo's new Aquaticus, where you'll find seals, octopi, lobsters, and hundreds of other marine life species in the pools and aquariums at the Noble Aquatic Center. Exhibits explore habitats from the depths of the Pa-

cific Ocean to the muddy bottoms of Oklahoma's own rivers and lakes. The center also features underwater viewing areas.

The only way to shoot fish in an aquarium, large or small, is with a flash. This prevents unnatural color shifts from unwanted ambient light and freezes the fish as they swim.

Put your lens right up to the glass of the aquarium, just as you would any glass enclosure, to prevent unwanted reflections. Your portable strobe can either be fired from above, simulating the direction of daylight, or be mounted on the side of the camera to illuminate the fish from the front.

Exposure can be tricky because the light travels through both glass and water. When shooting in a small aquarium, shoot a test roll prefocused at a preset distance, changing exposures in half-f/stop increments. Use a macro lens and set the lens aperture based on your test for that distance between subject and flash. Then take every shot without refocusing. Don't use the flash on automatic in a small aquarium (friend's or store's), because you'll be too close to the subject for an accurate exposure. Use it on manual.

Pet Stores

Pet stores sell more than just dogs, cats and fish. Some carry, or even specialize in, exotic birds, reptiles or amphibians. I've found large spiders, such as tarantulas, in some stores. If you approach them

I've discovered that reptiles and amphibians have some of the most interesting and bizarre eyes in the animal world. While working on a photo essay on eyes, I made arrangements with the owner of a pet shop to photograph this Malaysian leaf frog in his store. I put some wet, brown leaves and a few blades of grass on a piece of plywood. The frog was positioned in the middle of the set, with one of the store's employees ready to prevent it from getting away. I placed the flash unit directly above the lens to avoid creating harsh shadows on one side of the frog. The only return the owner asked was that I request the editor to mention the name of the store in the caption if the shot were published in a pet trade magazine.

Technical Data: *Mamiya RZ 67, 110mm lens, #1 and #2 extension tubes, Metz 60 T-2 strobe, f/16, Fujichrome 50D, hand-held.*

You can find striking pictures at the hundreds of state and national parks across the country. Silver Falls State Park in Oregon, where numerous falls cascade over rain forest vegetation and craggy rocks, is one of my favorites. Some of the trails go behind the falls, while others lead to the bottom, where you can capture with long shutter speeds the misty (what I call the "cotton candy") effect of moving water. Make sure you protect the lens from droplets of mist.
__Technical Data:__ Mamiya RZ 67, 180mm lens, 1/2 second, f/22, Fujichrome 50D, tripod.

politely and professionally, pet store owners will generally be quite willing to help you photograph a particular subject.

I have rented animals when I didn't want to shoot in the store. I found a fascinating forest chameleon once but the store terrarium was so unnatural-looking that I didn't want to shoot it there. It wasn't something I'd want for a pet, so I offered to pay the owner half the chameleon's price as a rental fee. I paid fifteen dollars plus another fifteen as a deposit for a one-week loan, with the provision that I return the animal in good health. In that week's time, I set up a natural-looking shot in my backyard with early morning sun; a background of distant, out-of-focus foliage; and a weathered branch in the foreground.

It's generally easier to shoot in the pet store, and many store owners will let you do this at no charge. Although it can be challenging to avoid the unnatural elements, you can place small creatures on a miniset you create. Nobody will ever know the difference. When I wanted to photograph a Mexican tarantula, I brought in a small piece of plywood on which I placed damp, brown leaves. A store employee positioned the spider for me (I wasn't going to touch that thing!) in the middle of the leaves. I used a flash mounted on my camera to make the exposure and shot down on the spider to fill the frame with it and the leaves, and to elimi-

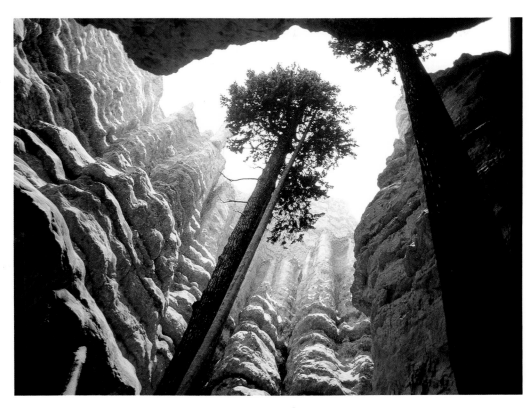

I find national parks to be most enjoyable in winter, when few tourists get in the way of my shots. The cold, gloomy weather in Bryce Canyon on this December day seemed to have discouraged everyone else from visiting the park. I had an excellent opportunity to wander the trails in search of interesting, new shots of the area.

Technical Data: *Mamiya RB 67, 50mm lens, 1/15, f/11, Ektachrome 64, tripod.*

nate any unwanted background elements.

I returned to the same store to photograph an African pixie frog. I wanted to shoot level with its face to create an intimate portrait, but that meant I had to create a suitable background as well as a set. Earlier in the week I had made a 16×20 photographic print of out-of-focus foliage. I put the mounted print behind the frog, placed it on wet leaves, and the resultant picture looked as if it had been taken in the wild. The employees and the store's owner enjoyed watching me work and helping me with my props on both occasions. I've discovered the same level of cooperation at many pet stores, but I always schedule a shooting session when the store won't be crowded with customers.

NATIONAL AND STATE PARKS

Many classic landscape images have been shot in national and state parks. Yellowstone National Park in Wyoming and Death Valley National Monument in California have provided photographers with hundreds of images. The National Seashores in the southeast, the Blue Ridge Mountains and the Everglades are all worth a special trip. The Ozark Mountains, the Mississippi River, and the Finger Lakes region of New York can also supply many scenic wonders.

My favorite time to photograph national and state parks is fall and winter. Few people visit at those times, and the transformation of the land is simply beautiful. The ultimate in fall foliage is, of course, in

New England. I've photographed fall in Vermont, New Hampshire and Maine and returned home with many salable photos more times than I can count.

One of the best ways to find good locations within the parks is to work with the rangers. They know the parks intimately and are always friendly and willing to share valuable information about wildlife sightings, interesting geological formations, and excellent vantage points for viewing famous landmarks. If there are reflecting pools, meadows full of wildflowers, petroglyphs or Indian ruins, the rangers will know where they are.

Make sure you prepare for the wilderness. Check the weather reports carefully; flash flooding or early snowfalls can happen in many parts

THE NATURE CONSERVANCY

The Nature Conservancy is an environmental protection organization that buys land to protect it from development. You can visit acres of pristine wilderness areas across the country. For information on the conservancy, write 1800 N. Kent, Suite 800, Arlington, VA 22209.

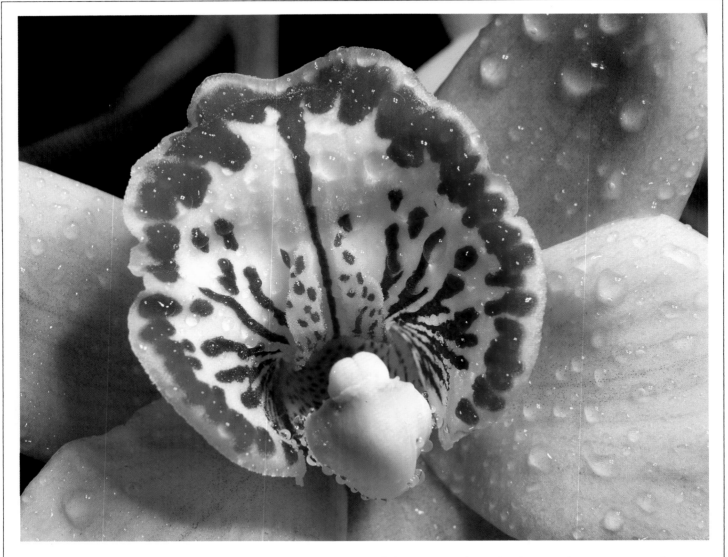

I photographed this in the greenhouse of an orchid club member. I had seen his plants displayed at a show and asked if I could spend some time shooting them. He was delighted and gave me free rein to shoot his large collection of both common and rare species. People who have a passion for something are usually happy to share their knowledge. Gardeners are delighted to have their plants photographed because they're pleased with the attention their plants receive.

__Technical Data:__ Mamiya RB 67, 127mm lens, #1 extension tube, Metz 60 T-2 strobe, f/16, Ektachrome 64, hand-held. The drops were sprayed on with a water bottle.

of the country. Always let the rangers at the visitor center know when you're making an overnight camping trip and roughly what area you'll be in. Accidents can happen to anyone at any time; it's good to know that if you don't return on time, you'll be missed.

PUBLIC AND BOTANICAL GARDENS

There are many beautiful public gardens throughout the United States. Among the more famous are the Bellingrath Gardens in Mobile, Alabama, and the Winterthur Museum Gardens in Delaware. Many other cities have outstanding botanical gardens and conservatories featuring plants in natural-looking settings. One of the most famous is the Missouri Botanical Garden in St. Louis, which showcases a wide variety of geographic regions; another is the greenhouse in Golden Gate Park in San Francisco. The Highlands Biological Station in Highlands, North Carolina, is an eighteen-acre facility that includes a nature center, hiking trails, and botanic garden with more than four hundred labeled specimens of native plants. Nearby, the Appalachian Environmental Arts Center offers classes in scientific illustration and wildlife photography.

Universities, public buildings and house museums often have lovely gardens where you can photograph different species of plants. Thomas Jefferson's home at Monticello is especially famous for its collection of eighteenth-century plants. Near Los Angeles, Huntington Library and Gardens, the estate of a railroad tycoon, has both a famous cactus and a Japanese garden. Check tourbooks that cover your area and contact local garden clubs, the botany department at a college, or the natural history museum for information on what's available. An additional advantage of visiting botanic or other public gardens is that both the common and Latin names are given for each plant. You should always include this with submissions; that's better than scrambling around at the last minute to find it if you need it.

It's best to visit botanical gardens on overcast days when no harsh shadows are on the plants. Soft lighting will show detail better, and the colors will be richer and more beautiful. Early morning and late afternoon are also good times to shoot. Avoid shooting in the middle of the day under full sunlight, because the contrast will be too great for many botanical subjects.

There are often clubs or organizations devoted to raising and showing specific groups of plants such as orchids, roses, bonsai trees, cacti, violets, azaleas and camellias. Many club members have their own greenhouses and

are willing to have their specimens photographed. I've attended flower exhibitions to meet people who will let me shoot their collections.

YOUR BACKYARD

Photographers are so accustomed to looking for exotic places to shoot nature and wildlife that they forget about the many possibilities in their own backyards. While you may not have migrating caribou or giant sequoia trees planted along your driveway, you'll be pleasantly surprised at what you'll find if you just look around you.

Attract local wildlife to your backyard by providing proper food and cover. Many easily cultivated plants provide both the nutrition and protective camouflage and shelter many animals need. One example of this approach is a butterfly garden. Passion vine will attract the gulf fritillary throughout the southeastern and southwestern United States. Monarch butterflies prefer milkweed and dogbane, while the tiger swallowtail is drawn to willows, cottonwoods and birches. Phlox, butterfly bush, sweet William, black-eyed Susan, lilacs, hyssop and zinnias offer nectar to thirsty butterflies, but many showy flowers, such as roses and peonies, don't.

Attract birds to your yard by planting berries and seeds, and foliage that offers nesting sites. Bird feeders will entice many feathered friends to your yard (along with squirrels and chipmunks), especially in winter. But don't just

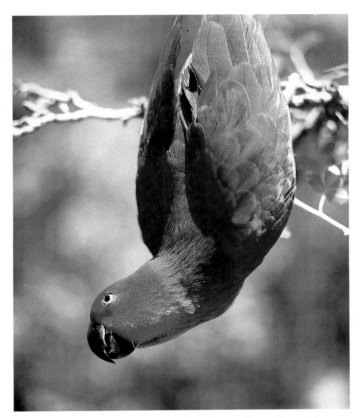

People who raise exotic birds commercially are often willing to let you photograph them. Sometimes the birds can be taken out of their cages. This goldie lorikeet posed for me in its owner's backyard. I found a place to put the bird where the background would be out of focus so the brilliant bird would be the sole center of interest. I used a telephoto to make the shot appear natural, because it could only be shot with a long lens in the wild.

Technical Data: *Mamiya RZ 67, 250mm lens, 1/125, f/5.6, Fujichrome 50D, hand-held.*

put food out in the winter; you'll get more repeat customers if there's food all year. Consult your local feed supplier for the mixture that will attract different birds. Finches, for example, prefer thistle seed.

Instead of putting birdseed or suet on a platform, make your feeder more natural looking for photographic purposes. Mount a large branch close to a window from which you can take photos unobserved. Drill a groove into the

branch large enough to put the food in. Neither the bait nor the groove will be visible from the camera's position. When a bird lands on the branch to take the food, you can photograph it without the setup looking artificial.

Special hummingbird feeders use a nectar mixture to attract these birds. Some formulas are more healthful than others; ask at your pet or feed store or a nature/birding group if you're not sure what to use. Make a hummingbird

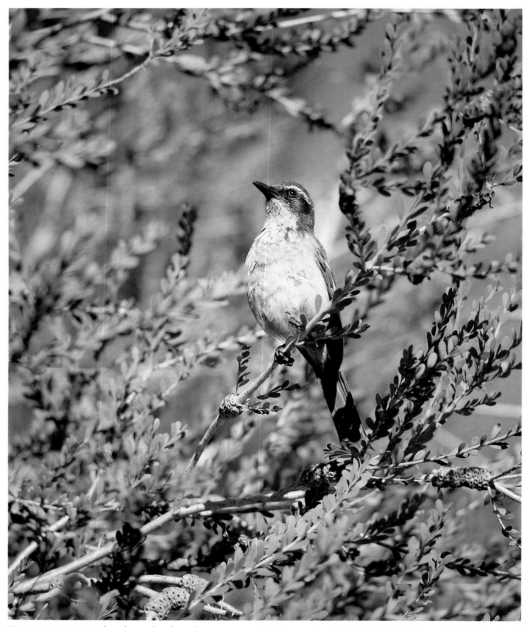

Have you ever considered your backyard as a source of nature and wildlife photos? If not, you should. I noticed this scrub jay habitually flew into the same tree in my yard. When bird and animal neighbors become accustomed to your presence, they can be captured on film with relative ease. This jay let me get fairly close for that reason. If you live in an apartment or a completely urban environment, visit local parks and botanic gardens regularly. Don't wander around constantly; settle in one place. If you don't move for a few minutes, birds and small animals will become bold enough to come within medium telephoto range. Birdseed and nuts are wonderful for encouraging close encounters.

Technical Data: *Mamiya RZ 67, 250mm lens, 1/250, f/8, Fujichrome 50D, hand-held.*

feeder look natural by camouflaging the tip with a flower. You'll also need to position flash equipment before any customers arrive. Many photographers place three or four strobes around the setup, but I feel that all those catchlights in the bird's eye look unnatural. I prefer to use one or two lights and position the second flash so it won't reflect in the eye. Before you use a strobe for a hummingbird photograph, find out from its specifications how fast it is. The bird beats its wings about two hundred times per second, so you'll need a very short flash duration to show detail. A flash of 1/1500 of a second will give a sharp picture of the bird's body, but the wings will be blurred. If you want a sharp picture of the wings, too, you'll need a unit that gives a burst of light around 1/20,000 of a second or less. Use a remote trigger—a long cable release or an electronic unit made for that purpose—to take pictures from the comfort of your home.

You can also attract animals to your yard. Deer and rabbits love vegetables—if you don't mind sharing your crop with them. In various parts of the country opossum, armadillos, ferrets, skunks and raccoons are easily attracted by food scraps. They may seem like common pests to you, but they make very salable pictures. Camouflage the food with natural-looking vegetation to make your photographs look as if they were taken in the wild. Prefocus on

the food and wait until the animal is in the plane of focus.

EXPERT ADVICE

One of the best sources of information on aspects of nature such as fossils, reptiles and birds is a natural history museum. The experts can often direct you to places where you'll get the best pictures of subjects in their field. They can also help you document and learn more about the subjects you've shot. The lepidopterist at the large natural history museum in Los Angeles introduced me to two groups devoted to observing and protecting butterflies: the Los Angeles Entomology Club and the Lorquin Society. The people I met through the clubs helped me locate and identify many species. In a relatively short time, I went from being a complete novice who couldn't tell a sulfur from a swallowtail butterfly to using the correct terminology and identifying many species in the field. I've now had six articles and many photos published, including a magazine cover of the ''88'' butterfly from Mexico.

I also got a head start photographing reptiles from the Los Angeles Natural History Museum. A club recommended by their herpetologists introduced me to people who had pets ranging from emerald tree boas to alligators. After photographing several reptiles, I gave a slideshow for the club and described how to capture reptiles on film. After the show, many people offered their pets as subjects. Within three months I had an extensive collection of photographs of reptiles and amphibians from all over the world.

Natural history museums also have wonderful displays you can shoot. Prehistoric skulls, fossils, gems and minerals can usually be photographed using a flash. Tripods are not permitted because of liability problems. I recently asked permission to photograph a dragonfly fossil outside its case. The paleontologist not only agreed but took it up to the roof for me so I could shoot it in natural daylight. I was extremely nervous when handling the one hundred fifty million-year-old rock, but I positioned it so the sunlight just skimmed the surface in order to emphasize the impression of the dragonfly.

Zoos and university science divisions are also good sources of expert advice. If you're not sure what kind of specialist you want, explain to the switchboard operator what you're interested in— snakes, birds, fish, mammals or insects—and they'll direct you to the appropriate person. You'll find that most scientists love their field and enjoy sharing knowledge with others. I've gotten so much invaluable information and so many good pictures that I can't recommend this approach enough.

Natural history museums are excellent resources for many nature pictures—gems and minerals, for example. Close-ups of these subjects provide representational or abstract images for calendars or fine art posters and even themes for articles. I photographed this rare dragonfly fossil from the Jurassic period on the roof of a natural history museum. I used extreme sidelighting to bring out the texture.

Technical Data: *Mamiya RZ 67, 127mm lens, 1/30, f/22, Ektachrome 64, hand-held.*

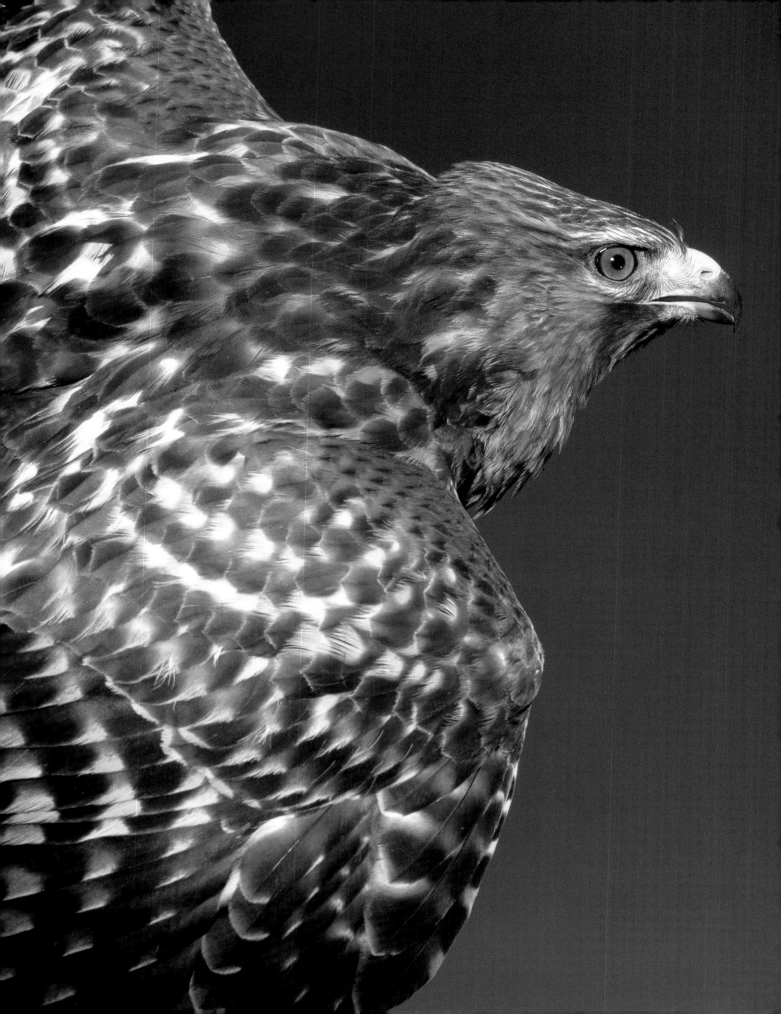

POWER PRESENTATIONS

How you present your work to a potential client is almost as important as the work itself. If you present yourself as a pro, you will be respected as one. If your presentation is amateurish, your chance of making a sale — and a living — is greatly diminished.

A power presentation consists of a strong body of work and, when you don't have an interview, a well-written query letter. Transparencies must be attractively packaged, with your name and the copyright symbol in plain sight. Prints must be artistically mounted and matted in a professional portfolio. Your query letter should be typed or computer-generated (letter-quality printing) on your letterhead, and it must be succinct. No one is interested in how you got the shots, how you feel about the images, or the technical data. If an editor wants to know, he or she will ask. The exception would be a photography magazine; that editor needs to know how the pictures were taken.

CHOOSING YOUR BEST WORK

Each image in your portfolio must be chosen carefully. You can have two or three different presentation packages. Each package should make a statement, convey a mood, or have an aesthetically pleasing arrangement.

You must be your toughest critic. Each shot you select has to be examined down to the last detail. Check the edges, look into the shadows, study the background. Do the background elements distract from your subject? Is a part of the bull moose you proudly photographed obstructed by an out-of-focus branch? Is there *anything*, no matter *how* small, that's not perfect?

CHOOSING YOUR MOST SALABLE WORK

When selecting pictures for your power presentation, ask yourself if these shots will adequately convey to a photo buyer your abilities and areas of specialization. Is the market using the types of images you've chosen, and has the buyer who will receive your package used this type of work recently?

If you have many great shots in a particular subject area, such as tropical sunsets, don't submit picture after picture of beaches. One or two is plenty. Show versatility in handling many types of situations in nature. If you have any doubt about whether to include a shot, it's usually best to leave it out. Leaving out one good picture won't spoil your

When I submit black-and-white or color prints to a publishing company, I mount the 8 × 10's within precut neutral mat frames — usually black or off-white — and send them in high-quality presentation boxes. The box protects the prints as well as makes a professional-looking package. These specialty items are available from University Products, Inc., 517 Main Street, Holyoke, MA 01041, 1-800-628-1912. Boxes like these aren't essential to a sale, but they do enhance the package's appearance. Check with your local art and photo supply stores for similar presentation boxes or cases. You can get sales with plain boxes or even with packages in envelopes; just be sure they're nice looking and adequately protect your images.

chances, but leaving in one bad picture will.

Order is important. Always begin and end with a powerful shot: bright colors, strong graphics, or an arresting pose. Pacing is important as well, with one image flowing smoothly into the next. The arrangement of shots should also be aesthetic.

Make a single sales point with a package or portfolio. If you're submitting a photo/article package, every image should show why this article is interesting and will appeal to readers. You might want to show versatility in an advertising portfolio, while a package for a stock agency would stress consistency and a volume of good images.

AVOID SUBJECTIVITY

The easiest trap into which you can fall is subjectivity. We all have fond memories of our experiences with nature, but these may have nothing to do with great photographs. Your last vacation might have been an outstanding experience, but if the photos aren't breathtaking, leave them out of your presentation. No matter how fond you are of the Pine Barrens in New Jersey, if your images don't convey the beauty in this area, don't include them.

Another common mistake is the "degree of difficulty" rating. It doesn't matter if you hid in a blind when it was forty degrees below zero to get a shot of an arctic fox. Nice try, but if the shot isn't frame-filling and dynamic, forget it.

TECHNICAL EXCELLENCE COUNTS

Without superior technical quality, all of your efforts are wasted. Examine carefully each transparency with at least an 8X loupe. Look for sharpness, and check for scratches and dust embedded in the emulsion. All of the images should be perfectly exposed, without washed-out highlights or too many black shadows.

Your prints must be dust-free and should be mounted cleanly, with no air bubbles or wrinkles in the emulsion. I prefer a glossy finish for color prints or a semigloss for black

and whites, but these surfaces show fingerprints easily. A one- or two-inch mat will allow a photo editor to handle the prints without touching the sensitive gloss. Make sure the color of the mat complements the pictures.

Include dupes if they are of high quality. Again, a loupe will give you the information needed to determine this. Be careful of increased contrast, which is characteristic of all dupes. I make my own duplicates, using Ektachrome Duplicating Film 6121. This minimizes the loss of highlight and shadow detail typical of a gain in contrast.

If you have a great wildlife shot but the composition isn't so hot, you might want to include it in the portfolio if it's of an endangered species or a rarely seen animal behavior. This, however, is an *exception* to a rule, *not* an excuse for breaking it.

QUERY LETTERS

The purpose of a query letter, with or without photos, is to grab the interest of the editor. When I send photos for consideration as a photo feature or for fine art sales, my letter is short and to the point. When I am submitting a photo/article package concept, the letter takes on more importance. It must immediately hook an editor with a powerful lead sentence. I include my strongest points first: why the subject is of interest, why it will appeal to the readership, and why the subject is timely.

I then briefly outline the content of the article, men-

Most photographers use a three-ring binder portfolio. I have never done this because everyone does, and I want my presentation to stand out. I also feel it doesn't look as slick or polished as the presentation boxes, because plastic pages scuff or scratch easily and tend to look cheap. On the other hand, you may want to use the standard portfolio, at least when you're starting out, because it's readily available, and buyers expect it. When going this route, always mount and mat your work so it looks attractive. Don't just stick photos under the plastic wherever you feel like it. Arrange them carefully for maximum effect. Package your portfolio for shipping with care, and keep track of where it is.

To submit your work to a stock photo agency, the traditional slide sheets that hold twenty images are fine. However, I prefer the sheets with black borders and fewer windows to send to editors. The black area that surrounds each picture serves as a miniframe, and it prevents extraneous backlighting from diminishing the impact of the slides.

tioning one or two particularly interesting aspects. For example, for an article on elephant seals in the Channel Islands National Park, I referred to the Marine Mammal Act of 1972, which prohibited a winter launch of the space shuttle from its West Coast base until scientists determined the sonic boom wouldn't disturb the seals. I thought this unusual tie-in would help sell the article. It did.

If you are an expert in a particular field, such as orchid cultivation or honey bees, and your submission relates to it, mention your expertise in the letter. It will give more credence to the proposal.

Proofread your letter several times. A spelling error or crossed-out word ruins its appearance. Take a few moments to catch mistakes — badly organized sentences,

omitted words, or incorrect phrasing. Make sure that you address your package to the appropriate person. Check the spelling of the editor's name and the company name, and make sure the street address is correct. Then read the letter to a friend who can give you intelligent feedback.

I rarely send a query letter without photographs. I feel that it is the pictures that really sell the photo editor or art director. Without them, my letter is just another on the pile. But with images in hand, photo buyers can make an instant decision whether they like my material and whether it is applicable to their needs. (Query letters that have worked for me are in the appendix to this book, page 131.)

When I submit my medium format 6×7cm transparencies, I use these custom-made 4×5 black card frames with gold foil lettering. Each frame opens, and I use easy-to-remove tape to hold the transparency in place. Many photo editors have complimented me on this impressive presentation.

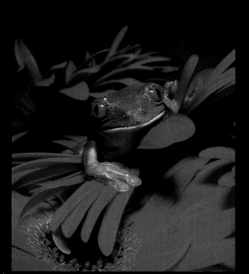

I always use the red-eyed tree frog to begin my presentation. Art directors' reaction to it is always positive. Although this is an older image, I keep it in my portfolio because it's brought so much work.

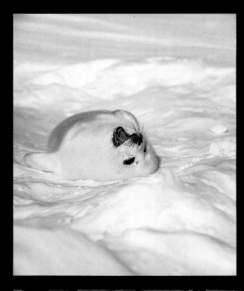

Humor is important in advertising, so I include this "laughing" baby harp seal. I tell the art director the little guy is obviously amused by some inside joke.

As a counterpoint to the brilliant color of the frog, I want to convey my ability to photograph mood. Art directors who need room for copy appreciate the negative space on the side of the composition.

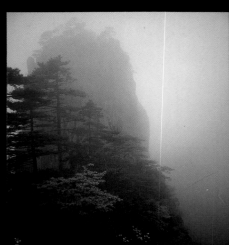

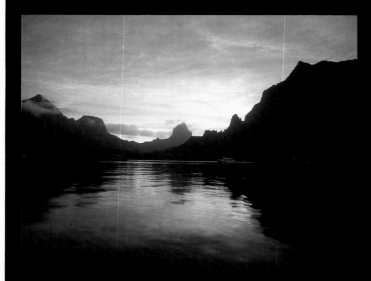

The Tahitian sunset is third in my portfolio because the warm, romantic colors are another counterpoint to the previous two shots. I try to visually jolt the art director as she or he looks at contrasting types of images.

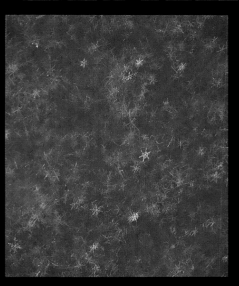

Advertisers frequently superimpose product shots over background photographs. I include two kinds of images that might be used as backgrounds: clover and snowflakes. I put these images toward the middle because they aren't strong enough to either open or close the presentation.

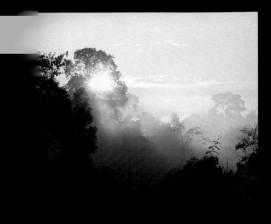

The environment is a major concern today, and some corporations use images from the rain forest in their promotions. I use this shot from northern Thailand in my portfolio to show I have stock that could be used for this purpose.

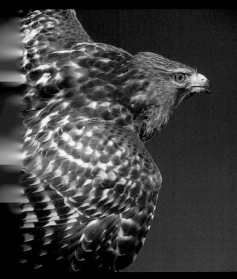

Hawks and eagles are symbols of strength, so I include this red-shouldered hawk with plenty of negative space for copy. I place it near the end of the portfolio because it is powerful enough to keep an art director's interest.

Much of advertising is moody shots designed to manipulate emotions. Whenever I give a slide show, this Oregon coastline receives "oohs" and "aahs," so I include it in my portfolio and get the same reaction from ad agency personnel. I've actually sold this print twice, to two different art directors.

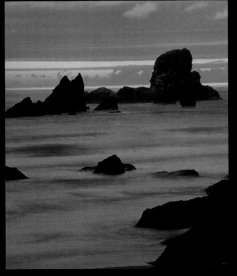

I end my portfolio with another picture that always receives a strong, positive reaction. It shows a unique perspective, and I want to leave the impression that my photographic vision is special.

AN ADVERTISING PORTFOLIO

When making a presentation to an advertising agency, I typically show ten to twelve prints or twenty medium-format transparencies. If I am showing 35mm, the slides are placed in a precut mat with twenty windows for the images. I use a few very strong images to instantly grab attention. I like to leave the buyer wanting to see more.

I present my 11 × 14 prints mounted and matted on 16 × 20 boards, and I carry them in an attractive portfolio box (see photo on page 47). I feel 8 × 10's don't have the same impact as the larger size. If you shoot 35mm, a print larger than 11 × 14 will suffer in sharpness and color saturation. Other photographers prefer ring-binder portfolios (see photo on page 48). I place my medium-format transparencies in 4 × 5 windowed mat frames with my gold-embossed name on each one (see photo on page 49).

Ad agencies look for professionalism plus top-notch work that has impact. They may not be able to use any of the images you show them at a first interview, but they want to feel confident that you have a good stock of images for later use or could handle a future assignment.

This group of shots shows several concepts: bold color, subtlety in nature, humor and endangered environments. Each type is used in a variety of ways in advertising.

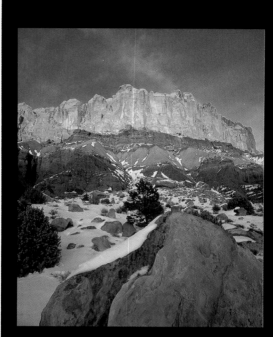

Capital Reef National Park is not as well known as other parks. But I included it because articles should inform as well as entertain.

Most publications try to add a human element to [...] Verde does that, so I made sure this was part of [...]

Landscape Arch in Arches National Park is a fa[...] landmark, but I'd never seen any published pic[...] fog. I felt the uniqueness of this picture would se[...]

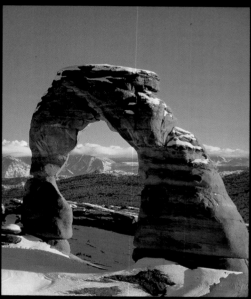

Delicate Arch offers such a dynamic graphic shape that it is frequently used in photo layouts. I thought the beautiful sunset lighting, plus the space available for the logo at the top, might appeal to Westways for a cover. It didn't, but they used it as part of the photo feature.

This was one of two Monument Valley images I submitted. It was a different view than is normally seen, and I thought it might work in the story. The photo editor, however, chose the more traditional view.

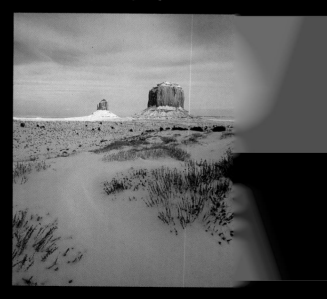

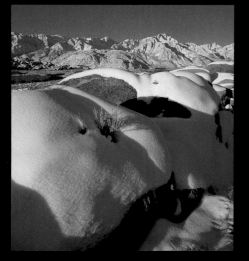

included a shot of the Eastern Sierras because Lone Pine, where this was taken, is only three hours by car from Los Angeles. Most of the readership of Westways *is in southern California, and I assumed the close proximity of this location would sell the shot. It didn't.*

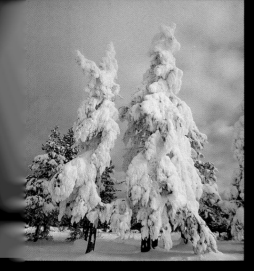

Trees laden with snow are certainly part of winter, and since this type of scene is rarely witnessed in southern California I thought it might appeal to the photo editor. Wrong again.

I thought certainly an old, rustic barn with the magnificent Teton Range in the background would be right for the layout. For reasons I didn't know, it wasn't. Photo editors, like everyone else, have individual tastes. They pick what they like—as long as the story is visually conveyed to the readership.

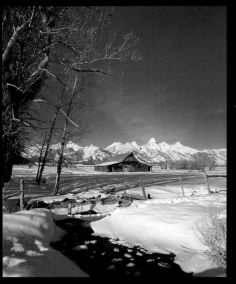

ARTICLE PACKAGES FOR MAGAZINES

When I make an editorial proposal, I include enough pictures to tell a story. The photo editor needs a variety of images with which he or she can make an attractive layout and still convey a message. I usually submit sixteen to twenty-four 6×7cm transparencies or twenty to forty 35mm slides. I also make sure there are a variety of horizontals and verticals, although I place greater emphasis on the latter because I always hope for a cover.

Publications are only interested in transparencies, unless you are submitting black and whites, which you should present as 8×10 prints, unmounted, with or without borders. Place 35mm slides in slide sheets that hold twelve or twenty photos. Captions should always accompany the slides, either on computer-generated slide labels or on a separate sheet of paper with each photo corresponding, by number, to a caption. Put your name and the copyright symbol on each slide mount.

The editorial market looks for a story in pictures. The text tells the reader about the subject at hand, but the images should communicate the information visually. If your work will be used without a manuscript, as in a photo feature, the pictures must stand by themselves in telling the story.

For *Westways*, the magazine of the Southern California Automobile Club, I submitted a group of photographs for a photo feature titled "Winter Comes to the Southwest." These eight pictures represent half of the total submission. They used the first four shown here and rejected the rest. I chose these shots for their diversity with respect to location. In addition, I wanted to show different facets of winter, from intimate macro shots of snowflakes to Anasazi Indian ruins and landscapes.

The final layout that the *Westways* photo editor designed included only a few of my favorite shots from the submission. I had included a number of images in the package to provide a well-rounded representation of the subject, but these weren't personal favorites. Photo editors have different considerations in making a selection for a layout than a photographer may appreciate. They might be looking for certain types of images that relate to the text, or possibly they need pictures that are significantly dissimilar to other shots chosen from that same issue. Or, the amount of negative space in the top portion of the frame might be important so copy can be inserted. Sometimes the choice is totally subjective, where the photo editor simply prefers one image over another.

Don't be offended if you think your best shots weren't incorporated into the layout. This is just the reality of the business. Some of your clients will have the same tastes as you do, while others will see things very differently.

MAGAZINE COVER SUBMISSION PACKAGES

The number of images to submit to a publisher for magazine cover consideration varies. Usually, however, I'll send from sixteen to twenty-four 6 × 7cm transparencies or twenty 35mm slides. Always send verticals, unless the picture will look good when cropped to a vertical or unless the magazine uses a horizontal wraparound cover, as *Audubon* does.

The presentation method is the same as for submitting your work for editorial consideration. I include caption information for cover submissions, as well. Tell the photo editor where the shot was taken, and if the images are animals, provide both the common and Latin names.

Photo editors want several things in a cover image. Bold color is preferred, but not required. Dark, somber and moody pictures usually are not chosen, especially if the magazine relies on newsstand sales. Strong graphics are always appreciated. Also, images must be sharp enough to withstand a significant enlargement.

These two groups of pictures represent two cover submissions. The first was for the Christmas cover of *Westways* magazine, and the second was for *Pets/Supplies/Marketing*. I chose the winter scenics based on strong color and design, and the wildlife and pet shots for being cute or unique. None of the scenics sold, but three of the wildlife/pets were used for covers.

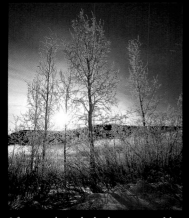

I frequently include the sun to add drama to a landscape shot. I submitted this winter photo, taken in the Grand Tetons, as a cover possibility because of the lacy quality of the white branches.

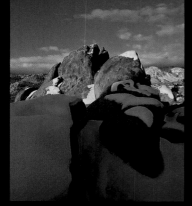

The striking color contrast of the yellowish rocks with the intensely blue sky and white snow made me include this image as part of the magazine cover submission. There is plenty of logo space at the top, plus room for blurbs at the bottom in the shadows of the foreground snow.

Strong color contrasts are important to a magazine because they catch a casual viewer's attention. I selected this alpine shot because of the brilliant contrast between the polarized sky and the snow-covered trees.

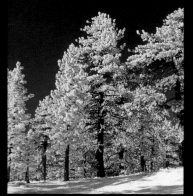

One of the most salable types of nature shots for magazine covers is one with brilliant backlighting. Even though there is little room for a logo at the top of the composition (it could be partially superimposed over the top of the tree if the editors wanted to use it), the lighting is so dramatic here that I thought I would try it.

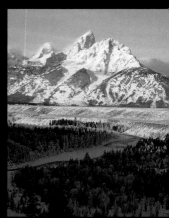

This view of the Grand Tetons at the Snake River overlook is well known. The shadowed portion at the bottom of the frame allows blurbs to be printed over the photo.

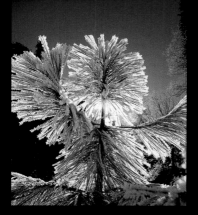

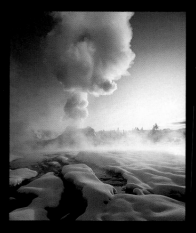

This shot of Castle Geyser in Yellowstone had been used the previous year on another magazine's cover, so I thought I would try again with a different market.

The first cover I did for Pets/Supplies/Marketing *was this forest chameleon. I allowed room at the top for logo space, and I chose an unusual-looking reptile to attract attention. It worked.*

Nothing in the world is as cute as a blue-eyed kitten. As soon as I shot this image, I knew I had a cover. The color of the eyes, the innocence, and the intimacy of the shot all go into making this a winner. It sold as soon as it was submitted.

Animals with cute expressions are always good choices for cover submissions. Even with trade magazines, emotional elements are salable in the marketplace. This Pomeranian puppy was captured in a yawn, and at this writing the shot is under consideration for cover use.

I included this photo of a common iguana because it's so visually arresting but typical of the sort of reptiles pet stores carry.

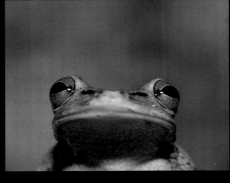

This blue-eyed tree frog was photographed both from the side and the front. I included this side view in my cover submission because of the striking color and protruding shape of the eye. It hasn't sold yet.

I chose to include this shot of my beloved Buffy in my submission for three reasons. First, it is a humorous shot. Second, I thought Pets/Supplies/Marketing *might do a story on canine orthodontics. And third, Buffy was my dear friend and companion for a long time, and I wanted to see him on a cover.*

This unusal black-faced Maine Coon cat is at present under consideration by PSM. I sent it to them because the cat is an award winner, and the dark-faced variety is not commonly seen.

Another successful image with Pets/Supplies/Marketing *was this sulfur crested cockatoo. I included it in my submission because of the bird's interesting pose, as well as the strong contrast in color between the white and the soft green background.*

FINE ART: CALENDARS, POSTERS AND PRINTS

Because it is hard to predict what a fine art publisher will like in my slide library, I tend to present many more images than normal. In a recent presentation, I showed one hundred twenty photographs of nature and wildlife to the owner and staff of a publishing company.

I prefer to present a slide show to a fine art buyer. This has several advantages over a mailed submission. First, I get immediate feedback. Second, a projected transparency is always more impressive than one seen in a slide sheet through a loupe. The colors are brilliant, and the large size indicates how it would look if reproduced as a fine art print, poster or calendar. A slide show lets you offer a large number of images because it's entertaining. If you show too few, your audience is disappointed. On the other hand, it's important not to saturate them with too many images.

Although I prefer to make fine art presentations in person with a slide projector, I have on many occasions submitted and sold images to this market by mail. When you're just starting out, plan to make all your submissions by mail. Fine art buyers generally don't have time to meet every photographer individually. After you've sold several photos to one buyer, make a play for a slide show to see if that will increase your sales. Always try to send approximately twenty-four images for each calendar or poster submission. If you have enough photos, make up several packages and keep them circulating. Although slide sleeves are acceptable for submissions, you might invest in some matted slide mounts (see page 49) to make your package stand out.

The fine art market is looking for art in nature—strong graphics, unique vision, powerful black and whites, and dynamic lighting. Buyers look for new ways of interpreting common subjects. Images using bold colors, as well as delicate, pastel ones, can be commercially successful.

I made this selection carefully, choosing each image for individual merits. The themes that went through my mind as I studied each photo was "art in nature" and "poetry in motion." Although each person has his or her own interpretation of these ideas, I used them as a framework for putting the slide show together.

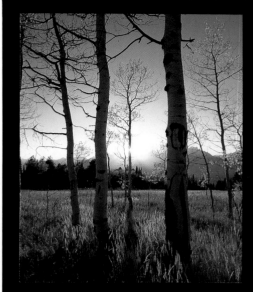

I like to present a variety of nature photographs to fine art buyers, from intimate details of nature to landscapes. I selected this shot of the Teton Range in Wyoming for the yellow autumn colors and the striking depth of the image.

The pink underside of a maple leaf, plus the interesting designs in the insect-eaten portions, made me include this shot in a fine art presentation. All of the photos I choose are only educated guesses as to what a publisher may like.

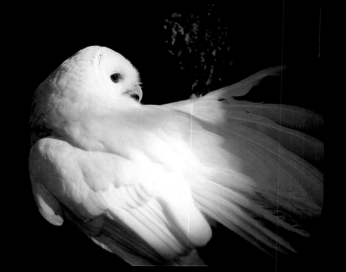

This is an extremely rare albino barred owl, and I thought the uniqueness of the subject would make it a strong selling point. Also, the snow-white color, patchy lighting, and interesting body language enhance the quality and appeal of the image.

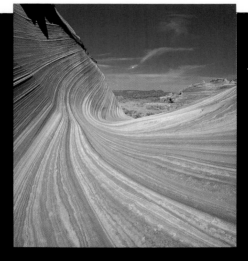

Strong compositions are very important in fine art sales. I selected this remarkable canyon for my presentation based on the powerful design of nature's own composition.

The brilliant color of this autumn foliage in Vermont became part of my fine art presentation because color is frequently used by decorators to make strong statements. Calendar companies also like the strong impact of bright colors.

This mirror reflection of the Grand Tetons, plus the first reddish rays of light on the peaks, suggested this might be a success as a fine art print or calendar page. Some paper products use horizontal shots, while others design their layouts vertically. Therefore, I usually take both formats of a particularly fine composition.

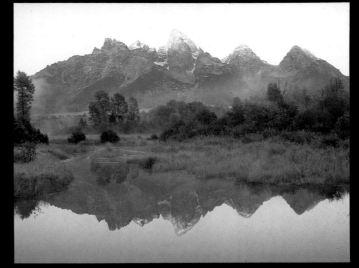

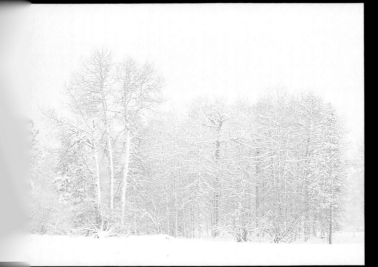

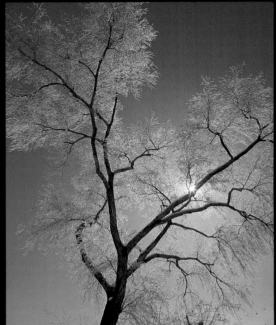

Delicacy in nature sells well in the fine art market. I chose both these images because of the fine detail and subtlety in the branch patterns. The inclusion of the sunburst in the one and the monochromatic quality of the other add to the artistry -- and hence the salability -- of the shots.

Trees are popular with interior decorators, and the juxtaposition of the rust-colored leaves with white birch makes for an artistic rendition of nature. The charcoal gray mat border frames the piece nicely, without detracting from the colors.

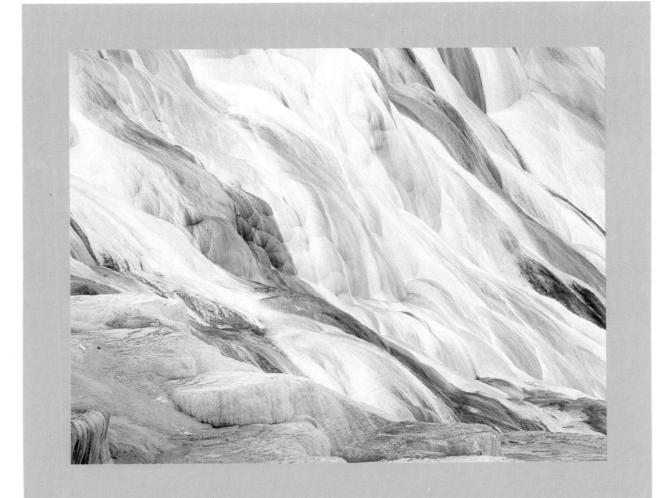

*Photographing Mammoth Hot Springs in Yellowstone was like
shooting art in nature. The exquisite lines and interplay of subtle
colors look more like a painting than a photo, and I thought it would
attract many decorators. The soft yellow/brown matted frame picks
up those colors in the image.*

A BOOK PROPOSAL

The number of pictures needed for a book proposal can vary considerably, but give the publisher confidence that you have enough high-quality images to fill a book. I usually submit twenty-eight to thirty-six medium-format trans-parencies; however, last year I sent sixty 35mm slides for one proposal, and this year I sub-mitted an idea for a children's book with only six pictures. For my submission for the book you're reading, I showed about twenty-five shots.

Always submit transparen-cies, because they're required for the best reproduction (un-less the book will be black and white). Mail submissions are preferred. It takes time for publishers to make a final de-cision. Numerous people are involved in such a large under-taking, so your slides and out-line will be reviewed over a period of weeks or months. Don't panic if you don't hear for a while; in publishing, it's often a case of "no news is good news."

Book publishers are look-ing for both timely and time-

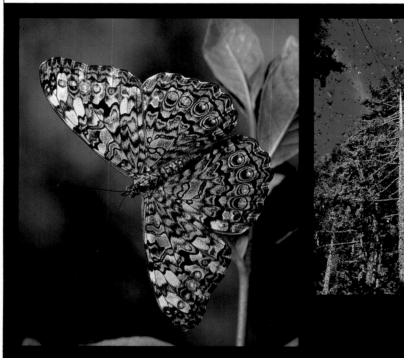

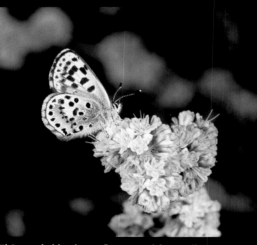

One of the most remarkable phe-nomenon in the insect world is the monarch butterfly migration. Any book on butterflies would have to include pictures of this.

Unusual patterns in butterflies are intriguing. I included this white-skirted calico in my book proposal submission because of the unique design on its wings.

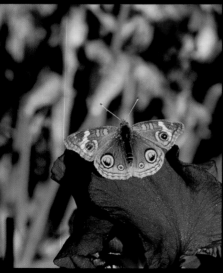

I chose the buckeye butterfly perched on an iris for its rich col-ors. The warm sunrise lighting en-hanced the flower. Book publish-ers, like magazine editors, are aware of the positive effect of bril-liant color on photo book sales.

The El Segundo blue butterfly is one of the smallest creatures on the Federal Endangered Species List. Because of its rarity, this shot was part of the group of transparencies sent to the publishers.

less concepts. The idea should appeal to a large group of potential readers. My publisher felt there was a large audience of nature and wildlife photographers who would want to learn to take better photos and successfully market their work. In fact, nature and wildlife topics are hot at the time of this writing due to the interest in environmental issues. Landscapes are more difficult to sell, unless the place is popular for tourists or is in the news. Children's books rely more on illustration than photographs, but science and nature books are popular and more likely to use photos. It's very hard to get a book of your work published, but that's no reason not to try.

The butterfly photographs reproduced here are part of a proposal for a coffee-table book on these beautiful creatures. I chose these images for their brilliant color and, in most cases, for the intimacy of the shots. Thus far, the pictures have been submitted to three publishers, all of whom appreciated the pictures but didn't commit to the project. But I haven't stopped trying.

I try to offer diversity, to give the photo editor a lot to work with. Tight, intimate shots add variety to photo layouts. I composed this shot of a Cynthia moth so the wing patterns dominate the composition.

Nature is especially fascinating when the camera shows people what they don't normally see. Photo books are successful precisely because they open new horizons for us. I chose this close-up view of a spicebush swallowtail because it illustrates anatomical features that most people never get to appreciate.

Although the painted lady is a common butterfly, I chose this photo for the submission because of the brilliant-colored flower on which the butterfly is resting. Remember, bright color is important in almost every submission you make.

A book publisher will want to show common butterflies as well as rare ones. People will readily recognize the tiger swallowtail because they're seen outside. This helps them relate to the subject of the book.

A STOCK SUBMISSION

Stock photo agencies typically want to see between three hundred and five hundred images before they consider accepting you. Some will ask to see less, and some may want to see more. They aren't looking for a few good images; they want hundreds of salable frames.

A slick presentation is not necessary for a stock agency. All they are interested in is the quality and quantity of your images. Cheap acid-free 35mm slide sheets are the norm when presenting stock, while medium format images should be presented in the black mat frames (see photo on page 49).

Stock agencies look at photographs quite differently than photographers do. A simple rainbow against the sky, for example, might seem uninteresting, but it could have dozens of uses in the marketplace that never occurred to you. Stock photo agencies want to see logo space for advertising sales, bright colors, sharp originals and great lighting.

I chose to submit this group of photos to my stock agency for all of the above reasons. Landscapes couldn't be ordinary; they had to be outstanding. Wildlife images couldn't be snapshots; they had to show artistry with interesting poses and movement, and they had to be tack sharp. If an image was even slightly out of focus, it couldn't be shown.

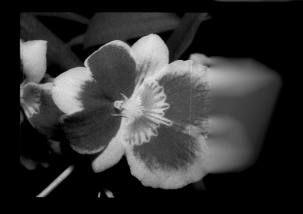

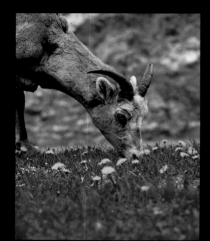

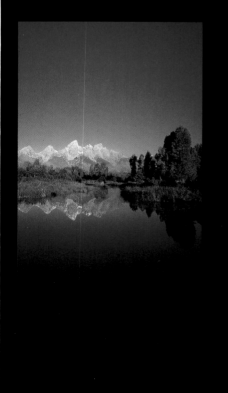

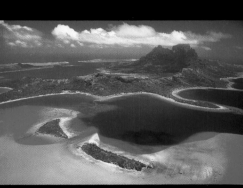

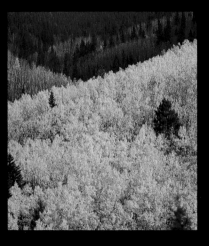

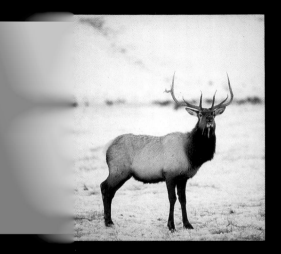

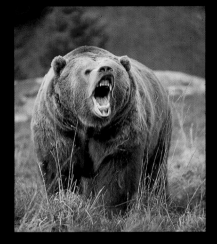

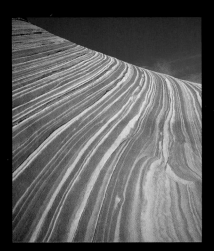

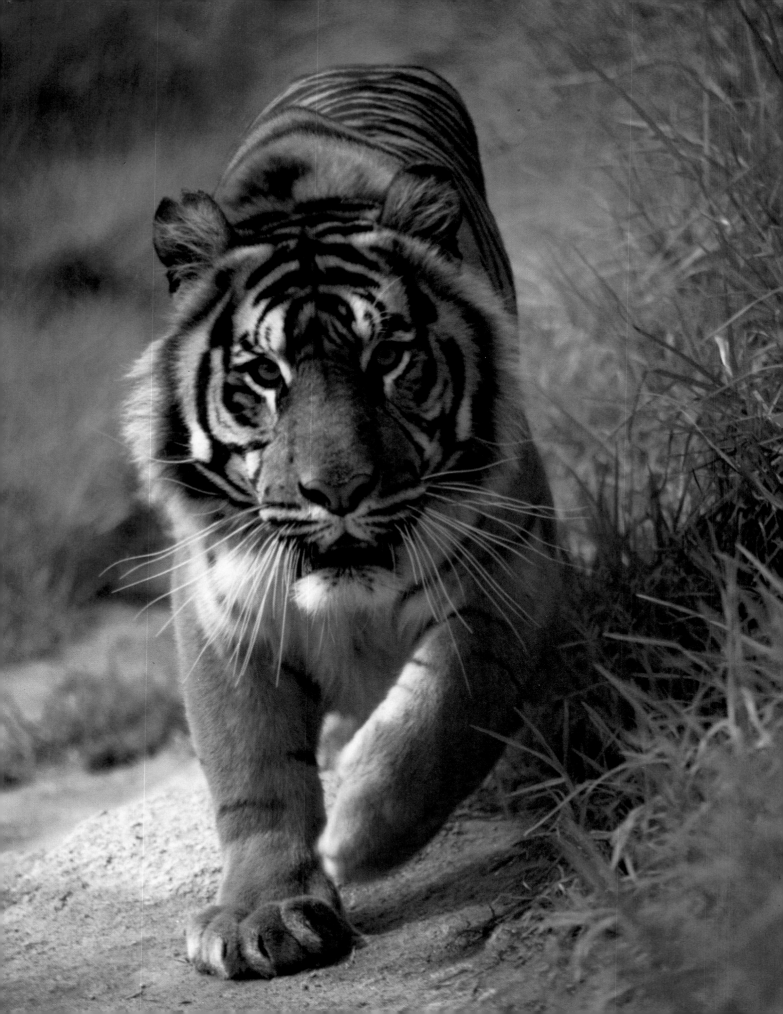

SUCCEEDING IN THE MAGAZINE MARKETPLACE

Any photograph that is used to tell a story, support an article, or disseminate information is considered "editorial." This includes magazine covers, pictures that accompany articles, and photo essays. Although it's a highly competitive one, the magazine market is enormous. Just consider that more than twenty-two thousand magazines are published every month in the United States alone.

If you look beyond the brand-name national magazines such as *Time, People* or *National Geographic*, there's a huge market that's open to photographers who don't have national reputations and even those of you just making the transition from hobbyist to professional. For example, few photographers know about *Woodmen of the World, Pets/Supplies/Marketing, Photo World, Terra, Mature*

Shots of endangered species always sell well. Because the Sumatran tiger is close to extinction in Indonesia, wildlife and nature publications are likely to feature it as a major story or perhaps a cover.

Technical Data: *Canon F1, 300mm lens, 1/125, f/5.6, Kodachrome 64, hand-held. I shot this in the wild game park at the San Diego Zoo through a chain-link fence. I prefocused on a point between me and the charging tiger and triggered the motor drive as he stepped into my zone of focus. The tiger actually crashed into the fence right in front of me!*

Years, Aloha Magazine and *Westways.*

These are examples of trade, special interest, business, association and regional magazines. The less familiar publications, such as those I just listed, typically have a smaller circulation, so they pay less and are less prestigious than the "big boys." But there are several advantages to going after the smaller magazines. You won't face as much competition and you may get paid a little quicker (if only because there's less lag between the time your image is selected and when it's used). You'll also have an advantage if you go after regional markets in your immediate area, because you'll probably have more shots of the local flora and fauna than photographers who don't live there. If you live in Vermont, for example, you'll have more images of New England than a photographer who lives out West, and you can easily come up with pictures of the Green Mountains for a cover or photo essay.

What does this mean for your reputation and your cash flow? Say you get one image in *Life* after two years of trying — and that's a remarkably short time to break in. You might get paid several hundred dollars. In that same time period, you could probably make more than that by selling several images to the smaller

magazines. You'll also be racking up more credits; the more sales you have, the more you make. Always try for the prestigious and high-paying magazines, but a shortcut to the top is often getting known in dozens of smaller markets first.

COVER ILLUSTRATIONS

Let's talk about magazine cov-

ers. Personally, I love to see my pictures on the front of a magazine — any magazine. It's exciting, it looks great in a portfolio, and it's income. The nature and wildlife photographs that get used on magazine covers are eye-catching. Cover photos have to draw "oohs" and "ahs," making someone want to share in the

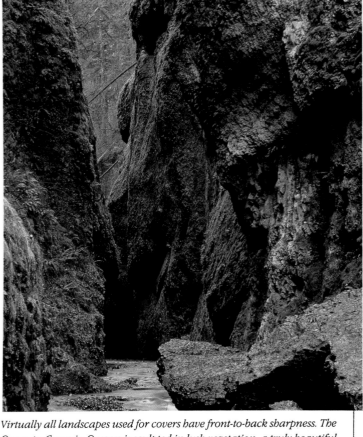

Virtually all landscapes used for covers have front-to-back sharpness. The Oneonta Gorge in Oregon is sculpted in lush vegetation, a truly beautiful spot to photograph. But to make this a salable shot for a magazine cover, the entire depth of the chasm had to be rendered in sharp detail. I used a telephoto lens with very shallow depth of field, mounting my camera on a tripod to allow for the small aperture.

Technical Data: *Mamiya RZ 67, 360mm lens, 1 second, f/22, Fujichrome 50D, tripod.*

moment. Try to be objective while reviewing your work. When you edit your slides for a submission, keep these qualities in mind:

- Are there a lot of bright colors?
- Are there strong color contrasts?
- Does the image have a strong, dramatic composition?
- How effectively lit is the subject?
- Are there interesting patterns of light and shadow?
- Is there at least one area with a rich, eye-catching texture?
- What is there to draw the viewer immediately into the scene?
- Is my image crisp, clear and razor sharp? Can it take a great deal of enlargement?

THE LAST WORD
Although you may be allowed to offer input, remember that the editor has the final say. I pushed hard to have my shot of a red-eyed tree frog on the cover of the January, 1990, issue of *Petersen's Photographic Magazine*. That time the editor and publisher agreed. On the other hand, *Westways* used in the article the photo I really wanted on the cover and put one I wasn't that excited about on the cover. Know when to back off; it's better to have a photo that you're not completely crazy about on the cover than to have someone else's photo there.

Compare your slides with work published by other photographers. Are your images as dynamic? As attention-grabbing? If not, what do their images have that yours don't? Access to exotic locales and animals is not the answer. Plenty of regional travel magazines, such as *Southern Living*, demonstrate the wide variety of subjects in your own backyard.

Before approaching any magazine with your photos, do some research. Classify your images by subject matter and consider the ways they might be used. A beautiful shot of a garden or a butterfly would work well for a gardening, regional, nature or even religious magazine.

Next, identify magazines that fall into the appropriate categories. You'll find many listings arranged by subject category in *Photographer's Market*, *The Reader's Guide to Periodical Literature*, and

The Standard Rate and Data Service (referred to as *SRDS*). The latter is harder to use but does list thousands of magazines. A photo of a lovely, interesting garden might fit the needs of magazines such as *American Horticulturalist*, *The Church Herald* or *Country Magazine*, as well as appropriate regional or local publications. I also find large newsstands, bookstores and libraries are good sources of magazines, including foreign ones.

Find copies of as many of these magazines as possible. Check your library, newsstands, and college or university libraries. You can submit without looking at back issues, but your chances of coming up with an appropriate submission are better if you've seen samples of the images they use. Make notes on how they use illustrations on the covers:

- Are the covers always verti-

Reptiles comprise a significant portion of sales for retail pet stores, so I thought this shot might make the cover of Pets/Supplies/Marketing *magazine, a trade publication for pet stores. I left room at the top and one side for the logo and blurbs, since that's the format for its covers. I sent it, along with seven others, as an unsolicited submission. I was rewarded for my trouble by selling it, as well as one of the others, for two different covers. Now I send a selection of shots every year for cover consideration, and I'll sell at least one or two. I rented this forest chameleon from a pet store for ten dollars and photographed it on a dead branch. I purposely placed my small subject in front of a tree, but used a relatively large aperture to render the background out of focus.*

Technical Data: *Mamiya RZ 67, 180mm lens, 1/250, f/5.6, Fujichrome 50, tripod.*

cal or are they horizontal wraparounds?

- Is there a lot of copy on the cover to be fitted over or around a picture?
- How much space do they allow for the publication's logo or banner?
- What kinds of images have they used in the past?

If they use vertical cover illustrations, don't put aside all your best horizontal images. Pick ones that could be run smaller to fit on the cover or, better yet, can be cropped to make an interesting vertical composition. If a lot of the cover is taken up by copy or a logo or banner, pick images that can be cropped in, have type dropped over, or have type run around. Pay careful attention to the subject matter

of previous images. You will only be looking at a sampling, but you can still make out general trends, such as people always appearing in scenics. Also be sure to send for the publication's photo submissions guidelines (it is usually free with a self-addressed, stamped envelope). These will tell you exactly what and when to submit.

When choosing images to submit, be aware that most magazines work on issues at least three months ahead of when they'll appear at the newsstand. For example, an April issue is typically "put to bed" (goes to press) by January 1. The editors decided what to use in April several months before the January 1 deadline. Therefore, make sure your winter scenics for a December cover are on the editor's desk no later than July. March or April would be even better.

Magazines frequently use a picture for a cover that ties in with a lead article. Write or call the editor of a magazine to whom you plan to submit work, and ask for a list of upcoming themes. Tell editors that you want to submit some outstanding images but would like to make sure they'll fit with lead articles. They have nothing to lose by telling you what's on the drawing board for the next several months, and you have everything to gain. You'll greatly improve your chances for getting images published when you can tailor them to a magazine's specific needs.

Subtle photographs are rarely used as cover material, but they frequently add a sensitive touch to an article/photo package. This shot, taken on the rim of Bryce Canyon National Park during a Christmas snowstorm, isn't bold enough to grab the attention of browsers on a magazine stand. Although many people appreciate subtlety in nature and love to capture it on film, editors will use this kind of imagery to support a story rather than visually promote it.

Technical Data: *Mamiya RZ 67, 27mm lens, 1/30, f/8, Ektachrome 64, tripod. The light reading here was made with a Minolta III flash meter, which doubles as an incident meter.*

Editors find brilliant color appealing for cover material. The painted lady butterfly is common throughout the United States, so it could be used by regional publications over a large geographic area. (A magazine published for a Florida readership doesn't want to use a butterfly native only to California.) I have had horizontal shots like this one cropped vertically because the editor liked the image and wanted to use it for a cover.

Technical Data: *Mamiya RZ 67, 110mm lens, on-camera flash, f/22, Fujichrome 50D, hand-held.*

One of the most important aspects of any editorial proposal is offering the viewer a new way to see the world. The face of the Mendenhall Glacier in Alaska reveals the intense blue of compressed ice, but the unusual aspect of this shot is the distance from the surface of the water to the top of the picture—about one hundred twenty feet. This is equivalent to a twelve-story building. I used a long telephoto to compress the scale of size.
 Technical Data: *Mamiya RZ 67, 500mm lens, 1/60, f/4, Fujichrome 50D, tripod.*

ILLUSTRATIONS FOR INSIDE USE

The procedure for submitting illustrations for inside use is much the same as that for submitting cover images. You must still be concerned with quality, appropriateness and timeliness. You need to see what format of images appears most often and what the subject matter is.

Check the listings in *Photographer's Market* and carefully review submission guidelines to see whether a particular magazine will use single illustrations to establish a mood or to add to its articles. Does it run photo features (pieces with photos and captions but no text)? How many photos are used per article? Is there a gallery section where only photos are used? These questions will help you determine if your pictures are good candidates for that magazine.

PHOTO/ARTICLE PACKAGES

Submitting a photo/article package is an excellent way to offer your work, because you are offering a finished product. (This doesn't mean you have to write like Hemingway; editors expect to do a certain amount of reworking. An editor can drop a completed piece into any issue, depending on how much editing and revision it needs.)

CREATING THE PHOTO/ARTICLE PACKAGE

There are probably as many methods of creating photo/ar-

ticles as there are photographers and writers. The three methods I discuss here are the ones I've most often used successfully. Methods One and Two rely heavily on my existing collection of stock. Method Two discusses some tricks for shooting for a specific article when you don't have an assignment. Method Three describes how a partnership with a writer can improve your sales.

Building an article from your existing stock is the most economical way to go if you already have a good collection. Shooting for a specific article is very risky, but that's going to be your primary way to sell if you haven't yet built up

your own stock of images. I often take photo trips without a definite sale lined up, and then put together several packages. If it's an expensive trip, however, I try to line up some interest in advance and then shoot with some specific articles in mind.

METHOD ONE. Go through your stock photo library and try to fit your pictures into thematic groups. Look for story ideas in every subject grouping: wildflowers, butterflies, interesting geology, a wild animal raising its young, a series of international sunsets, forest fire devastation, ecological disasters, lightning and so on.

Some themes are easily ap-

parent. If you have a number of slides on a particular subject—wildflowers of the Blue Ridge Mountains or Indian petroglyphs, for exmaple—you have a ready-made theme. You shouldn't stop there, however. A collection of reptile and amphibian photos could produce themes as diverse as "Funny Frog Faces" or "A Night in the Everglades."

Art directors and magazine editors can often be good sources of ideas. Write and ask about their plans for upcoming issues. Then check your existing stock and pull images to fit those themes. For example, a couple of years ago I wrote *Photo World*, Aus-

Many times my ideas for articles come after I shoot the pictures, when I've collected enough photographs around a central theme. I shot these icicles near Juneau, Alaska, then used them in an article on photographing natural ice formations.

Technical Data: *Mamiya RZ 67, 50mm lens, 1 second, f/22, Fujichrome 50D, tripod.*

tralia's leading photography magazine, and asked about its future plans. The staff gave me a list of themes they would look for, one of which was centered around national parks. I offered them a piece on Bryce Canyon National Park in Utah. They expressed interest, so I went through my collection of images and put the package together.

Study dozens of publications on newsstands or in grocery stores. Many of the themes reproduced in print are used over and over again. I've often taken an idea I got from one magazine and proposed it to another noncompeting magazine and been ac-

cepted. But of course, *my* treatment of the subject was very different from the article I saw and, certainly, the photos were different.

Sometimes I'll make it a goal to get published in a particular magazine. I'll study back issues to see the direction its articles take and try to come up with an idea that might appeal to the staff. I took this approach for *Animal's Voice Magazine*, which I spotted in a health-food store. It featured articles and photos concerning the prevention of animal abuse. I felt there was a chance they might want some beautiful wildlife photos; people who are com-

mitted to protecting animals usually love the beauty of wild animals, too. I sent *Animal's Voice* a selection on speculation, and they bought two shots: an oil-covered western grebe on the coast of Washington and a mountain lion in a snowstorm, which they used as a double-page spread in an article. Since then, they've kept asking me for more material.

You're more likely to sell your photo/article if you focus on a single, relatively narrow, theme. A magazine is more apt to use a story such as "Backpacking in Bryce Canyon National Park" than "Backpacking in Utah." If

your theme is too broad, the limited editorial space allotted to you won't prove sufficient to cover all the points. You're better off to cover completely a narrow subject, than just touch on a broader one.

You must have a workable method of quickly finding and viewing the material. The best method I've found is organizing my storage system by *subject category*. In fact, almost every photographer I know uses a category system because it is so effective, and I strongly recommend you do the same. There are no hard-and-fast rules about what categories you use. Customize your system to fit your images. Some of the categories I use are lightning, Pacific Northwest landscapes, black-tailed deer, the sky (includes cloud formations, sunsets and sunrises, but you could break out sunsets if you've shot quite a few) and butterflies.

Review your stock library frequently. You may have marketable themes within your existing files. I go through the images in my files regularly, looking for themes I never noticed before. Since I'm always adding to my stock library, I may create new themes without any conscious effort. The discovery that I had collected quite a few southwestern winter scenics inspired a proposal to *Westways* for a photo essay titled "Snow Comes to the Southwest."

Because *Westways* is a travel-oriented magazine, my proposal focused on the editor's need to provide interesting and informative material

on a potential travel destination. I pointed out that winter is a magnificent and exciting time to be in the Southwest, and that this article showed a different side of that region. This was enough to capture his interest, and the pictures locked up the sale.

In this case, I had worked with the editor before and could make a fairly informal proposal by phone. With an editor who didn't know me, I would have gone into much more detail. I would have discussed the benefits of showing a unique view of the Southwest and carefully explained why I thought readers would find these images intriguing. I would also have included a sampling of the pictures I planned to use to illustrate my theme.

Show the editor how your images and article will benefit the magazine and its readers. Later in this chapter, we'll discuss how to find out which types of articles magazine editors want (see pages 75-76) and how to tailor your piece to their needs. The point I want to make here is that you must focus on the editor's needs; having pretty pictures and a great idea is not enough.

Once you've interested an editor in your proposal, you have to put together the actual photo/article package. Editors generally require captions for every photo submitted. Don't be surprised, however, if your carefully written captions don't appear with the final article. Editors may rewrite your captions or

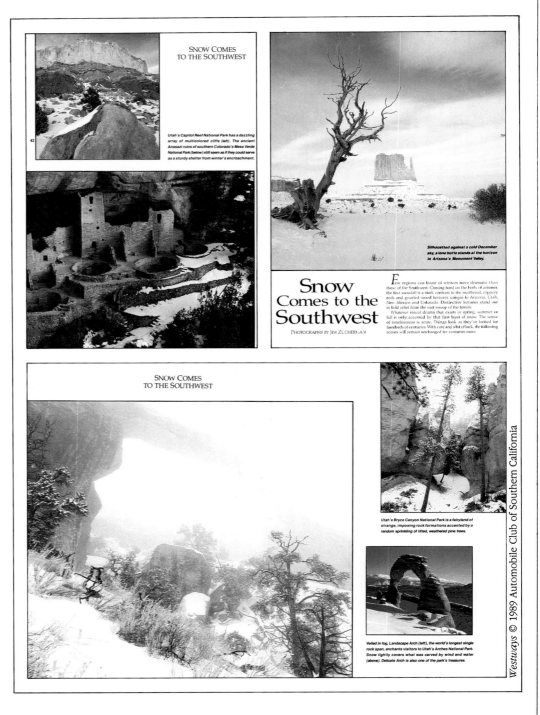

choose another slant and use your information to create completely different captions. I wrote captions as requested for "Snow Comes to the Southwest," but the editorial staff disregarded mine and used their own. You can see the actual article reproduced

for you here.

The information you include in these captions will vary according the type of publication that's buying the article. A caption for an article in a photography magazine must contain technical information about each image. For

example, the caption for a waterfall might be "Wailua Falls on Kauai was photographed with a Mamiya RZ 67, 250mm lens, f/22 at 1/2-second, polarizing filter and a tripod. It was shot on Fujichrome 50 Velvia film."

Readers of other types of

publications don't want to know how you got that picture. They want details about the place or the subject. For a travel magazine, the same shot of a waterfall might be captioned, "Wailua Falls on the island of Kauai is accessible from the main road. The double column of water forms a perpetual rainbow at the bottom, and many different kinds of birds play in the mist. A steep trail from the parking area allows you to descend behind the falls."

Note how different these two captions are. If you sold this shot to a water management publication or to a religious magazine, the information provided would again be different. If you're not certain what an editor wants in a caption, ask. He or she will usually be quite specific.

I always put caption information at the end of an article. If I'm selling the photo essay without a manuscript, I simply submit the caption list by itself. In either case, it's important to match each caption by number with the corresponding slide or transparency. That way, there's no question which caption belongs to which image. (Making sure your name is on each transparency also helps ensure that you get all your images back.)

When you submit a manuscript, the content will obviously vary according to the magazine you're targeting. But all manuscripts share certain characteristics. All have an introduction, a main body of information, and a conclusion. Both the introduction

and conclusion are no more than one or two paragraphs (or sentences, for a very short article), and the editor will set the length of the body of the manuscript. Typically this is no more than six to eight double-spaced pages. (*Never* send a single-spaced manuscript; they're too hard to read or work on comfortably.)

A how-to article must contain step-by-step information on doing something. Assume the audience is unfamiliar with your subject, so start from the beginning and take them through the procedure.

Since you're familiar with the subject, it's easy to assume the reader knows something that you consider absolutely basic, but that may not be the case. To prevent this, have someone who doesn't know the subject as well as you do read your manuscript before you submit it. His or her feedback will tell you if you have communicated clearly and covered all your bases.

General-interest manuscripts should contain interesting and informative facts about your subject. The facts could be historical anecdotes,

geological or geographical data, biological information, or your personal experiences with the subject or place featured in the pictures. For example, an article on a backpacking trip to Havasu Falls in the Grand Canyon would include information on how to prepare for the trip, the hike's degree of difficulty, some background on the Havasupai Indians, a discussion of the area's wildlife, and perhaps one or two paragraphs on the ancient fossils there.

You don't have to tell everything you know. Select details

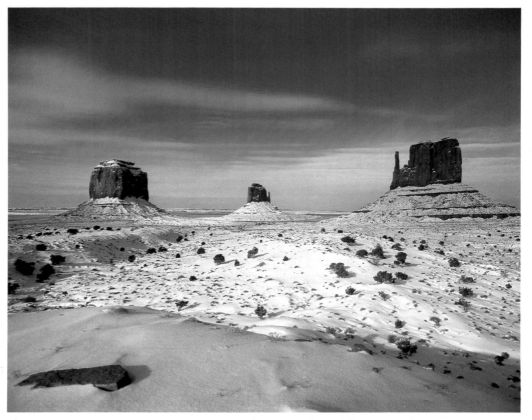

If you capture a common scene in an unusual condition, your shot will be more marketable. This familiar view of Monument Valley from the parking lot is shot most often without any snow. I decided that I would try to capture the scene when it was snow covered. Twice a week, I called the weather service in northeast Arizona, hoping for snow. Finally, after a month and a half, I learned a storm was moving in. I drove for a day and a half to get there and then waited for the fierce weather to subside. On this morning, just after the end of a three-day blizzard, I had outstanding photographic opportunities and, hence, great sales potential.
Technical Data: *Mamiya RZ 67, 50mm lens, 1/15, f/22, Ektachrome 64, tripod.*

and information that the *reader* wants to know. For a travel magazine, focus on how to get there, where to stay, and what to see and do. For an environmental publication, focus on the history, the geology and the Indians.

One of the most important parts of an article is your personal experiences. The twelve-mile trail I hiked to Havasu Falls runs through a narrow canyon bordered by two, hundred-foot-tall, vertical sandstone cliffs. As I stopped for a moment to enjoy the view, a raven took off from his perch and flew through the canyon. This isolated place was so quiet that I could hear the echoing of its wings against the canyon walls as it swooshed through the air. The experience was absolutely magical!

Including these personal moments brings your manuscripts alive. Personal experiences give your work a unique flavor. No one else will describe a place, a beautiful flower or butterfly, or an interesting animal the same way you do. Travel magazines, especially, want these special insights that convey mood and atmosphere. A travel magazine not only brings back the flavor of places, but also interests readers in going there. Personal experiences promote both responses.

METHOD TWO. If you don't have the transparencies in your files you need to illustrate a particular article, and you want to produce that piece, you'll have to go shoot it. If

you can get a magazine to commit in advance (at least tentatively) to publishing the article, you have a somewhat better chance of having part of your expenses covered. I say a *somewhat* better chance because, on two occasions, I had magazine editors who had committed to packages change their minds when I turned them in. They liked the manuscript and the photos, but the magazine's editorial direction had changed. Of course, nobody thought to warn me. So be careful when investing your time and money in a special shoot. Unless you have a written contract from a magazine that states it will publish that piece, any change at the magazine can keep your article and photos from being published—and editors don't have to notify you of such changes. It's not fair, but that's just how it is.

If you have an idea but no specific buyer lined up and you still want to shoot photos for the article, try to amortize the expenses over several sales. Photograph a story from different points of view and get as much visual material as possible to appeal to many buyers.

For example, let's say you're going to Round Island off the coast of Alaska to photograph walruses. A wildlife magazine would be interested only in the animals, but a travel magazine would want a more comprehensive approach, showing your boat trip to the island, your campsite, and pictures of you tak-

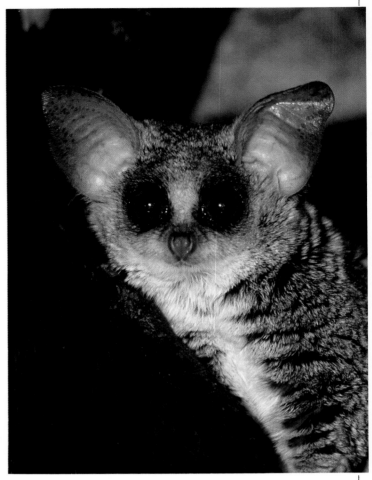

You can take almost any aspect of nature and build a visual theme around it, and then sell the idea to one or more magazines. I photographed this bushbaby and then realized I could pitch a story with the theme of "eyes" to magazine editors. I then sought out other animals with unusual eyes and sold the idea based on my close-up shots.

Technical Data: *Mamiya RZ 67, 360mm lens, flash, f/11, Fujichrome 50D, hand-held.*

ing shots of the animals, if someone else will take those for you. Therefore, capture the entire experience on film if you want to maximize your chances of making a sale.

How do you come up with an idea if you don't have any pictures for it? I've often been inspired by photos I've seen published, and I've made a mental note to visit many of the places where they were taken. I first saw an article about the monarch butterfly migration in *National Geographic* in 1976, and I knew I

had to see it myself. I finally got there in 1983, and it was an incredible experience. Since then, my photo/article package based on that trip has been published in two magazines. I've also sold some of those photos as part of a general article on butterflies.

Remember that travel is expensive, and the money earned through editorial sales is frequently low. Depending on your aggressiveness in marketing your work, it may take two or three years to earn back your investment in a trip.

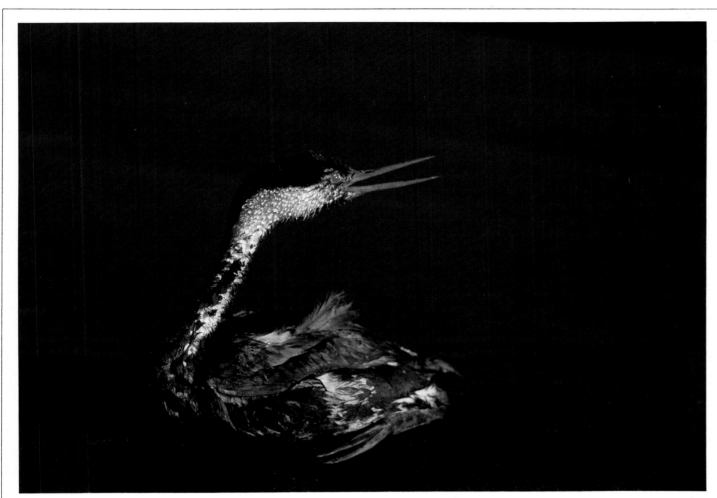

If you go places and photograph subjects that few other photographers have captured, you will more likely have ready markets for your work. If you shoot common subjects, such as sunset at the Grand Canyon, you'll be competing with almost every other nature photographer.

METHOD THREE. Pair up with a writer to create articles. You do what you do best — take pictures, while the writer does what writers do best — create narrative. Many photographers haven't developed strong writing skills and feel they can't do articles. Writers, on the other hand, aren't photographers — which can make it difficult for them to get work published because a photo editor has to pull the illustrations from some other source. The rising cost of commissioning photographs or buying them from stock photo agencies can eliminate interesting pieces from consideration.

A writer-photographer partnership also allows you to pool contacts and resources. Each of you has the chance to break into markets the other has already tapped, as well as explore markets previously closed to each of you alone. An additional benefit for the photographer is having editors see your collaborative skills, which may prompt them to put you in touch with other writers. (And if they like your work, you might pick up some straight commissioned

Ecological disasters affect us all, but they can be especially devastating to wildlife. I was photographing in Olympic National Park, Washington, when I heard on the radio about a large oil spill on the coast. I immediately changed my plans and drove to Ocean Shores, the area hardest hit by the tragedy. Local citizens had organized a rescue effort, so I pitched in. This western grebe was taken to a high school, where volunteers had formed an assembly line to wash off the debilitating sludge.

Between pulling oil-soaked birds from the surf and washing them off, I documented the story for a future article. Although my primary concern was for the wildlife, I knew I had the makings of a compelling photo article on the impact of an oil spill on wildlife.

Technical Data: *Mamiya RZ 67, 110mm lens, 1/125, f/8, Fujichrome 50D, hand-held.*

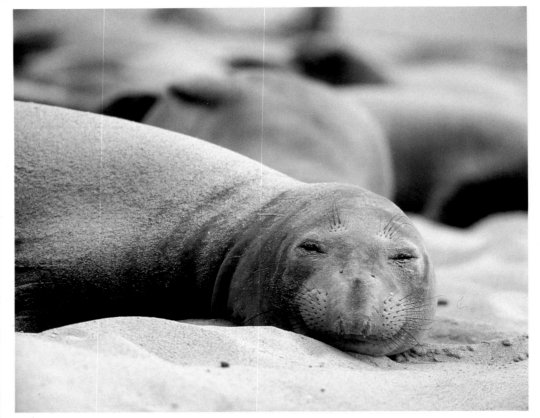

Pictures that support articles must tell a visual story. This often means shooting a subject from many angles or perspectives at different times of the day, or with different lenses. For an article on elephant seals in the Channel Islands off the coast of southern California, I included an aerial shot of the beach on which the seals haul out every winter, as well as an intimate portrait of a snoozing female. Photo editors appreciate the establishing shots as well as close-up details.

Technical Data: *Aerial shot— Mamiya RZ 67, 180mm lens, 1/250, f/8, Ektachrome 64, hand-held. Snoozing female—Mamiya RZ 67, 180mm lens, 1/125, f/5.6, Ektachrome 64, tripod.*

shoots, too.)

I broke into *Westways*, for which I'm now a regular contributor, through just such a writer-photographer partnership. I had put a notice on several college and university English department bulletin boards that read, "Wildlife/nature photographer looking for writer to collaborate on magazine articles," and included my phone number. Even though I am a writer myself, I hoped to expand my markets and the number of articles I could produce.

One of the callers was a young English major who sounded very interested, so I arranged to give her a slide show of my work. I wanted her to think about themes in my work that could be developed into articles. A week later she called to tell me that *Westways* had assigned her to write an article on Havasu Canyon in Arizona. Would I be interested in taking the shots? I, of course, jumped at the chance to shoot this magnificent place.

I spent the next three-day weekend at the canyon, but it was cold and rainy. I didn't get the shots I'd wanted of people swimming beneath the falls; however, the scenic photos turned out excellent because the soft, cool light created by those weather conditions complemented the rich tones of the high desert. The round-trip drive from Los Angeles was about fourteen hours, and I had a twelve-mile hike to and from the canyon. For all that time and trouble, I sold only one picture, run full

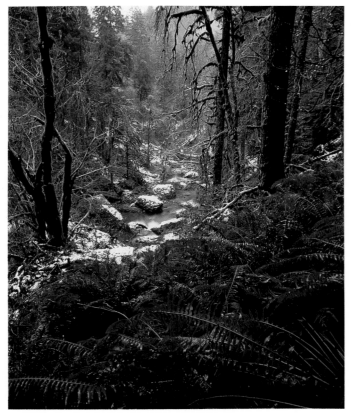

Always think of dramatic ways to make points in photo/articles. For a story on northern rain forests, I wanted to strongly contrast the cold climate of the American Northwest with the hot, steamy atmosphere of the tropical forests. By including snow in the composition (on the rocks and along the river) with the dense undergrowth of ferns, I illustrated the difference between the two rain forests.

Technical Data: Mamiya RZ 67, 50mm lens, 1/2 second, f/22, Fujichrome 50D, tripod.

page, for a grand total of fifty dollars—which didn't even cover my film, processing, and gasoline. This hadn't worked out quite the way I had planned

The story ends happily, however. Now that I had my foot in the door, I showed the editor and photo editor more of my work. As a result, I have sold them four magazine covers at four hundred dollars each (including one shot from my trip to Havasu Canyon that they hadn't used in the original article) and the cover for their 1988 corporate Christmas card. I've also sold them six photo essays, worth about

four hundred dollars each, so my earnings from this magazine to date total roughly forty-five hundred dollars. All of this came about because I teamed up with a bright, young English student.

MARKETING YOUR PHOTO/ARTICLE

The key to selling into this market is learning which magazines are out there and what their editors need. It takes a little time and effort to do your homework before sending a submission, but the payoffs can be enormous. You'll soon get back that investment in increased sales and credi-

bility with editors. They will remember that you made their jobs easier by thinking about and trying to meet their needs—not just trying to sell them what you happen to have on hand.

I use four sources of information to locate markets. The first is the latest edition of *Photographer's Market* (published annually by Writer's Digest Books). This lists hundreds of publications and provides invaluable insight into what types of pictures each company wants. When I don't have time to preview the magazine itself, the brief description in *Photographer's Market* helps me make intelligent decisions about which pictures and articles to send to the various editors.

Second, large newsstands, supermarkets, drugstores and bookstores have hundreds of magazines, some of which are published abroad. When I find a possible market for my work, I buy a copy and write to the editor for the submission guidelines.

Third, college and municipal libraries have excellent collections of periodicals, including magazines, scholarly journals and trade publications. In larger libraries, these cover practically every conceivable area of interest and provide a vast range of potential markets. Record the name of the editor and the address of the editorial office for the ones that interest you so you can send for the submission guidelines.

Finally, I use *The Standard Rate and Data Service*

(SRDS) in the library for listings of thousands more publications. It's a great resource for trade and special-interest publications; for example, I never knew so many magazines were devoted to dairy farming. *SRDS* doesn't provide details for submitting photographs or articles, but it does list each magazine's address, a brief reader profile, and types of features. If the magazine sounds as if it might be worth investigating, write and ask if they review the work of freelance photographers, and get submissions guidelines and a "want list."

How do you know which kinds of articles are needed? First become familiar with the magazine:

• Does it feature a single geo-

DO YOU NEED A PORTFOLIO?
Unlike most areas of photography, a portfolio is not essential in editorial photography. Only those few magazines that send photographers on assignments will request a portfolio, although a portfolio of published work is impressive because it shows you're successful. Publications that don't have budgets for assignment photography, however—and that's most of them—have no need to see your portfolio. What they want is to review a specific proposal, whether it's for cover shots or photo/article packages. You're judged each time on one particular package, not your overall performance.

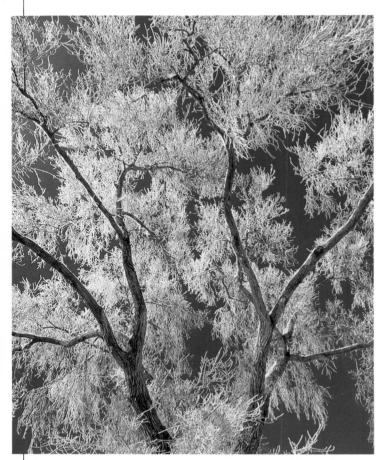

Once I get my foot in the door, I try to take advantage of the new leverage. After selling Westways *magazine a shot for its December 1988 Christmas cover and corporate Christmas card, I produced a number of other wintry images that I'm hoping will work for subsequent years. I shot these bare branches covered in hoarfrost near Lone Pine, California, against a deep blue sky before the rising air temperature melted the lacy designs.*

Technical Data: *Mamiya RZ 67, 50mm lens, 1/125, f/5.6, polarizing filter, Fujichrome 50D, tripod.*

graphical locale in an article, or does it cover more general topics or areas?
- Will a single species of animal be discussed?
- Are environmental issues addressed?
- Will it consider a piece on personal adventure?
- Does it use nature or wildlife images in a context that has nothing to do with the outdoors, such as religion or personal growth?

Once you feel you know which kind of material the magazines you've targeted look for, write query letters proposing one or more ideas. I usually include several transparencies with my cover letter, because good pictures help sell the story. If the editor doesn't like the article proposal but likes my photography, he or she may invite me to propose other ideas in the future.

Sometimes I will submit a photo/article package unsolicited. Many magazine editors prefer a query first, but I feel it's difficult to really communicate in a letter the impact of dynamic photographs. Therefore, I take the chance and send a sheet of twenty 35mm slides or a small selection of 6 × 7 transparencies with an outline of the article if not the completed piece. The worst that can happen is that I will have spent four or five dollars on postage for nothing. At least another publication will be aware of my work, and if they don't want the submission, they may invite me to send other packages in the future. Many times, however, I've sold unsolicited packages because my perception of what the editor would like — based on my study of the publication — was right.

Because editorial markets pay less than other areas in photography, it's necessary to get as many sales as possible from each photo/article package you put together. I frequently submit simultaneously two or more identical packages to noncompeting magazines — for example, *California Living* and *Outdoor Photographer*. Just make sure you sell one-time rights only to your photos and articles.

I sold an article entitled "Whiteout," a how-to article for photographers on shooting in fog and snow, to two different photography magazines, one in the United States and one in Australia. (I found the Australian photo magazine on a university magazine rack.) Nobody objected because they are noncompeting publications.

ON TOP OF THE HEAP

These are some suggestions that will help get your submission at the top of the pile:

1. Send for the "photo submission guidelines," which are usually free with a self-addressed, stamped envelope. These will tell you how, where and when to send your pictures. This is important, because a magazine's policy may be to review cover material for the upcoming twelve-

PROMOTE THYSELF

Self-promotion is the most important factor in succeeding in editorial photography. It consists of three basic components:

1. A thick skin. Don't be crushed by the return of your work with a polite form letter. Send it out somewhere else in the next day's mail.

2. Persistence. Keep submitting ideas to the same editors until you come up with a winner. (According to Bill Hurter, editor of *Petersen's Photographic Magazine*, I became a contributing editor by wearing him down with article ideas.)

3. Tooting your own horn. If you don't promote your talents, who will? I'm basically shy. I feel very uncomfortable selling myself, even with all my credits. Show off what you do well, even if you squirm a little as you do it. Soon you can squirm all the way to the bank.

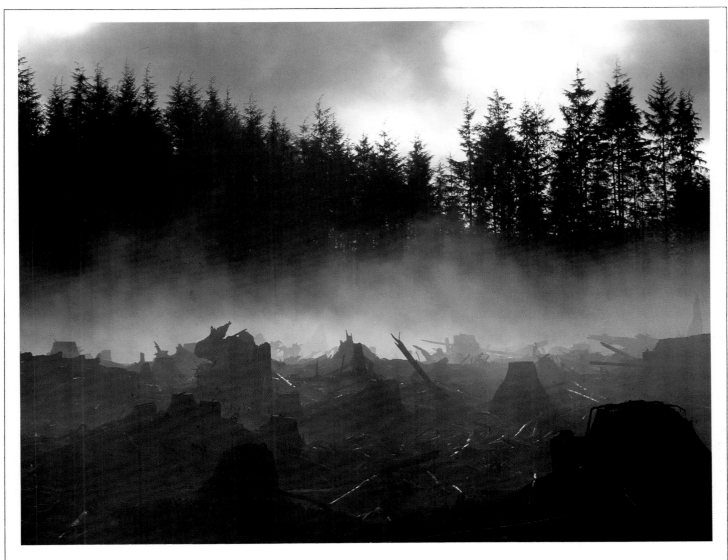

month period every September. If you send cover ideas in November, you'll get a rejection simply because you didn't know their in-house schedule. You've got the best chance for making a sale if you respect each company's procedure.

2. Submit only images that have a direct bearing on the subject matter covered in the magazine. Familiarize yourself with each publication you solicit. Don't send pictures of Idaho to *Arizona Highways*, for instance, unless you previously queried them about it. Offer pictures or story ideas that parallel their general trend.

3. Send slides to any publisher that prints in color. For black-and-white magazines or newspapers, send prints. Color prints are acceptable, but black and white are usually preferred.

4. Each slide or print you submit must be razor sharp, especially 35mm ones. Since a 35mm slide has to be greatly enlarged to fill a magazine cover, it must be extremely crisp not to suffer in reproduction.

Publications that feature environmental issues regularly use photos that depict human destruction of the planet's natural resources. The aftermath of a logging company's harvest is especially poignant in this shot, with the smoke rising from the charred tree stumps.

Technical Data: *Mamiya RZ 67, 180mm lens, 1/30, f/11, Fujichrome 50D, tripod.*

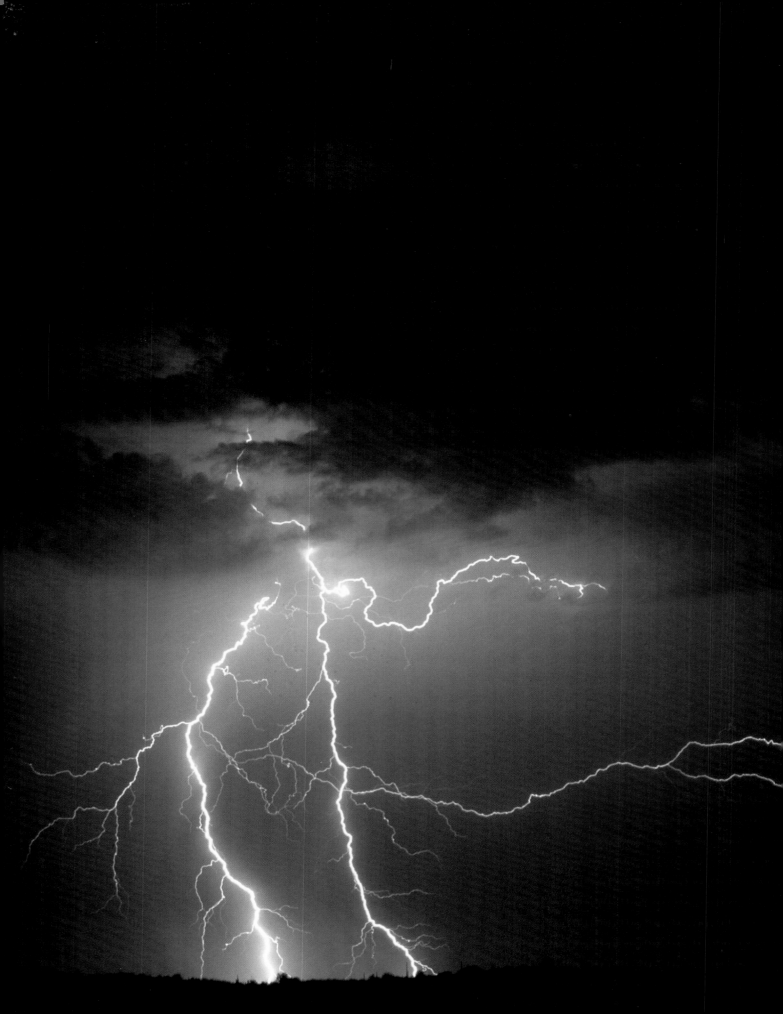

ADVERTISING PHOTOGRAPHY

Everyone reading this book would rather take pictures than sell them. I certainly include myself in this group. Selling isn't my idea of fun, but trudging through knee-deep snow in Yosemite is!

Because I prefer taking photos to selling them, a constant debate takes place in my mind: Do I go out and spend weeks in the wilds taking great shots of nature and wildlife, hoping to sell them later, or do I solicit assignments now and know I'll get paid when I submit the images? To make sure I eat, I must do the latter. But to feed my soul, I must do the former. So, in the end, I've done both.

Advertising agencies use both assignments and stock

Few natural phenomena are as powerful or awesome as lightning. Great shots of lightning are a valuable asset to your portfolio, because these images communicate the concept of "power" like nothing else. The shape of the lightning tentacles are of the utmost importance. We obviously have no control over this, so this means you will have to shoot many frames to get that one spectacular burst. I spent practically the entire month of August one year driving all over Arizona to get three images that were salable.

Technical Data: *Mamiya RZ 67, 180mm lens, time exposure (the shutter was locked open at night until the lightning discharge occurred), f/4.5, no filter, Ektachrome 64, tripod.*

photography to get the pictures they need. A large stock of nature images will, over the years, earn you a lot of money if placed in the right hands. Likewise, assignment work pays very well and, at the same time, increases your stock.

WHAT IS ADVERTISING PHOTOGRAPHY?

Advertising is a huge field and can include diverse promotions such as record albums, capability brochures, printed advertisements in newspapers and magazines, direct mail pieces, billboards and product packages. Photographs used in advertising can bring the highest dollar return per image. Whether you sell from your stock library of images or shoot an assignment, the advertising dollars spent per image are large compared to other types of photo markets. A nature photograph used as a national billboard, for example, will net you much more money than if that same shot were sold as a framed decorative print.

We are inundated with advertising. It's impossible to escape it. Everywhere you look, photographs are vying for our attention, silently saying, "Look over here and remember this picture the next time you spend money!"

Advertisers use wildlife and nature to sell their clients' goods because people relate to the subject matter. We consumers like to look at pictures that stimulate our fantasies. An advertiser succeeds when we enjoy these images, because that creates a comparison between what we already like and the product or service being promoted. Positive association means increased sales.

When companies want to present a product or service to the public, they are primarily interested in conveying a *concept*. This is an idea, or ideal, expressed by a picture—something photographs do well. Wildlife and nature photographs present a surprisingly diverse set of concepts for advertising. Recall the many instances when you've seen a photograph of wildlife or nature used to sell something. A promotion for

When you think of koalas, which country comes to mind? Australia, of course. This a perfect example of one animal being used to promote an entire country. Millions of people have come to love this cuddly little creature—and they spend thousand of dollars to fly halfway around the world to see where it lives.

Technical Data: *Mamiya RZ 67, 180mm lens, flash, f/11, Ektachrome 64, hand-held.*

Kool cigarettes used a waterfall surrounded by green foliage. Marlboro used white horses running through water. Travel ads also use these images: orchids for Thai International Airways' Royal Orchid Holidays, and white sandy beaches with turquoise water for Caribbean tourism. Chevron used the El Segundo blue butterfly as a symbol for its slogan, "Chevron takes care of the environment."

HOW TO FIND PHOTO BUYERS

To make a living—or even part-time income—from your photos, you must present them for sale to the marketplace. The one piece of information that has been the most valuable to me in becoming a salesman is that photo buyers need pictures—mine or somebody else's. Part of an art director's job is to find good photographers, both for assignment work and stock. In other words, he or she needs to find people like me—and you. They must have several people to rely on to provide professional images on demand—and often under tight deadlines.

As a photographer, it's my responsibility to make sure the AD's (art directors) know I exist. Before I show you how to do that, let's look at the development of an advertising campaign and see how we fit into the whole process.

EVOLUTION OF AN ADVERTISING CAMPAIGN

A product manufacturer or distributor consults with an

When a company wants consumers to identify stability, duration, longevity and reliability with it, it will often use a dynamic landscape showing a powerful granite formation. Delicate Arch in Arches National Park is such an impressive shape that it lends itself perfectly to this concept. Notice that this wasn't taken at midday, when the sun is overhead and the shadows are harsh. Instead, it was shot about twenty minutes before sunset, to take advantage of the warm hues and gentle lighting. This makes the image beautiful as well as powerful.

Technical Data: Mamiya RZ 67, 110mm lens, 1/30, f/16, Fujichrome 50D, tripod.

Humor is effective in advertising. When a commercial makes people laugh, they talk about it: "Hey, have you seen the ad where . . . ?" Animals in humorous situations or positions can be used effectively when an advertiser carefully chooses copy. These elephant seal pups were photographed in the Channel Islands National Park near Ventura, California. Their juxtaposition makes the shot, of course, but equally important is the eye-level contact. I was on my belly for this one, capturing the world from their point of view. Shooting this from a standing position, looking down on them, would have been ineffective.

Technical Data: Mamiya RZ 67, 250mm lens, 1/125, f/8, Ektachrome 64, hand-held.

advertising agency to discuss a campaign. The agency needs to know everything about the product to formulate an effective method of presenting it: why people should use it, how it's different from the competition, what the public's attitude toward it is, how that attitude can be changed to increase sales, and so on. Creative personnel and art directors come up with the ideas, which are shown to the client. If the idea calls for a series of magazine ads or billboards, a "comp" is sketched to show what each one is going to look like.

A photographic image must be created to match, as closely as possible, what the art director has drawn. Say, for example, a horse feed producer has introduced a formula for healthier livestock. Rather than showing horses eating, they want to convey health and vitality by portraying a horse and rider in the splendor of Grand Tetons National Park. The sketch that the client approved shows the massive, snow-capped Tetons in early morning sunlight dwarfing two cowboys in the lower left corner. Enough room must be left at the top and the far right of the horizontal image for advertising copy.

This rough drawing will be given to a photographer to reproduce on film. How you achieve this is your problem. You hire the models, the horses and the horse trailers; you rent the remote two-way radios (your cowboys will have to be equipped with some method of listening to

You never know how an image will be used by a creative art director. This album cover made use of one of my fall foliage shots taken in Vermont. However, the original shot was a hillside of colorful trees reflected in a pond. The photo was divided horizontally so the top half appeared on the front of the album, while the reflection was used on the back. The image also was used on the compact disc and cassette tape of the same recording. The torn paper was added to my shot by the art director. I was very pleased by final product.

Technical Data: *Mamiya RZ 67, 250mm lens, 1/125, f/5.6, Ektachrome 64, tripod.*

(Reproduced with permission by Sandstone Music, a division of Dunhill Compact Classics, Inc.)

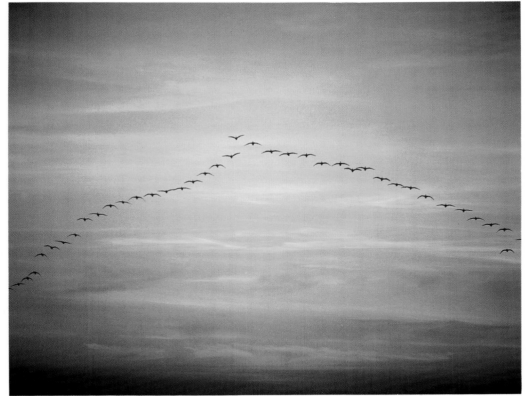

A concept that many corporations and political parties use is leadership. It is also used in management training programs. Frequently, migrating geese are pictured to illustrate this. Only one bird leads the flock, and the graphic formation of the flight pattern is a perfect symbolic representation. These are Canadian geese over Tule Lake, California.

Technical Data: *Mamiya RZ 67, 360mm lens, 1/250, f/4, Ektachrome 100, tripod.*

your direction—chances are that you'll be too far away to yell), and rent the clothing if necessary. The client may provide some of these things, but frequently they're the photographer's responsibility.

Making the Contact

Large corporations usually hire advertising agencies, so if you contact the corporation itself to show your portfolio or to suggest innovative advertising concepts, you will only be referred to its agency.

Illustrating Concepts

Look through your stock library with advertising concepts in mind, and you'll begin to see what I'm talking about. Here are some examples:

Concept: Photo

Speed: Running cheetah, galloping horse

Power: Lightning, tornado, huge ocean wave

Grace: Butterfly, swan, bird in flight

Family: Mother and baby of practically any species

Leadership: V formation of flying geese, cliff

Strength: Lion, tiger, bull

Tranquility: Beautiful landscape, waterfall

Reliability: Large rock formation

Delicate: Dragonfly wings, butterfly wings

Destruction: Forest fire, volcanic eruption

Competition: Fighting elk or sparring horses

Paradise: Tropical beach or silhouette of coconut palms

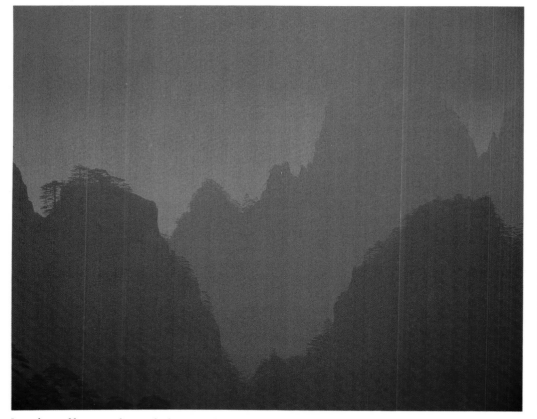

I rarely use filters to enhance the beauty of landscapes, but this elegant shot of the Huangshan Mountains in China was photographed under very soft natural light, and the original color was a cold blue/gray. I wanted to infuse the image with warmth and make it an outstanding background shot for an ad. The color was added in the duping process, when I dialed in ninety units of magenta and ninety units of yellow. The copy was made on Ektachrome duplicating film. This image certainly has an Oriental feeling to it, so perhaps it could be used to advertise Asian rugs or fine teak furniture. Or maybe an importer of Southeast Asian orchids could use it as a background to flower close-ups. When you create a new series of images, the ball is in your court. You choose prospective buyers—those to whom you present your portfolio—based largely on who you envision will like your work. Match some of your nature photographs with promotional campaigns you see. Then, create some advertising strategies based solely on your own pictures. This may help you in providing a direction to market your best work.

Technical Data: *Mamiya RZ 67, 500mm lens, 1/125, f/8, Ektachrome 64, tripod.*

Smaller firms frequently have an in-house advertising department, which writes copy, does paste-up, and contracts for advertising space. Photos usually are purchased from freelance photographers, either on an assignment basis or as stock. Even those companies with staff photographers use stock images because, more than likely, the in-house photographer shoots table-top products, and he or she won't necessarily have the dynamic shot of Monument Valley that is needed for the background of an ad.

How do you know which companies hire advertising agencies and which are small enough that their in-house ad departments will hire you directly? You don't. The only way to find out is by using the telephone. Probably the best source of information are the secretaries and receptionists who answer the phone for each company. Don't be afraid of sounding ignorant or misinformed. Simply ask the receptionist if the firm has an in-house advertising department and, if not, which agency represents them. She or he will know if they formulate advertising campaigns from within the company, but may not know the name of a hired agency. In this case, ask to speak with someone who would know. There is no reason for them not to tell you.

If the company you call handles promotions from within, ask the receptionist the name

of the person who reviews photographer's portfolios. This usually is the art director. Ask to speak to that person to set up an appointment. Each advertising agency, and in-house advertising department, will have its own policy for reviewing new work. Some will gladly make an appointment with you right away. Others will want you to drop off your portfolio overnight while they take a look at it. Still others have set aside one or two days per week to see new photographers, and your schedule must accommodate theirs. In other instances, the agency may not review new work for the next three months or longer.

I recently made an appointment with an advertising agency in Los Angeles to show a sample of my stock photography. My timing happened to be right—they had just received a contract to put together a trade show display for a toilet manufacturer. One of the images they needed was a desert shot at sunset showing Saguaro cacti in silhouette. (Don't ask me to explain the relationship between cacti and toilets. This just goes to show that you never know how your pictures might be used.) I happened to have that image, and they bought one-time rights for a large print. I agreed to their price of three hundred dollars. They asked if I did assignment work, and of course I said yes. The next day they phoned me for a two-day assignment, for which I charged eight hundred dollars per day.

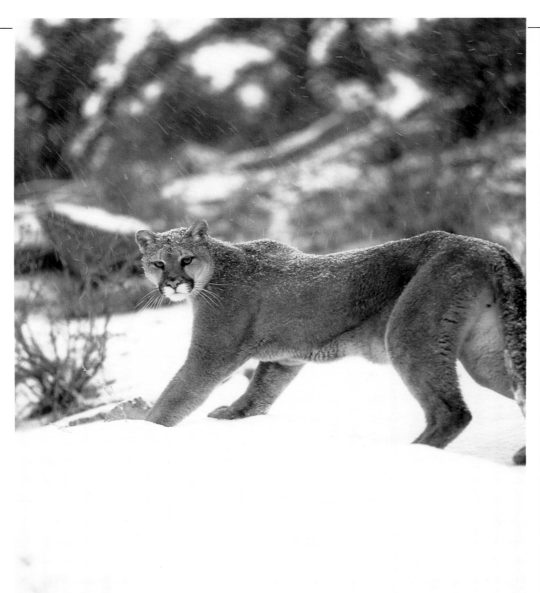

This particular agency was very open to photographers whom they hadn't worked with before. Others I've contacted took months of appointments and calls before I got any response. But if you never take the first step and call, you'll never get anywhere.

REFERENCE BOOKS YOU CAN'T LIVE WITHOUT

Two invaluable sources of information that will help you contact ad agencies and art directors are *Photographer's Market*, published annually by Writer's Digest Books, and *The Encyclopedia of Associations*, a reference book available at most libraries. *Photographer's Market* lists many advertising agencies by state and describes the kind of pictures they use, whom to contact, and the firm's address and phone number. Most important, you are given the types of clients each agency services. Use these data to formulate an aggressive self-promotion that will put your work in front of the people who buy

One of my all-time favorite images is this shot of a mountain lion in a Rocky Mountain blizzard. It conveys strength, power and agility, and could easily be used to communicate those traits in an ad.

Technical Data: *Mamiya RZ 67, 180mm lens, 1/15, f/2.8, Fujichrome 50D, hand-held.*

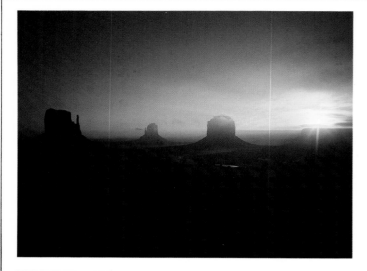

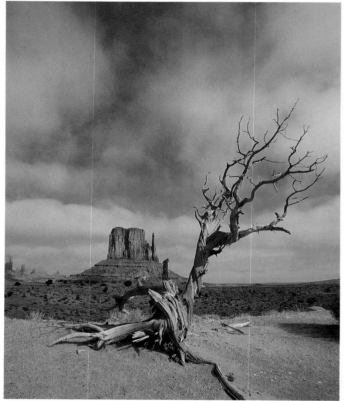

Many times a beautiful landscape or wildlife photograph can be used as editorial material or fine art, but it doesn't work as well in advertising. The sunrise in Monument Valley is a perfectly fine image, but it is too subtle for most advertising purposes. Although there is plenty of room for ad copy, there is little detail in the land and, to many people unfamiliar with these three buttes, the nonverbal message may be unclear. When the bold graphics of the butte is combined with a foreground tree, a stronger image results. While still providing room for advertising copy, this shot would more likely be used to promote a product. Note also how the vertical composition is more dynamic than the horizontal.

 Technical Data: *Sunrise—Mamiya RZ 67, 50mm lens, 1/15, f/16, Ektachrome 64, tripod. Tree and butte—Mamiya RB 67, 50mm lens, 1/60, f/16, polarizing filter, Ektachrome 64, tripod.*

photography.

 The Encyclopedia of Associations names several special-interest associations of which art directors and advertising agencies are members. If you can obtain an active membership list, you'll have a valuable marketing tool. You may have to become a member yourself to gain access to this information.

SELF-PROMOTION

There are several primary forms of self-promotion: paid advertising, direct mail self-promotions, and showing or sending your portfolio to potential clients. Tailor the method(s) you use to the clients you want to get; you'll probably use a combination of all three. Your other consideration in planning self-promotion is the expense. Never spend more than you can afford out of current income. Good, well-planned self-promotion will pay off over the long haul, but you may have to wait some time to see definite results.

PAID ADVERTISING

Several ultra-slick books are published every year that art directors and other photo buyers use to locate professional photographers for assignment work or stock. Volumes such as *The Creative Black Book*, *American Showcase*, and *The Stock Workbook* are filled with the best and most salable images from some of the top photographers in the country. Each photographer pays for this ad-

vertising space—about four thousand dollars and up per color page. This is a serious investment, but the rewards can be substantial. Just one good assignment from an ad agency can turn your investment into a profit.

 Thousands of photo buyers see these books, so your exposure is excellent. Many photographers who advertise in these books have large studios and do primarily product, fashion, architecture, commercial portraiture and food photography. However, a number of pages are purchased by wildlife and nature photographers who appear year after year—because the ads sell their work.

DIRECT MAIL

Everybody who has an address receives direct mail literature. Catalogs, appeals for contributions, political letters and the like are constantly sent to consumer groups because statistics reveal that the method works.

 Direct mail marketing has proved successful for many photographers. If you decide to go this route, produce a beautifully designed promo piece featuring your photography. Get a mailing list of AD's, and send the piece every two or three months to every person on your list. It will keep your name and specialty in front of them.

 Part of the psychology of direct mail solicitation is to use the same mailing list several times (if it was effective the first time). Some people need

two or three reminders before they call you. On the third mailing to the same one thousand AD's, you may get a call from someone who normally uses another photographer, but whose first choice can't meet a current deadline. So the AD is willing to give you a try. For a location shoot, this one assignment can be worth ten thousand dollars in your pocket.

When magazine, newspaper and newsletter publishers rent a list of prospective subscribers, they expect a relatively low return of new business—and you should, too. One and a half to two percent is considered good. Three percent is excellent. This may seem like a big waste of time, but it's not. Suppose you rented a list of one thousand AD's and got an assignment from only 2 percent. Two percent of one thousand is twenty. If you made only one thousand dollars from each agency (which is very low), you would have earned twenty thousand dollars, less the cost of the mailing. This income wouldn't happen all at once, because the assignments or stock sales could take place over the course of a year or more. But you would build a basis for a business that should last as long as you continued to provide good work and dependable service to your clients.

The least expensive way of producing a mailer is to have it made in postcard form. Some photographers use only one outstanding image along with their name, address and

Color is crucial in ads. Lush vegetation must be a rich green, not a washed-out, weak tone. Sunsets should have deep shades of yellow, orange and red. Ice must have beautiful shades of blue. Blue implies coldness. If an advertiser wants to convey this concept, color is going to be crucial to the sale. I shot this frozen fountain in Jackson Hole, Wyoming, with the sun behind it in the early morning.

Technical Data: *Mamiya RZ 67, 127mm lens, 1/250, f/8, Fujichrome 50D, tripod.*

Love can come in many forms and, no matter who's loving whom, people want to identify with it. Advertisers know that love attracts both the eye and the heart. (Of course, cuddly animals such as Bengal tigers are easier to get close to emotionally than, say, two affectionate grasshoppers.) I stood in front of the tiger exhibit at the Los Angeles Zoo on two occasions for a total of nine hours to get this photograph. The relationship between these two magnificent felines was beautiful to watch. I knew their actions would make a classic picture of intimacy. I felt that people would be attracted by the beautiful, affectionate gesture and by the contrast between big cats' perceived image and the affection shown. This image leaves a lot of room for copy. It might be difficult, however, to use it as a double-page spread because the crease of the magazine would cut right through the faces of the cats.

* **Technical Data:** *Mamiya RB 67, 500mm lens, 1/60, f/8, Ektachrome 64, tripod.*

phone number laid out in an attractive design. You might include a short message, indicating your specialty. Other photographers prefer to show several images, to give potential clients a feel for their work. Be careful not to make each of the pictures too small; otherwise, they will lose their impact. The overall size of the card can vary, but most promotional cards are around 5 × 7 inches and most, but not all, are in color.

The back of the card should have room for a postage stamp and an address. This enables you to mail at postcard rates and save on envelopes. Make sure you check

into bulk postage rates at the post office. If you mail enough pieces and arrange them by zip code, you can obtain additional savings.

Continue your direct mail campaign as often as you can afford it. Frequently, an AD will put your promotional piece on a bulletin board because it's attractive, and six months later you'll get a call. Change the photographic imagery on each mailing, but keep the themes similar so you will become identified with a certain type of work.

LIST BROKERS AND DIRECT MAIL. An invaluable but little-known (by photographers) source of

information on any specific target group—such as advertising agencies—is through a list broker. List brokers handle mailing lists of every conceivable group of people. To give you an idea of the diverse lists they represent, here is a sampling:

- Religious donors and book-buyers
- Reagan and Bush contributors
- Colonial yacht buyers
- New home owners
- Subscribers to *Popular Photography*
- Subscribers of the *Wall Street Journal*
- California dentists
- Newly licensed real estate salespeople
- Investors in South African gold

Since you want to obtain the names and addresses of all the AD's and ad agencies within a certain radius, you can request this information by zip code.

You can locate list brokers through the Yellow Pages under the heading ''Mailing Lists'' (see Appendix for names and address of list brokers). When you call one of the firms in your area (or perhaps a large broker in New York or Los Angeles), explain to the sales staff precisely what you want to do. Tell them who you want to target with your promotional campaign, and what kind of piece you will be mailing. They will help you rent a list that will benefit you. The cost is usually between four and fifteen cents per name, or forty to one hun-

To many people, paradise is a South Seas island—peace and tranquility without daily responsibilities. This image is particularly appealing to those who live a fast-paced life in large cities. This sunset over Cook's Bay in Moorea, Tahiti, is a very commercial image because it has striking color to grab the viewer's attention, lots of room for advertising copy, bold graphic shapes, and a message that says, ''Wouldn't you rather be here?'' Shots such as this can be used by myriad advertisers, from airlines to boat manufacturers, from companies that produce suntan lotion to those that make swimwear. It might be laid out as a half-page ad or a double-page spread. This kind of flexibility appeals to photo buyers. If an important element was in the center, this image couldn't be used easily for a double-page spread because that element would be lost in the gutter.

Technical Data: Mamiya RB 67, 50mm lens, 4 seconds, f/4.5, Ektachrome 64, cable release, no filter. The camera was placed on the railing of my bungalow balcony for steadiness.

dred fifty dollars per thousand names. Some lists have a five-thousand-name minimum, while others will rent smaller portions of their total list. In a city such as New York, you will find a huge concentration of AD's and advertising agencies. In a smaller community, there will be proportionately less names.

When you pay the rental fee for the list, you buy the right to mail a letter or promotional card to these people only once. If you use the list again, there is a second fee.

SHOWING YOUR PORTFOLIO

Since most photographers, including myself, hate to sell themselves, this can be the most difficult and tension-filled way to go. It is full of rejection potential. It is also an effective method of presenting yourself. *People enjoy doing business with people they like.* If you can establish a personal rapport with an AD, he or she will want to buy some of your photography.

An advertising agency, for several reasons, should be contacted in person. No matter how good your work is, the decision-making people at the agency will want to get the feeling that they can rely on you, that you are conscientious and responsible, that you can easily handle tight

These two shots of young great horned owls in their nest were taken only moments apart, yet only one of them would sell for advertising. With all six eyes looking at the camera, the photo on the bottom is more compelling. In the shot on the left, we don't have the attention of all our subjects. Advertisers spend enormous amounts of money to communicate a message to the buying public. The images they use are chosen with great deliberation. You can lose a significant sale because of a small detail—such as an owl not looking at the camera. Take lots of pictures to make sure you allow for the needs of your clients.

Technical Data: *For both—Mamiya RZ 67, 360mm lens, flash, f/16, Fujichrome 50D, tripod.*

deadlines, and that you can take direction from the AD. Some photographers insist that *their* way is the only way. This rigidity is all too common, and ad agencies like to avoid working with inflexible attitudes.

Another important reason to meet agency personnel face to face is that you want to sell yourself as a creative asset—not just as a skillful photographer, but someone with valuable ideas. Many times AD's have asked me for input on a project. They ask if I have any shots that might work with a certain product, as well as ideas for copy. Whenever I can help, I know the favor will be returned manifold.

Recently, an agency I contacted was putting together a visual presentation to be used in management training. One idea they wanted to convey was that their client's employ-ees should "look beyond the obvious" in their work. They weren't sure what kind of pictures to use. In talking to the art director, I suggested a series of macro shots I'd taken of flowers, bark, leaf patterns, spider webs and so on. Each image on its own wasn't recognizable— it was only an abstract of color and form—but when the entire subject was seen in its entirety, the message was clear: "Look beyond the pretty flower and you will see things you didn't see before."

The sale was made because I gladly offered constructive suggestions to help solve the AD's problem. He will now think of me as a valuable resource both in photography and ideas.

Solicit firms in your immediate area. You can find lists of ad agencies near you in the local Yellow Pages (check both Consumer and Business-to-Business editions). Look under the heading "Advertising Agencies." In any large city, you will find many listings. The agency's size or specialty isn't indicated, so you'll have to call and query the receptionist.

When you present yourself to an ad agency in a personal interview, your work should be flawless and you must look absolutely professional. Dress well, and exhibit an air of confidence (even if you don't feel it inside). Your business card should be well conceived, and if you leave the portfolio overnight you should have the agency sign a delivery memo.

Businesses like to portray themselves as successful competitors. This concept can be graphically illustrated by many types of images—athletes, fighting animals, and executives in business suits running a race. You can find many examples of competition in the animal world. For example, this shot of two horses sparring against a sunset gives a dynamic message. The forms are powerful, the sky is beautiful, and the frozen moment in time is full of suspense. These qualities all contribute to a compelling image that will entice people to read the ad.
 Technical Data: *Mamiya RZ 67, 500mm lens, 1/250, f/8, Fujichrome 100, tripod.*

SHOULD YOU GET A PHOTO REPRESENTATIVE?

This serves as a receipt for your work, and it lets them know they are dealing with an established pro.

In addition, you should have predetermined rates for your work. The American Society of Magazine Photographers (ASMP) guidelines are very helpful for this. The question that always rears its ugly head is, "How much do I charge?" Establish a per diem rate, and have it on the tip of your tongue. Don't hesitate, almost apologetically, and meekly quote your price. All artists have trouble with money in relation to their work. But this is business. Get tough. Be reasonable, but tough. You can be open to negotiation, but don't work for a pittance. You won't respect yourself, and neither will your prospective clients.

A stock sale is more difficult to assess. Carry a chart showing the various uses of photography and how much the marketplace will pay for them. If asked for a quote on something you're not sure about, tell the art director you'll get back with the information in a day or two. Then go get it.

A "rep" usually handles several noncompeting photographers at once. He or she may carry the portfolios of a food photographer, a nature photographer, one or two people who shoot small and large products, a sports photographer, someone who does special effects, a fashion photographer, and so on.

For reps to consider promoting your work, you must fill a niche in their stable of photographers. If they don't currently represent a wildlife

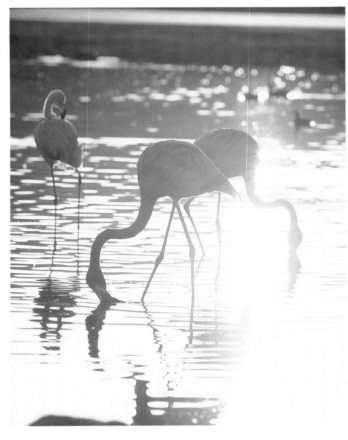

All wildlife are fascinating in their own way, and every species has a place on our planet. But people have inbred prejudices toward certain creatures, and advertisers are sensitive to this. For example, everyone loves butterflies, yet most other insects are feared, hated and considered ugly. Some birds suffer the same fate as the majority of insects—they make people uncomfortable. This shot of a roosting turkey vulture at sundown is a favorite image of mine, but no advertiser would use it. Vultures are synonymous with death. A silhouette of another avian species, the flamingo, conjures up just the opposite emotions. We think of grace, elegance, and that beautiful orange/pink of their feathers. This image could easily be used to convey a positive message.

Technical Data: *Vulture— Mamiya RZ 67, 500mm lens, 1/125, f/8, Fujichrome 100D, tripod. Flamingos—Mamiya RB 67, 500mm lens, 1/250, f/8, Ektachrome 64, tripod.*

or nature photographer and they think your work is marketable to their clientele, they may decide to give it a try for a designated contractual period. A typical commission structure is 25 percent to the rep, depending on how established you are, but everything is negotiable.

Large metropolitan cities have the highest concentration of photographic reps, especially New York and Los Angeles. Detroit, Chicago, San Francisco, Dallas, and other major centers of commerce have their share also. Most of these people don't advertise because there are more photographers without reps than the other way around. To con-

tact a photographic rep, speak to professional photographers and receptionists in ad agencies to see if you can get some names. Also, the photographers' agents are often named in the large books that advertise commercial photographers, such as *American Showcase* and *The Creative Black Book*. You can get the phone number and address of the rep through the photographer.

Having a rep doesn't mean that you are prohibited from making sales on your own. But if you have a diligent rep knocking on doors to show your work, you may be so busy that you won't have time for anything else.

A SALES PARTNER

Another arrangement you can make is an actual business partnership with someone who wants to market your photography in the advertising field. Many husband-and-wife teams are essentially partners in their photography business, and there's no reason why you can't form this type a partnership with a spouse, friend or associate. A fifty-fifty split can be structured, but your partner doesn't represent anyone else. He or she only promotes and sells your work.

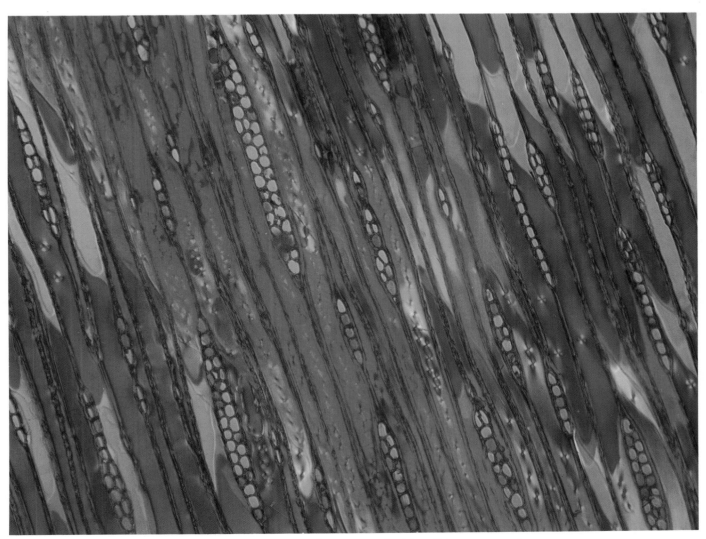

Brilliant color always attracts the eye. This abstract pattern is a photomicrograph of the cellular structure of the redwood tree. The color is generated by using two polarizing filters, one under the microscope stage, and the other placed between the objective lens and the eyepiece. You never know how an image will be used until you put your work out into the marketplace. I feel it is part of my responsibility to help my clients market their products and ideas. I make myself a valuable asset to my clients by suggesting ways for them to use dynamic imagery to their best advantage. This image could easily be used in a promotional campaign for a lumber company, for instance.

Technical Data: *Mamiya RB 67, Bausch and Lomb microscope, 60X magnification, tungsten illumination, 1/4 second, Ektachrome 50.*

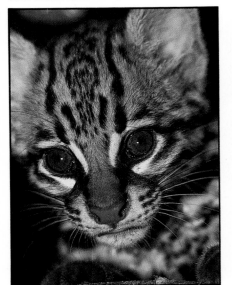

5665 WL Ocelot kitten

5666 WL Arctic Wolf

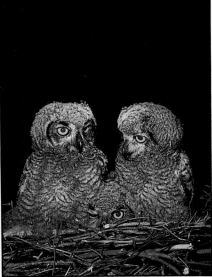

5667 WL Great horned owlets

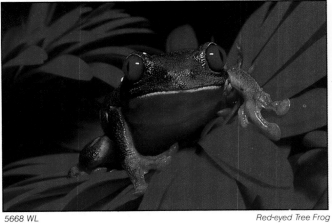

5668 WL Red-eyed Tree Frog

5669 WL Bengal Tigers

5670 WL Wild mustang

5671 WL Arctic Fox

5672 WL Red Shouldered Hawk

STOCK PHOTOGRAPHY

Stock photography is the business of selling pictures that already exist. If an advertising agency wants to use a picture of a winter sunrise over Grand Canyon, the staff knows it's not necessary to contract for a photographer to spend days or weeks in Arizona waiting for the perfect shot. All they have to do is find someone who has the image on file and buy it or rent it. This turns out to be much less expensive for the ad agency, and it provides a residual income for the photographer.

Stock photography is like a pension fund for photographers. We can derive continual income from pictures that were taken months and even years ago. Whether you prefer to let a stock photo agency warehouse your work and handle the promotion and sales or you want to act as an individual entrepreneur in the stock business, you can turn your library of photographs into a substantial income.

WHAT MAKES A GOOD STOCK IMAGE?

With wildlife and nature, there are basically two types of stock images. For the editorial market, such as biology texts and magazine articles, specific

My ad in the stock agency's catalog shows a broad range of my work. The ad's purpose is to attract many buyers with differing needs.

behavioral shots of animals and plants are very much in demand. These might include two bull elk fighting, a squirrel burying a winter cache of nuts, or unique cloud formations.

The advertising market, which generates more income for stock photo agencies than does the editorial market, uses nature photographs that convey a mood or communicate a message: foggy forests, pastoral meadows, or a running cheetah. In addition, patterns in nature are used as backgrounds for ads. These could be a hillside of evergreen trees, a frame-filling shot of poppies, or a close-up of the texture of sand or rock.

An exceptional stock image will have universal appeal and can be used in many ways. Striking rainbows, cloud patterns, and sunbursts work for any market, as do lightning bolts and ocean panoramas. A close-up of a beautiful rose would also have broad appeal.

Good stock photography must take into consideration other factors as well. Because ad agencies are the most lucrative market for stock photos, an image should have room for advertising copy. An advertiser needs to impart a written message, and your pictures should make this easy to do.

Technical excellence is an absolute must for stock photography. *Every* image must

be sharp, well exposed, nicely composed, free of scratches or dust embedded in the emulsion, and have good color saturation. Examine each image with at least an 8X loupe, because the smallest imperfection eliminates a slide from stock use. It is true that once in a while poor images are used, but *no one* can consistently sell mediocre work.

GOOD CAPTIONS MAKE GOOD STOCK

Every picture you submit either to a stock agency or a client must be captioned. I use computer-generated labels

One of the fascinating aspects of selling stock is that you never know how a photo will be used. I have sold pictures composed of geometric shapes, like this octopus, to book companies who publish geometry and trigonometry texts. Common shapes, such as triangles, diagonals, circles, cubes, polygons and polyhedrons, are a recurring theme in stock. This picture was taken at the Monterey Bay Aquarium in California.
Technical Data: *Mamiya RZ 67, 127mm lens, Metz 60 T-2 strobe, f/16, Fujichrome 5OD, hand-held. The flash was positioned at a forty-five degree angle to the glass to avoid a reflection.*

A good example of the kinds of markets a stock photo agency encounters on a daily basis is represented by these two shots. The Mendenhall Glacier near Juneau, Alaska, (top) was taken with a wide-angle lens and shows a large portion of the ice field in context with the landscape. You can see its distinctive form and unusual color. This is a good editorial picture that could be used in a text-book or magazine article.

The photo on the bottom shows the interior of an ice cave inside the Reid Glacier in Glacier Bay National Park. Without identifying this photo, no one would know what it is. It doesn't say "glacier." However, an advertiser could use it for a rich, textured background in print, to promote anything from toothpaste to camping gear.

Technical Data: *Mendenhall Glacier—Mamiya RZ 67, 50mm lens, 1/30, f/5.6, Fujichrome 50D, tripod. Ice cave—Mamiya RZ 67, 50mm lens, 1/2 second, f/8, Fujichrome Velvia 50, tripod.*

because the type can be shrunk to get a lot of information on each slide. The following should appear on each caption:

1. Copyright symbol. Most computers or typewriters can't make a "c" enclosed in a circle, so the acceptable symbol is (c).

2. You can include the year, but some agencies remove it because they feel it dates the image, even if time is irrelevant to the subject (such as a shot of a blue jay). I do not include the date on any of my captions because I agree with this theory.

3. Your name. Don't include your address or phone number because clients may re-

A complete label is essential when submitting slides to a stock agency or when packaging material for direct submission to a client. Here's what my computer-generated label looked like when I gave this shot to my stock agency:

(c) Jim Zuckerman/West Light. Malachite butterfly hiding under leaf in rainstorm; Miami, FL (Siproeta stelenes)

It's important to explain what the butterfly is doing, as the buyer might not understand or want the photo. Where insects are sighted also is important, so I included it on the label. "Malachite" is the common name of the butterfly, but since it could be called by a different name in another part of the southern United States, it is essential to include the Latin name. I found this information in the Audubon Field Guide to North American Butterflies.

Technical Data: *Mamiya RZ 67, 127mm lens, Vivitar 285 flash, f/16, Ektachrome 64, hand-held.*

The ocean is always a popular stock image. Seen from above with a low sun reflecting off the surface of the water, it takes on a shimmering quality that makes it attractive for many clients, including religious, textbook, advertising, and scientific.

Technical Data: *Mamiya RZ 67, 360mm lens, 1/250, f/8, Fujichrome 50D, tripod.*

SHOOTING FOR STOCK

You'll improve your chances of selling your work by shooting specifically for stock usage. When I shoot for stock, I evaluate the scene with marketing in mind. I shoot both horizontal and vertical compositions, leave enough room for copy, and seek out the strongest graphic qualities. I go for classic images that I think people will easily recognize or relate to. I look for dynamic images that have immediate emotional impact. I'll shoot several duplicate originals of a particularly strong image. This allows me to submit a sharp original without fearing that my *only* original will get destroyed.

If you include people in your scenes, make sure they are attractive. They should be interacting with each other or reacting to the scene. You must have a model release before the picture is submitted to a stock agency. Without the release, the shots may be used in the editorial market, but the higher-paying advertising sales will be denied to you.

turn transparencies to you rather than the agency. Frequently, the agency's name will follow yours, separated by a slash, e.g. (c) Jim Zuckerman/West Light.

4. A description of the subject. Be brief, but include the necessary information a photo buyer needs to understand the picture: location, season, the species, and any other information to explain what's happening in the image. All animals and plants should have the correct scientific nomenclature on the label. If you don't already own the set of *Audubon Field Guides* for this valuable information, buy it.

5. If there are people in your shots, or if you've included someone's private property (such as a barn) in the composition, indicate whether the image is model released or property released. (See sample release on page 133.)

WORKING WITH A STOCK AGENCY

Consider two major factors when choosing a stock photo agency. First, does the agency market the type of work you shoot? Some stock houses don't promote nature and wildlife as much as industrial, medical, and other business-related pictures. Many agencies heavily promote people photos with model releases. The kind of company that will make money for you must specialize, at least in part, in nature and wildlife.

Second, you must decide whether you want to seek out

a large agency, with hundreds or thousands of photographers represented in their files, or a smaller firm, perhaps one just building its library. A larger agency gets more requests from photo buyers daily, and it has a high profile in the industry, which can be a prestigious association for you. Because there are so many photographers, however, there is more in-file competition. The likelihood of your shots getting sent out on a job request is less than with a smaller agency, which has fewer images from which to choose.

An agency that is growing and trying to compete in the marketplace is more likely to guide its photographers by holding seminars and private consultations. This kind of assistance helps everyone shoot the kinds of images that sell well. Rather than just guessing what to shoot, you'll *know* what kinds of shots they need

When you shoot, keep stock photography in mind. The small grouping of Alaskan cotton plants (bottom) nicely documents the species. But there is no room for advertising copy. A stock agency first examines the slides for sharpness, then looks for space to put ad copy. The photo on the top is a macro shot of a single Alaska cotton plant, but there are two major differences. First, it's lighter and therefore more ethereal. Either light or dark type could be superimposed over the image for an ad. Second, there is plenty of room for copy. The soft nature of the image is a perfect backdrop for a message.

When you take pictures, consider carefully which markets you intend to approach. If you are shooting for stock, you'll always be safe if you capture both types of images—editorial and advertising.

Technical Data: *Group of cotton plants—Mamiya RZ 67, 110mm lens, 1/4 second, f/16, Fujichrome 50D, tripod. Single cotton plant—Mamiya RZ 67, 110mm lens, #2 extension tube, 1 second, f/16, Fujichrome 50D, tripod.*

but don't have, and which files they want to update or improve. I would not join a stock agency unless this kind of support was part of the package.

There are many other factors in considering an agency. How often does it pay? Does it publish a catalog of its top images to get more exposure? Can you get tearsheets of your published work? (These are useful for your portfolio.) Does it provide "want lists"—listings of images it needs? Does it give you a computer readout of your shots that sold? How quickly after you've submitted them do your submissions get into the files?

You can find a listing of stock photo agencies in *Photographer's Market*, along with a brief description of the agency, whom to contact, which types of pictures they carry, and how many photographers and images are connected with the company. *The Stock Photography Handbook*, published by ASMP, has listings similar to those in *Photographer's Market*. It provides legal information that pertains to the stock industry as well.

SUBMITTING YOUR WORK

Once you have selected a few agencies that look most promising, talk to some of the photographers who are in the agency to determine if they would recommend joining. Get a feel for the agency's reputation among photo buyers as well. You can get the names and phone numbers of many of these people out of the *Stock Workbook, American*

Showcase, and *The Creative Black Book*.

If you live near the stock agency in which you're interested, make an appointment to show or drop off your portfolio. Otherwise, you'll have to send it through the mail. Either way, the photo editor usually will want to see between three hundred and five hundred slides, captioned as if you were submitting them for their files. This may seem like a lot of pictures, but it's the only way a stock agency can determine if you have enough material, and if you

are capable of continually providing good images.

Ask for a tour of the agency and try to get a sense of how professional the operation seems. Look at the quality of the images on the wall. Try to determine how photo buyers are treated. Is the file area clean and neat? Are the slides protected both in storage and in shipping? Is the staff enthusiastic and hard working? All of these factors influence how successful an agency is.

Ask whether the company publishes its own catalog and what it costs to be in it. Most

Photos that convey a message and at the same time have enough room for ad copy are usually excellent sellers. This budding snapdragon conveys the concepts of birth, new life, youth, rebirth, wonder, and many more. When I took the picture, I used a composition that placed the flower off-center so there was enough room on the side for an advertiser to place copy. In addition, I added a little diffusion for an ethereal effect.

Technical Data: *Mamiya RB 67, 180mm lens, 1/4 second, f/8, diffusion filter, Ektachrome 64, tripod.*

agencies charge to be in their catalogs. Does it charge a research fee when a photo buyer requests images? This fee, usually fifty to seventy-five dollars, pays for the time it takes a photo researcher to pull the slides for a job and is usually deducted from the final sale. You'll want to know if this fee is figured into your commission split. It may not sound as if this would make much of a difference to your income, but it does add up over time. Does the agency charge a holding fee to a client who ties up pictures for a long time, and do you get a percentage of it? How much does the agency recover for lost or damaged slides?

An important question to ask is, who pays for duplicates, and how much does it cost when your best images are duped? Will the agency deduct this amount from your future sales, or will you have to pay for this at the time of duping? How does the agency maintain contact with photographers? You want to get regular updates on your sales and information on what images are needed. How many images does its top earner have in the files? How much money does this person make per year? (This tells you the best you can expect to do.) Ask to see a sales statement, and don't forget to get the names and phone numbers of two or three photographers in the agency for references.

I learned a great deal about stock when I joined an agency. There are factors involved in selling pictures that had never occurred to me. For example, these two pictures of ice crystals are very different from each other in one major respect: color. The photo on the top is brown and white, while the photo on the left is blue-gray and white. Which color do you think best depicts the concept of "cold"? Obviously the latter. A client wouldn't choose the one on the top to convey the idea of "cold." No matter how much room there is for ad copy, it just doesn't convey the message. Blue and blue-gray are colors that people associate with winter and low temperatures.

Technical Data: *Brown ice—Mamiya RZ 67, 127mm lens, #1 extension tube, 1/2 second, f/16, Fujichrome 50D, tripod. The ice crystals were protruding from an ice shelf above a stream bed. Blue ice—Mamiya RZ 67, 180mm lens, 1/30, f/16, Fujichrome 50D, tripod. I shot the ice crystals on the side window of my car with the sun behind the glass.*

THE CONTRACT

When an agency accepts you, it will present you with a con-

tract. All contracts are negotiable, so study it carefully before signing. The most important factors to consider include:

Length of time. Standard contracts are between three and five years.

Renewal option. This allows an out for both you and the agency, should either of you wish to dissolve the agreement at the end of the expired term. If you wish to terminate the contract, it is your responsibility to inform the agency. Some agencies do renewals based on the date you send in an image, so keep careful track of these dates.

Return of images at contract's conclusion. Determine the agency's procedure for returning your images. Most agencies take a long period of time to do so—sometimes a few years—because work is filed by subject, not photographer.

Commission split. The standard is fifty-fifty.

Exclusivity. Does the agency allow you to submit some of your work to other stock houses, or are you exclusively bound by contract? If you shoot different types of pictures, it may want all your nature and wildlife, but perhaps the travel photography or special effects may be submitted elsewhere.

Pay periods. Many agencies pay quarterly, while others pay monthly.

Take the contract home for close scrutiny, and show it to your lawyer before agreeing to the terms.

WORKING WITH YOUR AGENCY

Stock photography is a business, *not* a hobby. Many photographers think all they have to do is send in a hundred slides and the rest is financial history. This is far from the truth. The more pictures you have on file, the more sales you will make. This means that to make a significant income from stock, you must continually submit images to the agency. Several hundred images a month is indeed a serious investment in both time and money, but all businesses require an investment. Over time, it will pay off. Shots that you submit today can still sell ten years from now.

When I first joined an agency, I was told to calculate a typical income from stock by using the formula of one dollar per slide per year. This varies with the quality of your work and the types of subjects photographed; but as an average, if you have ten thousand slides on file, you can expect to receive about ten thousand dollars per year. However, it takes from twelve to eighteen months before you start seeing *any* income at all.

Just as important as it is to keep the numbers up, you must also keep the quality up. Don't feel that just because you've been accepted into the agency you don't have to work as hard. You must maintain the technical and artistic quality of your work.

Each submission received will be reviewed by a staff person at the agency. Besides the obvious technical considerations, that person will look for depth of coverage of your subjects. A lot of unrelated pictures in a submission is con-

Action and behavioral shots of wildlife are excellent sellers in stock. Always judge your pictures objectively, however, without emotional input such as, "I love this picture, even though it's not perfect." This photo of a leaping white tiger taken at the Los Angeles Zoo is relatively rare. It would be an excellent stock image, even though it's not tack sharp. Motion is often portrayed with a blur. The problem is the out-of-focus bush in front of the cat. It seriously detracts from the picture and reduces the value of an otherwise valuable stock shot to practically zero. I can't show you a good comparison photo, because I don't have one.
Technical Data: *Mamiya RB 67, 500mm lens, 1/60, f/8, Ektachrome 64, tripod.*

When you travel abroad, don't forget to photograph nature. Endangered environments are always in demand. This is part of the bamboo forest in China in which pandas live. As I was writing this chapter, I received a "want list" from Harcourt Brace Jovanovich, a large textbook publisher in Florida. They were looking for, among other images, a horizontal picture of the Chinese bamboo forest. They had shots of bamboo forests in other countries, but not China. I sent three dupes, this frame plus two others, using the Federal Express number the client provided me. I called the art director the next day to make sure he had received them, and he said one would probably be used. He'd let me know in a month or two.

To receive "want lists," call art directors or photo editors of publishing companies and ask if they send out such information. If so, request that your name be added to their resource list.

Technical Data: *Mamiya RB 67, 180mm lens, 1/2 second, f/22, Ektachrome 64, tripod.*

fusing to edit. Many bird shots with related landscapes works better than a few pictures of birds, a few landscapes, and a few animal shots. If you shoot a winter storm in the eastern Sierras, cover it from all angles. Use a telephoto for tight shots of storm clouds, a wide angle for broad landscapes, and a macro lens for details of snow-covered plants. Shoot several frames from each vantage point so the agency has plenty of duplicate originals. The best second-generation dupes won't compare in quality to the original ones.

Get the agency's input on what it needs. If it doesn't have any good pictures of huge ocean waves and as a result had to turn down several job orders recently, be on the

next plane to Oahu's north shore. The few hundred dollars spent on shooting waves could net you perhaps three thousand dollars — or more — per year for the rest of your life.

Shooting for agency requests does not inhibit your creativity. It may inspire you to explore an area of photography that you've never considered before, and it will certainly increase your income.

SELLING STOCK YOURSELF

Some photographers act as their own stock photo agency, which offers several advantages. You can maintain total control over your images. Rather than split the sale price, you get the entire amount. You don't have the pressure from an agency to continually submit pictures. You can also get leads for assignments from clients that have been pleased with your submissions.

The disadvantage of selling your own stock is the time and effort involved in marketing your work. This is no small task. The time you spend on taking pictures must, by necessity, be decreased and applied to selling your work instead.

ORGANIZATION COUNTS

You can't sell a picture if you can't find it. Good organization is not just a means of being neat; it is necessary to efficiently run a stock business. You need to *quickly* locate specific images for the scores of submissions you package.

The best way to categorize slides is by broad subjects, which are then broken into subdivisions. For example, one of my major headings is "Alaska." Within this grouping, I have several subdivisions, including "Glaciers," "Denali National Park," "Temperate Rain Forest," and "Miscellaneous." When the Miscellaneous file gets a number of related shots, I will establish a separate subheading for that grouping.

Your system must be flexible enough to continually refine, add or subtract categories. When I started shooting hundreds of butterflies, for example, I had to take them out of the "Insect" heading to create a separate file just for butterfly shots. Within the "Butterfly/Moth" major heading, I now have subdivisions called "Monarchs," "Silk Moths," "Endangered Species," and so on. The way you divide your slides into headings and subheadings will be tailored to your needs. Each photographer shoots with a different emphasis on nature, and the categories you create will reflect your interests and approach.

All of my 35mm slides are stored in acid-free slide sheets that hold twenty frames. These are kept in hanging files that are stored in a file cabinet. I can go into a subheading and hold up five sheets of slides, instantly reviewing a hundred images.

My 6 × 7cm medium format transparencies are stored in two ways. My best images are mounted in glass mounts for

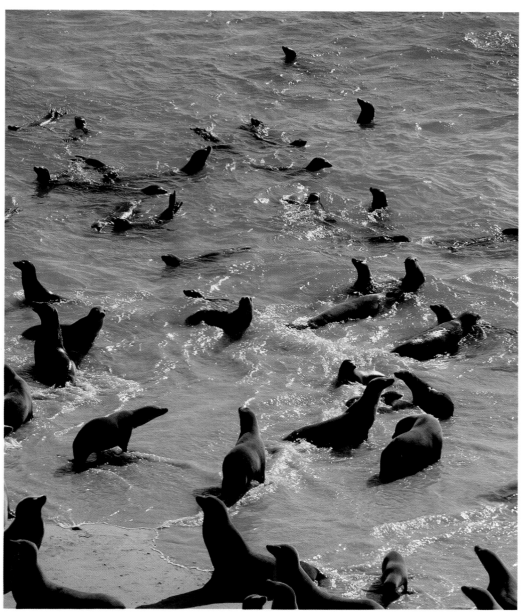

It is important that you understand the natural world enough to know what you are photographing. For example, this picture of California sea lions is not a rendition of a "surf party." These animals were disturbed from their slumber on the beach and are retreating into the sea for safety. This fact should be described on the caption.

Technical Data: *Mamiya RB 67, 500mm lens, 1/125, f/8, Ektachrome 64, hand-held resting camera on a rock.*

Life cycles always make important stock images. I photographed this beautiful caterpillar of the hawk moth as part of a series showing the stages of metamorphosis. Descriptive captions should always explain the photos.

Technical Data: *Mamiya RZ 67, 110mm lens, #2 extension tube, Metz 60 T-2 strobe, f/22, Fujichrome Velvia 50, hand-held.*

protection from dust and scratches. I use these for slide shows as well when I lecture. The glass-mounted slides are then filed in a custom-built case composed of many drawers. Each drawer has six partitioned rows in which I place the pictures. Black Plexiglas® dividers with typed labels identify the headings and sub-headings.

I keep the duplicate originals and the shots that aren't good enough to be mounted in a separate file. I cut the film into individual frames and place them in similar categories to the main file.

The trickiest part about classifying slides is the cross-referencing. A Douglas fir tree taken in Glacier National Park could be filed under "Trees" or "National Parks." If it's a winter image, you might be tempted to have a separate category, as I do, called "Snow on Trees." The problem occurs when you get a request for an artistic picture of a Douglas fir. Which heading do you check? Some people stick cross-reference cards in their files, some use computers, and some rely on their visual memory.

With a computer, you can easily code your shots so they can be located automatically for many requests. I'm frequently asked whether I use a computer to keep track of my images. The answer is no. When I return home after a month of shooting in the field, I typically have around two thousand pictures. The time it would take for data entry on each frame would be staggering, and it would be time lost in making sales. If I shot 4×5 and returned with perhaps one hundred salable pictures, I could invest an hour or two and describe each frame and assign it a code for cross-referencing. But the volume of medium format and 35mm shots I take every year makes this impossible.

You will find that as you submit pictures, you review your files so frequently that your visual memory becomes highly developed. When a request comes in for a certain view of Yosemite, you will know immediately if you have the image. If you're not sure, a quick check in the files under "Yosemite National Park" will give you the answer.

STEPS IN A STOCK SALE
In the beginning, there is promotion. Photo buyers must know you're out there. Every photo buyer that buys wildlife and nature photography should know you exist and what kind of stock you have. Direct mail self-promotion gets the word out on your stock agency. (See pages 84-87 for more on this.)

Once you get a request from a potential client, you must spend time in researching your pictures to pull the appropriate images. This is easier to do if you have an organized system for storing your slides. (See "Organization Counts" above.)

When you have selected one or more images, prepare a delivery memo and invoice for the research fee (if you charge one). Some clients state up front that they don't pay research fees; others won't object. As an incentive, you may waive the fee for the first submission. Otherwise, you can let them know that the fifty-dollar fee is applied to the sale of the photo.

A numbering system helps track submissions in two

ways. You can log each slide into a computer when it is submitted, and you can use a blank white card to replace the position of that image in your collection. On the card, write the name of the company receiving that slide, the date, and a brief description of the shot. When the picture is returned, don't forget to put it back where it belongs.

Next, package the slides. 35mm frames should be protected by Kimac (small plastic coverings) and then inserted into slide sheets. I send out medium format transparencies in 4 × 5 black folding cards with a 6 × 7cm window cut in the middle (see photo on page 49). The actual film is covered by the plastic sheath used by the photo lab to protect the delicate emulsion.

Several services can send your package to the client. For intercity service, you can use the U.S. Postal Service, United Parcel Service (UPS), Federal Express or similar services. The post office offers registered, certified, and express mail delivery. Registration is the safest method of transport, but it is not the quickest. Certified delivery numbers your package for tracing purposes, but the package still goes in with the regular mail. I don't recommend this method.

You should always purchase a "return receipt" card from the post office. The person that signs for the package at the other end also signs and dates this card, which is then returned directly to you. This is your proof that the package was in fact delivered.

Express mail is overnight service and is usually reliable. But I have found that the post office sometimes delivers the package after the stated deadline. Although you get a refund, your credibility suffers if a client needs a package by a certain time and doesn't receive it.

UPS and Federal Express are extremely reliable, and I use them frequently. They guarantee that your package will be delivered by 10:30 A.M.

One of my favorite subjects is patterns in nature. This image of pink and beige sand under water on the Big Sur coastline of California captivated me for an hour. It is also a good stock image because it is an excellent background. I took two rolls of 120 film of this composition so my stock agency had plenty of dupe originals.

Technical Data: *Mamiya RZ 67, 110mm lens, 1/60, f/16, Ektachrome 64, tripod.*

My lightning photos have been excellent sellers in my stock agency. They have been used both in advertising and editorial, including use in a Time/Life book. The magenta is typical of photo renditions of lightning at night, although I enhanced the intensity of the color when I duplicated this image.
 Technical Data: *Mamiya RZ 67, 250mm lens, 30 second exposure, f/4.5, Fujichrome 50D, tripod.*

you can charge a holding fee. I don't do this. Instead, I speak to the photo editor and find out how long the shots will be held. Usually, they won't be needed more than two or three months. Since I send out duplicates anyway, I can still market these images elsewhere.

If a publication or ad agency wants to hold originals for a long time, I will put a time limit for which there is no charge. After sixty days, I'll charge a holding fee of fifty dollars per image per month. Many times a company will request dupes to avoid the holding fee. In this event, I send them the copies at no charge and get my originals back.

REFILING
Make sure you quickly refile all returned images into your system so you don't lose track of where anything is located. Dust the slides with a camel hair brush or compressed air before they go back into your files. Over a long time, particles of dust can imprint the sensitive emulsion and ruin a picture.

Make sure the caption information is still legible; make a new label immediately if any part of it isn't. Also, see that the slide itself hasn't slipped within the mount. When you make a correction, do so without touching the film with your fingers. Wear the white cotton gloves that photo labs use to protect film.

PRICING YOUR WORK
The hardest part about selling your stock is the pricing struc-

the next day, and if you are within their geographic area they will usually pick up your package within a hour or two of your call.

If you live in a metropolitan area and the photo request comes from a local client, courier services will deliver your package within an hour or two. While this may be expensive (thirty to fifty dollars is typical), when time is of the essence, it is the fastest way to put your pictures in the hands of the client without driving there yourself.

IMAGE RETURNS
When a buyer returns your photos, make sure all images

are accounted for, even if they weren't used. In addition, examine the transparencies for damage such as scratches, creases in the film base, or even a tear in the picture area of the slide.

I seldom send originals to a client for fear of damage to a prized original. I don't mind sending duplicate originals (two or more original frames taken consecutively), but a one-of-a-kind photo doesn't leave my possession. If a photo is damaged beyond repair, the client is liable for an amount determined by a court of law. No one wants to litigate, but if you feel that you have a case, speak to a lawyer.

Several years ago a client damaged an original slide of mine. Instead of threatening a lawsuit, I suggested that they pay me by using four of my images over the next two years on the cover of their magazine. These covers probably would have gone to other photographers. They agreed, and in this way I kept a client and at the same time made more money than I would have had I sued and won. I also got excellent exposure. I negotiated in good faith and produced a situation in which everyone benefitted.

If most of your images are returned except a few that a client holds for further review,

NEGOTIATING FEES AND RIGHTS

In business, everything is negotiable. Even when a magazine states that it only pays a certain amount for a cover, a special shot may be worth more. This logic holds true for all aspects of selling pictures.

The rights you sell are also negotiable. Many types of rights are associated with the usage of photographs. The most common is "one-time rights." Other rights include "book rights," "one year calendar rights," and "poster rights for the United States only."

Negotiate in good faith and with good grace. Don't give away the store, but don't automatically conclude that a client is trying to rip you off by offering a lower fee. Look for a compromise whenever possible. The most successful negotiations are those in which both parties get something they want.

Do your best to get the full amount you want for a photo. When that's not possible, decide how badly you want this particular sale or how much you want to keep this particular client. If you end up getting less than you had hoped, accept the smaller amount gracefully. Leave the client feeling that you are happy to have had the work, and that the door is always open to future association.

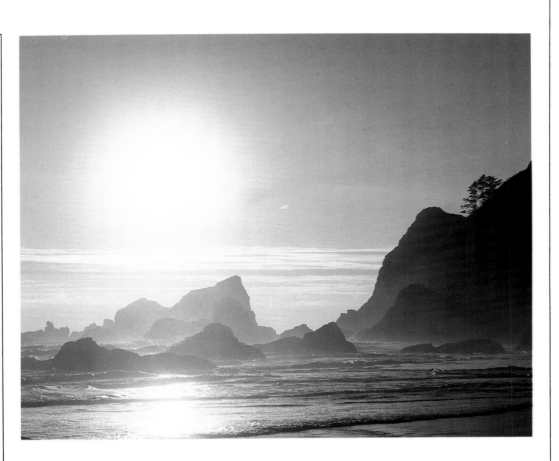

ture. Most photographers are uncomfortable negotiating price, and I'm no exception. There comes a time, however, when you realize that if you are going to make a living at selling your pictures, you must be well compensated for it. The price for every slide depends primarily on two factors: (1) how the shot will be used, and (2) how much the client is willing to pay.

When you receive a purchase order from a client, make sure the terms agree with your understanding of the sale. If you negotiate a sale over the phone, make detailed notes to check against the purchase order.

Usage helps determine price. A photo to be used as part of a television ad will ob-

viously bring more money than the same shot that's part of a how-to article in a photo magazine. Generally, advertising usage pays the most, then industrial and corporate, and finally, editorial.

To help me with a pricing strategy, I always ask the client, "Is there a budget for the shot?" If the photo editor says, "We can only pay four hundred dollars, tops," then I know the upper limit and will make a decision whether I want to submit pictures for this sale. If the editor says a budget hasn't been discussed yet, I will ask all the pertinent details, such as print run, size of final reproduction, name of the publication in which the shot will appear, and so on. Then I'll give a price based on

Another good seller in my stock agency is this sunset shot of the Oregon coastline at Ecola State Park. There are strong graphic shapes in the rocks, and I've left plenty of room for copy. Artistry is important in both the advertising and editorial arena.

Technical Data: *Mamiya RZ 67, 250mm lens, 1/125, f/11, Fujichrome 50D, tripod.*

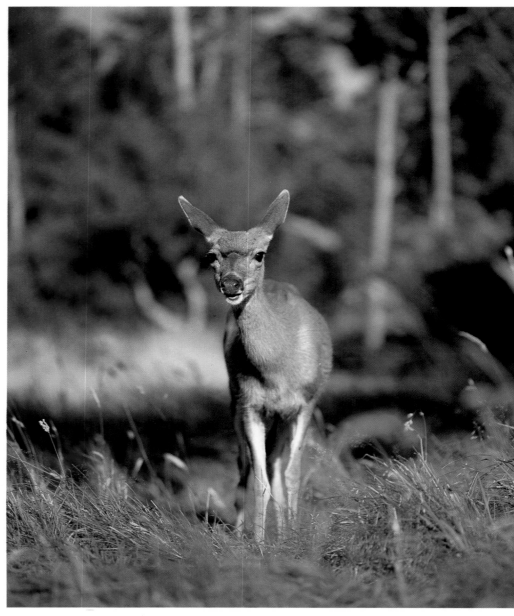

Most of the wildlife pictures I have sold, both through my stock agency and from my personal stock, are images in which the animal is looking into or toward the camera. Eye contact creates an intimate glimpse into the subject that make photo editors immediately sympathetic to the picture. This photo of a black-tailed deer fawn was photographed on Vancouver Island, British Columbia.

Technical Data: *Mamiya RZ 67, 360mm lens, 1/125, f/6, Fujichrome 50D, tripod.*

the published figures of ASMP.

I will also quote a range. This way, I haven't priced myself out of the ball park, and at the same time don't seem too cheap. I might say, "I usually get between four hundred fifty and seven hundred fifty dollars for this type of usage." Last year, I quoted four hundred to five hundred dollars for a magazine cover and eventually settled for two hundred fifty dollars, but over the course of eighteen months I sold ten covers. In this case, I accepted less money per image but built up a long-term client relationship and earned some decent money at the same time.

Some sales offer more visibility and prestige than others. A large print run, an oversized magazine, both English and foreign language editions, and high-profile publications such as *Life* are all good reasons to be excited about seeing your work used. You may be willing to accept less money, if necessary, in exchange for the photo credit.

If a particular shot cost you a lot of money to get, you may want more for it in a stock sale. For example, if you spent three weeks in the Alaskan bush to get a picture of mating caribou, you're not going to be too willing to settle for fifty dollars to see the picture on a magazine cover. And if you would accept this paltry sum, you'd be doing yourself a disservice because competing magazines wouldn't use the same shot as a cover for many years. You would have limited

the income on this hard-to-get photograph by underpricing yourself.

It's important to establish a sense of worth for your photography. Know your bottom line. Emotions have nothing to do with it. Your favorite image doesn't have more value than other shots; conversely, a picture that doesn't especially appeal to you isn't necessarily less valuable.

HAVING IT BOTH WAYS

Can you belong to a stock photo agency and act as your own stock agency? The answer is yes. You will have the best of both worlds. Professionals in a stock house will be selling your work, plus the clients with which you have established a working relationship will continue to buy from you. You can develop and maintain a steady cash flow, generate assignments, sell the type of work your agency may not represent, and increase your sales efforts in areas where the agency may have decreased revenue.

Your largest client, however, is really the stock photo agency that represents your work. You will have to continually feed it, and at the same time continue with your own sales and deal with the paperwork involved. Selling stock directly to clients and actively participating as a member photographer in a stock agency is a lot of work. Down the road, though, the rewards are certainly yours. You've earned them.

Some photos, because of their uniformity, provide a background over which copy can be written. There may not be a clear sky or large area of out-of-focus foliage; instead, a homogeneous area serves as an appropriate place to superimpose a message. The photo on the top was taken in the Hoh Rain Forest in Olympic National Park, Washington. I filled the frame with greenery in such a way that lettering could easily be read over this background. The one on the bottom was taken in the same forest but is much busier. The dark, diagonal trunks with perpendicular branches outlined in light green would confuse the eye, should ad copy be superimposed. This shot could be sold for editorial purposes as an example of decay in the rain forest, but it wouldn't earn the top dollars in advertising. To maximize your return from stock, always think in terms of selling to the advertising market.

Technical Data: *Left rain forest shot—Mamiya RZ 67, 360mm lens, 1/15, f/22, Fujichrome 50D, tripod. Right rain forest shot—Mamiya RZ 67, 360mm lens, 1/8, f/22, Fujichrome 50D, tripod.*

THE BOOK MARKET

It's a great coup to have your photographs featured in a book. It says that you are a recognized figure in the field. Compared to other types of books, few photography books are published each year because they are expensive to produce and typically don't have large sales. A publisher's taking a chance on your work says you are well known enough or your work is outstanding enough to appeal to an extremely broad range of people.

There are three major categories of photography books. The first is heavily illustrated or coffee-table books, which are primarily picture books with a minimum of text. They can also be organized around a theme or topic, such as the vanishing wilderness, in which case they will still be heavily illustrated but have more text. This is the hardest market to break into. Since these books are extremely expensive to produce, generally only "brand name" photographers such as Ansel Adams and Eliot Porter appear be-

tween their covers. Occasionally books feature less well known photographers, but the photos in these cases are exceptional and have very broad appeal or deal with a hot topic.

The second market is how-to books. These show people how to do something better—design a photograph, handle lighting, or, like this book, shoot and market nature and wildlife photos successfully. Instructional books are popular and have a fairly large mar-

ket, because most photographers are constantly trying to improve their work. You have a better chance of breaking into this market, but it's still difficult to do so.

The third market is children's books. Although only a minority of children's books teach about nature and wildlife, these do use photos. Being able to tell a story with pictures or to illustrate someone else's narrative is important in this category. The use of photograhy in children's books is

increasing due to the success of the *Eyewitness* series, but opportunities are still limited.

APPROACHING PUBLISHERS

You don't need a national reputation to sell your work in the fine art, magazine, stock or advertising markets. As you get your photos published more often, you will build a reputation that in turn brings more work. But you won't necessarily become famous. This isn't the case with the

Although exotic animals are the subjects of many books, common backyard visitors are also interesting. I'm thinking of proposing a book on animals that have adapted well to city life, such as pigeons, racoons and squirrels.
Technical Data: *Mamiya RZ 67, 180mm lens, 1/125, f/5.6, Ektachrome 64, hand-held.*

This extreme macro shot of a Tokay gecko from Thailand shows one of the most bizarre eyes in the world. Photos such as this are always in demand for textbooks. You could also use this to capture a how-to book publisher's attention with both shock value and technique.
Technical Data: *Mamiya RZ 67, 110mm lens, #2 extension tube, Metz 60 T-2 Strobe, f/22, Fujichrome 50D, hand-held.*

When trying to develop a concept for a book, take an interesting nature picture and write down the themes it might fit. This photo of Zabriskie Point in Death Valley could be used in a book on western deserts, California or geology, or in a how-to book on landscape composition.

 Technical Data: *Mamiya RZ 67, 180mm lens, 1/15, f/11, Cokin filter (1/2 clear, 1/2 tinted), Ektachrome 64, tripod.*

book publishing industry.

 Publishers prefer photographers who are well known in their respective fields. People will buy a book by a famous photographer, but they won't invest in a photography book by someone they've never heard of unless the images are simply sensational — and maybe not even then.

 It helps to have a large stock library. It's easier to keep putting proposal packages together if you have in-depth coverage of a number of areas or a variety of subjects. This is especially important when approaching a how-to book publisher. They need to know that you can consistently produce high-quality work — and that you have been published — before publishing your work as a teaching tool.

DEVELOPING BOOK CONCEPTS

The first step in getting a book published is to come up with a concept. You should have a theme, topic or subject that can be communicated primarily through photographs, unless you're a writer or plan to work with one. Review the categories under which you file your images. See where you have enough work in a single area to fill a book. Look for topics that run across categories, too.

 Learn what books are already out there. Examine as many titles as you can on wildlife, nature and photography. Don't limit yourself to North American plants and animals; study books dealing with for-

TEXTBOOKS

Textbooks use images from many photographers as illustrations. You probably won't write and illustrate an entire book, but textbook publishers do purchase thousands of images of wildlife and nature for books on biology, geology, microbiology, and many other subjects. When major books are in production, publishers send out "want lists" describing hundreds of images they might need. You can find listings of textbook publishers in *Literary Marketplace* at your local library. Write them to get their want lists. These stock sales can add up to a nice extra income if you have the kind of photos they want. Photomicrography in particular is always in demand.

eign countries as well. Review books on all aspects of the field: underwater photography, baby animals, rain forests, big game animals, forest animals, zoos and migrations. Don't just look for ideas; learn what the competition for your book is.

Nature books often focus on individiual animals, birds or flowers that have a lot of popular appeal. Baby harp seals, koalas, polar bears, tigers, otters, squirrels, seagulls and songbirds are perennial favorites. You could also have many photos for books on flowers, plants, trees, and other gardening-related subjects. Although few books of miscellaneous landscapes get published, photos of a partic-

Young animals tend to receive a more favorable response than adults. I think they're often livelier, more active, and, in some cases, cuter than fully grown animals. I'd probably submit both of these pictures to a publisher for a book on the swamp or alligators to show the full range of alligator life. If I could only send one, I'd probably choose the young alligator, because it seems to be smiling. It's also a less intimidating, more charming view of alligator life than that of the adult.

Technical Data: *Young alligator—Mamiya RZ 67, 250mm lens, 1/125, f/8, Fujichrome 50D, hand-held from boat. Adult alligator—Mamiya RZ 67, 360mm lens, 1/125, f/6, Fujichrome 100D, hand-held from boat.*

DON'T GIVE UP

The book market is probably the toughest for a photographer to crack. We'd all like to see a book of our work published, so competition is fierce. If you want to get published, you've got to be patient and persistent. If one publisher turns you down, don't give up. Your concept may not be right for their line because they want to publish travel-related books and yours is on wildlife. Your timing may not be good because that publisher has already contracted for a similar book or the topic isn't hot right now (although it might be next year). There could also be a dozen other reasons why they don't want to publish the book, none of which have anything to do with your pictures or book concept.

No matter why your proposal was rejected, continue sending it out until you've explored all possible avenues. And if you get any suggestions from the rejection notices, try to use those to improve your package.

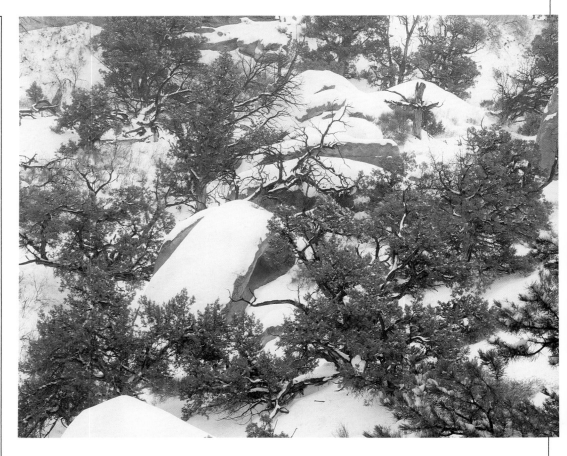

I often come up with themes and then take pictures to fill them in over several years. This shot fits my theme of "Patterns in Nature." The softness in the image wasn't created by a diffusion filter, but from shooting the falling snow at a long shutter speed. Many of my collections of themes may never be published as books, or even magazine articles, but keeping them in mind gives a focus to my shooting. Rather than random shots of many subjects, I have groupings that can be used together many ways. And that makes it easier to market my work.

Technical Data: *Mamiya RZ 67, 500mm lens, 1/4 second, f/22, Ektachrome 64, tripod.*

ular travel/tourist destination might produce a successful concept. Recent books have showcased the mountains of China, the California coastline, and the American Midwest. It's rare, but an outstanding book about a specialized subject can succeed if the package and timing are right. Michael Freeman and veteran journalist Roger Warner recently collaborated on a book on the temple at Angkor Wat in Cambodia.

A lot of great photography is in print, but there's still room for another book from an outstanding photographer. Even if your theme has already been used in a book, ideas can often be successfully repackaged. Just because a book has been published on white-tailed deer doesn't mean that no one will ever publish another. Think about how many books there are on flowers, landscapes or baby animals. Hundreds. And more will be published in the next ten years.

New slants, new perspectives, or new images can make an old idea fresh. Places change—wetlands fill with silt or get drained by developers, coastlines get altered, animal populations migrate—justifying a new book with up-to-date images. Finding a new slant or applying a different technique can make a subject interesting again. For example, one photographer has recently become well known for her infrared, black-and-white photographs of lighthouses. Probably every photographer has shot clouds, but there could be a book for children on funny cloud formations. Maybe there could be a book on coastal sunsets or one on racoons and other urban animals interacting with people.

A book on a hot topic may have a good chance of success. Books on environmental topics such as endangered species, oil spills, or the destruction of the rain forest are more salable now because of

public interest. Places in the news or popular travel destinations may spawn some photography books. Many regional publishers bring out books that highlight the landscape or animals of their area or feature the latest topic of local interest. For the how-to market, you'll have to focus your thinking on specific aspects of photography. Some books that are general in scope, such as *The Joy of Photography*, stay on the market for a number of years, but the current trend is toward books that specialize. The aspect your book covers should offer a solution to a problem everyone has or describe something special many want to do. I've had two other books published that fit these criteria: *Visual Impact*, a book on photographic composition, and *Shoot Early, Shoot Late*, on taking pictures at sunrise and sunset. John Shaw's fine book, *John Shaw's Closeups in Nature*, is an example of a more specialized book that deals with a specific aspect of nature photography.

Many ideas you develop will be based on the type of shooting you like to do. If you photograph primarily backyard wildlife, perhaps you can interest a publisher in either a book on the animals and their habitats or special techniques for photographing them. If you specialize in close-ups of rare and beautiful flowers, you could do a book with a gardening theme or abstract images from nature, or you could focus on a specific variety.

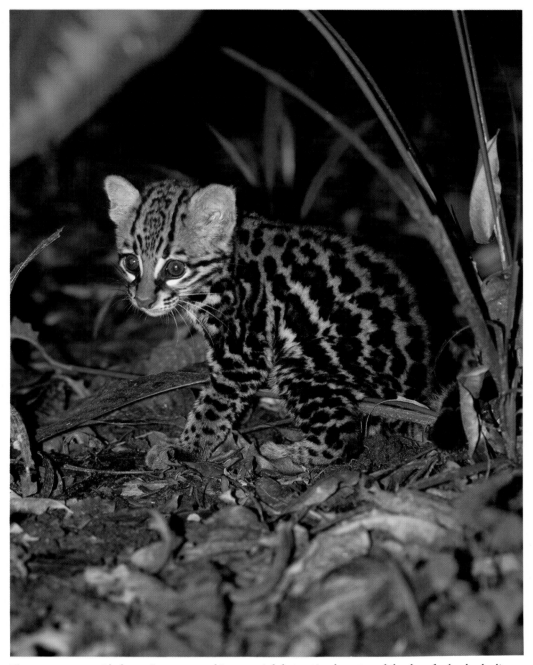

The new concern with the environment and its potential destruction has opened the door for books dealing with endangered environments and animals. Books on the rain forest or any aspect of it are popular, so I'll probably look for a book package that I can put together quickly and send it around. I could use this charming ocelot kitten to arouse the reader's concern about animals in the Peruvian jungle.

Technical Data: *Mamiya RZ 67, 360mm lens, Vivitar 285 flash, f/6, Fujichrome 100D, hand-held.*

Book projects usually have a specific scope, but many images could fit a particular concept. This shot of petrified wood could be part of a proposal for a travel book or a book on southwestern geology. Because you must catch the attention of publishers as quickly as possible, I always include bright, colorful pictures with strong graphics, like this one, in my proposal packages.

Technical Data: *Mamiya RZ 67, 110mm lens, 1/8, f/22, Ektachrome 64, tripod.*

A BOOK PROPOSAL

Offer your book idea to a prospective publisher with a proposal package. This consists of a query letter and sample photos with captions. Don't waste your money on an elaborate book dummy. Publishers don't need to *see* your idea executed; they just need to understand what it is and see what your photos look like.

The query letter must be well written and succinct. Don't begin the letter with an elaborate description of your career or the background for your idea. Describe your idea and give a brief outline to show how the book would work—which points you would cover and, for a how-to book, what the reader will learn and how you'll teach it. Include only background information that's essential to understanding what your book's about. Don't enclose your entire résumé or professional bio; just mention experiences that show why you are the right person to do this book. *Always* give a sales pitch for your idea; explain who will buy this book and why. But be realistic when describing the potential audience; overinflated claims will just sound phony.

Send duplicates of the actual images you think you'll use in the book. A publisher won't want to see your photos of tigers if you're proposing a book on flowers. Your pictures and captions should offer a sample of what will be in the book. Your captions should have interesting facts and other information about the image. Don't just tell where and how you took it unless you're proposing a how-to technique book. Make sure all the captions relate to the theme, subject or topic of your proposed book.

BOOK CONTRACTS

If a publisher accepts your proposal, you'll be offered a contract. Most of these contracts are very similar. The publisher will pay you a sum of money up front, an advance against your future income from the book. If you receive an advance of five thousand dollars and your royalties would equal one dollar per book (these are just examples; the amount of the advance and the percentage of sales you get as royalties varies from publisher to publisher) you wouldn't get any more money until book number five thousand one sold. Royalties are a percentage of the full or net selling price of the book. Unless you've already been published, you'll probably be offered royalties on the net price. There's usually a sliding scale on royalties, with your percentage increasing as the sales reach certain levels.

The advance is usually paid in three parts. You'll get one-third on signing the contract, another third on delivery of the bulk of the book, and the final third when all the materials are in or when your responsibilities for reviewing materials are over. Once the book is published, you'll get regular, usually semiannual, statements telling you how many copies have been sold and if you have any royalty income.

Both you and the publisher assume certain legal obligations. You agree to deliver the book in a timely manner and to make any reasonable

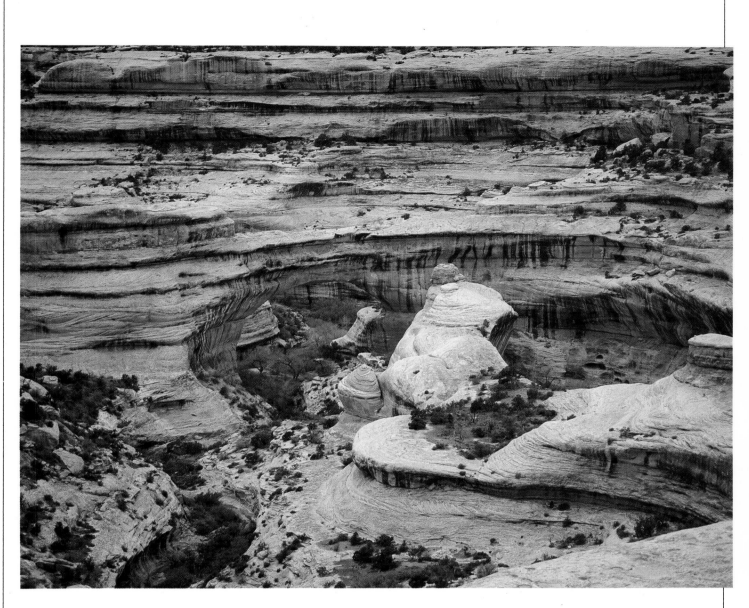

changes requested. You may also be asked to help promote the book. The publisher agrees to finance, edit, produce and distribute the project. Make sure the book is copyrighted in your name, not the publisher's, and that you understand what rights you're giving the publisher. These often include selling excerpts from the book to magazines, foreign editions and paperbacks.

Many publishers include a clause giving them right of first refusal on any other book projects you undertake. If they then decline to publish that book, you're free to seek another publisher. You may want to ask that this clause be eliminated from your contract or limited to only certain types of books. You can, of course, always publish your images or articles while that book is being considered. But if you want to explore book projects with other publishers, you can try to negotiate having that clause removed.

Sometimes I look over my stock library, trying to pick out new themes for book ideas. Even if I can't use the image that sparked the idea, at least it's gotten me thinking. I recently came across this shot in my files, and it took me a moment to find the natural bridge I knew was there. It occurred to me that there might be an idea for a children's book on "Illusions in Nature" in this picture and others like it. (The natural bridge is almost dead center in the photo.)

Technical Data: *Mamiya RZ 67, 180mm lens, 1/8, f/16, Ektachrome 64, tripod.*

FINE ART PHOTOGRAPHY

Many professional photographers take their first pictures of nature and decide to go pro based on their love of creating this kind of beautiful imagery. Then, when they find out there is so much money in commercial work, they give up what they love doing for a more secure financial future. A friend who owns a very successful commercial photo studio in New York, upon seeing my shots from a recent sojourn to Colorado, said wistfully, "I haven't been out of the studio in ten years." I could hear in his voice the tinge of sadness from not following his heart and shooting wildlife and nature.

The irony is that you can make a lot of money in fine art photography. The markets may be harder to reach, but once you invest the time and energy to break into them, the rewards can be very remunerative.

Images that are used solely for decoration are considered fine art. This includes calendars, posters, and framed prints marketed through galleries or to interior decorators. Let's look at each of these aspects of the fine art market and analyze the pros and cons of approaching each one, as well as the method to use in making initial contact.

CALENDAR SALES

A significant portion of photographs used in the calendar industry are of nature and wildlife. Many themes, such as rainbows, birds, waterfalls, Oregon, orchids, butterflies, and endangered species, have been used for calendars and will probably be repeated every year.

Some companies publish calendars featuring the work of one photographer. Pomegranate Publications in Petaluma, California, is known for this. Getting a one-photographer calendar published is a real coup, because your work must be superb and highly marketable. To try for this market, you suggest the theme, and send at least twelve strong images that focus on a particular aspect of nature. In your cover letter, suggest reasons why a calendar featuring your photography will appeal to the public.

Discuss how you might be able to help the company market the product. If you can offer suggestions to increase sales—or better yet, bring a distribution network to a publisher—you will stand a much better chance of selling a package.

Most nature calendars, however, feature the work of many photographers. The publisher decides on the themes it wants to market, and then seeks out images that fit them, reviewing submissions by freelancers to see which shots fit the proposed calendar. Any theme can feature one photographer or many. It just depends on who thought of the idea first, and who has the best photographs that depict the concept.

Calendar companies generally pay two hundred to four

Fine art nature photography can encompass a broader spectrum than landscapes and flowers. A large number of subjects, such as feathers, may not immediately occur to you to shoot. Feathers provide beautiful color, rich texture and interesting design. The brilliant macaw feathers were photographed as the bird was resting on his owner's arm.

Technical Data: *Mamiya RZ 67, 110mm lens, Vivitar 283 flash, f/16, Ektachrome 64, hand-held.*

People like searching for starfish at low tide, and good photographs of them remind us of the simple joy of discovery. The popularity of starfish make them very marketable subjects for the fine art market. They won't sell as many copies as cute baby harp seals or a cheetah mother and cub, but they are nevertheless salable. This ochre sea star on the California coast was actually attached to a rock that was dull and unattractive. I gently moved it a few inches onto some seaweed to add color to the final result.

Technical Data: *Mamiya RZ 67, 110mm lens, 1/8, f/22, Fujichrome 50D, tripod.*

Fine art photography is concerned only with the visual appearance of a subject. This photo is biologically incorrect: a western tiger swallowtail doesn't alight on iris and is never seen against a black background. I arranged the juxtaposition, manipulating the insect with a low temperature. When the thermometer falls below fifty-six degrees Fahrenheit, butterflies can't fly. This shot was taken in my living room, and I opened a window on a chilly spring evening to cool the room down. I used a photoflood to simulate the sun, and the butterfly opened its wings to gather warmth from the light source. Using a flash for the exposure, the background several feet away was underexposed because it was too far from the camera to record any exposure with the small lens aperture I used.

Technical Data: Mamiya RB 67, 127mm lens, #1 extension tube, diffused flash, f/16, Ektachrome 64, tripod.

hundred dollars per shot for the right to use it once, but this can vary. If a group of your shots is used in a single calendar, you may get paid on a royalty basis. A typical arrangement is 10 percent of the wholesale price of the calendar. If the calendar sells well, you make more money from royalties than a flat fee.

To make the calendar market a viable source of income, you must make many sales every year. This means that you must have your work seen by as many companies as possible. Ideally you'll send out many images to photo buyers. Until you build up your own

large file of stock, however, you may not be able to do this.

If you shoot primarily scenics, take several originals of a great composition so you can make simultaneous high-quality submissions (and avoid having to make dupes). If you shoot a lot of wildlife, you probably only have one frame of your best shots. You'll have to get several duplicates made of each to give your work the best exposure. In your cover letter, let each firm know that you've sent simultaneous submissions to other calendar companies. This is a common practice, but you must tell the photo buyers what you're do-

ing. Otherwise, you could find yourself in a very embarrassing position.

Being up front about simultaneous submission can encourage a company to get back to you right away if it likes your work. If two firms want the same shot, and both want to purchase one-time calendar rights for the same year, you'll have to choose which sale you prefer. Although a calendar company won't appreciate losing out, it generally won't hold it against you. Rather than alienating a publisher, I think this scenario may establish you as someone whose photography

is in demand, and allow you to negotiate from a position of strength.

MARKETING YOUR WORK

The first step in marketing your work is to get a list of companies that publish calendars. There are several sources of information you can consult:

1. *The Thomas Register of American Manufacturers* is a multivolume set of books published annually. Most libraries include it in their reference section. Under the heading "Calendars," companies that publish calendars are listed alphabetically by state.

2. *Publishers Weekly* is a publishing industry magazine that lists calendar companies in a special issue every year, usually around the second week in April.

3. *Gift and Decorative Accessories Magazine* includes a "Gift and Decorative Accessory Buyer's Guide" that lists scores of calendar companies in one of its issues.

4. *Photographer's Market*, published annually by Writer's Digest Books, lists the names of many calendar companies and provides tips on submitting work to them.

5. Local stationery and gift stores, drug chains and even supermarkets sell calendars from mid-September through January. Browse the selections and jot down the names of publishers.

The next step is to write each company for photo submission guidelines. Send a #10 self-addressed, stamped envelope along with a *suc-*

cinct cover letter.

Step three is to take a hard look at your photographs. Every image you send must be razor sharp, eye catching, graphically strong and very beautiful. Most of the images you send should be horizontals, because that's typical for calendars. Examine each slide with a loupe to make sure it doesn't have any scratches or other flaws. If a photo buyer finds one such problem, your entire submission may be rejected. If you send duplicates, make sure they are of the highest quality.

Submissions are typically made by mail. Calendar companies generally don't have time to review individual portfolios. If a firm is near you, you might call to see if you can arrange a showing. Otherwise, package your material professionally and send it by mail.

THE POSTER MARKET

You can tap the poster market by either selling an image to a poster company, who will print and sell the poster, or by producing and selling your own poster. Successful posters have ranged from spectacular landscapes to the simple design of flower petals. Marketed properly, virtually anything done well can sell.

Pursue what you most love to photograph. It's certainly true that the subjects you love shooting may not be highly marketable. But I feel you should start with the things you like to photograph because, if your heart isn't in something, it usually shows.

It is impossible to predict whether a particular image will sell thousands of copies. But before I spend money developing a poster, I'll show the image to many people— friends, family, photography associates, and students in classes I teach—and ask for feedback. If enough people respond positively to the image, I know that many other people may like it.

WORKING WITH A POSTER COMPANY

There are two ways to work with poster companies. First, you can sell a photograph to a poster company and receive a flat fee for whatever rights are purchased. You are paid once, no matter how well the poster sells. If the poster makes a lot of money, the company reaps the reward of its investment— in you, in the printing, and in finding a distributor.

Second, you can sell a photo and receive royalties from the sale of the posters. The more posters sold, the more you'll make. On the other hand, if few people buy the image, you won't make any money at all.

Companies that specialize in nature and wildlife will generally accept any image, from macro work to aerial perspectives, that falls within that category. A tight shot of an orchid could easily sell to the same company that used an aerial view of Bora Bora and a grizzly cub comically sitting on a tree limb.

Soliciting poster companies is similar to soliciting calendar publishers. Compile a list of manufacturers, send for their

Foggy scenes are big sellers in fine art nature photography. Fog creates a beautiful mood and provides subtle colors that can complement any room. It seems that there are more things to look at, more places to which the eye is drawn. The photo buyer, like all viewers, tries to peer through the fog. The hidden details that can't quite be seen are alluring and tantalizing— frequently enough to make a sale. I shot these subtle autumn colors in the White Mountains of New Hampshire in October.

Technical Data: *Mamiya RZ 67, 180mm lens, 1/4 second, f/16, Fujichrome 50D, tripod.*

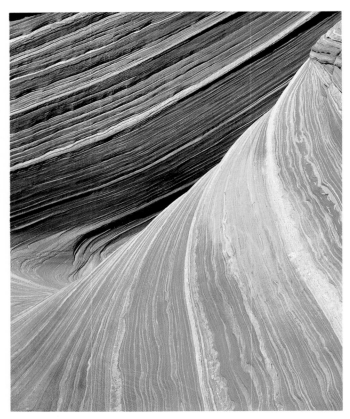

One of the most appealing aspects of nature photography in the fine art market is simplicity of natural design. Most subjects have complex lines and distracting backgrounds, but if you can reduce a subject to its simplest form, you'll have an image that should sell. This unique Navajo sandstone in the Paria wilderness in Utah provided me with a unique design and beautiful contrasting colors as well. This picture cost eight hundred dollars in damage to my Mamiya RZ due to a violent sandstorm that roared through the canyon. There was no shelter from the wind.

Technical Data: Mamiya RZ 67, 180mm lens, 1/30, f/22, Fujichrome 50D, tripod.

and then discuss several strategies for marketing it.

SELECTING THE IMAGE. Color posters are printed using color separations made directly from positive transparency film, so your original image must be a slide or transparency. If you want to use an original image that was shot on negative film, you must convert it to slide film. Kodak's VPF film is made for this purpose. Unfortunately, if you take this route, your transparency is now a second-generation image, which means it's not as sharp as the original. With some posters, this is acceptable. However, if sharpness is an important factor, it's best to use only a first-generation transparency.

Due to the size of most posters, your original image is enlarged many times. Therefore, it should be as sharp as possible and free of scratches, particles embedded in the emulsion, and fingerprints. If you have a choice regarding format, go with the largest one you've got. Medium- and large-format originals produce the sharpest enlargements, but many successful posters have been made from 35mm's. Just make sure your original is perfectly sharp and very clean. Examine it with a loupe to check those critical, minute details.

THE GRAPHIC ARTIST. The next step is to hire a graphic artist to design a poster that complements your image. The

photo submission guidelines, and send them appropriate photographs with a succinct cover letter and self-addressed, stamped envelope. The best way to get names and addresses is to visit retail outlets that sell posters. They should have the names of several companies that produce wildlife and nature posters.

PRODUCING YOUR OWN POSTER

You can produce your own poster by putting up the money for the design work, the color separations and the printing. You must find a distributor to sell it, or you must sell it yourself. Although producing your own poster involves the biggest risk, it also offers the opportunity to make the biggest return on your photography. If you have a special image that people often ask to buy, you can consider this a serious business venture. Let's examine the actual production of a poster

DISTRIBUTORS
Here is a list of a few distribution companies I've contacted. Each specializes in a particular segment of the market.

Arpel Graphics
P.O. Box 21522
Santa Barbara, CA 93121
Specialty: Landscapes, wildlife, nature, travel

Spring Arbor
10885 Textile Road
Belleville, MI 48111
Specialty: Religious, nature

Best to You
P.O. Drawer B
Fayetteville, AR 72702-1797
Specialty: Religious, nature, animals

Advanced Graphics
982 Howe Road
Martinez, CA 94553
Specialty: Wildlife, scenics, dogs, cats, still life

Warner Press
1200 E. Fifth Street
Anderson, IN 46018
Specialty: Meditative religious themes, including nature

Beautyway
P.O. Box 340
Flagstaff, AZ 86002
Specialty: Nature, florals, wildlife, hunting, fishing

Arthur Kaplan Co., Inc.
460 West 34th Street
New York, NY 10001
Specialty: Flowers, scenics, abstracts, animals, Americana

best way to find a designer is through a referral from a photographer who has worked with one. Ask for examples of his or her work so you can see if the design style is right for your photography. Experience with poster design isn't important. If you like the design style, you'll probably like the design for your poster. If you can't locate a designer through a referral, try looking in the Yellow Pages under ''Artists, Commercial'' or ''Graphic Designers.''

If you know roughly what you want (or at least think you do), the designer will use your ideas to create drawings from which you'll select the final design. If you have no idea, he or she will offer some suggestions and give you a few sketches. When the two of you decide on the final look of the poster, the designer will produce the black-and-white camera-ready layout with written instructions for the printer. The printer will use this mechanical to make his plates for the printing process.

WORKING WITH THE PRINTER. Perhaps the most crucial part of the whole process is working with the printer. First, you must have your color separations (usually referred to as ''seps'') made. These are special sheets of film with a dot screen pattern the exact size of the final image on the poster. They are used to make the plates that transfer the color inks onto the paper. A poster requires at least four

separations, one for each ink color.

Seps are priced by the square inch: The larger the picture, the more it costs. There are several grades of color separations. I feel that if you are serious about producing a beautiful product, you must have the best. Color seps are expensive, especially if you need retouching, but this is a one-time cost. Make sure it's spelled out in writing that the color separation negatives belong to you. When you pick up the printing job, take those negatives with you.

When you see the color key, you can get a good idea of how the colors in the poster will turn out. If the color key is too red or too blue, or if it has lost detail in certain areas, ask that it be done again — until it's right. You're paying a lot of money for this and should be satisfied with the result.

There are indeed certain limitations in this process, but the color balance should be accurate. There are no hard-and-fast rules about how many times a color separator will remake the color key until it is right. But it is his or her job to provide you with accurate separations, and I wouldn't pay until it's done to your satisfaction.

Imperfections in the original, such as scratches or dust embedded in the emulsion, aren't the responsibility of the separator. These can be corrected, but you'll have to pay extra.

Printing costs include labor, paper, plates, set-up charges, press time and consultations. You must make several important decisions: the number of posters you'll run, the type of paper, and the number of colors. Let's look at each.

Subtle tones and delicate structures can be especially appealing. This hoarfrost-shrouded willow in Lone Pine, California, couldn't be more fragile, and the white-on-white monochrome can work in any decorative environment. This artistic treatment of winter could work as both a fine art poster and as photo decor.

Technical Data: *Mamiya RZ 67, 360mm lens, 1/60, f/6, Fujichrome 50D, tripod. Light reading was determined by a hand-held incident meter.*

SAMPLE COST TO PRINT 1,000 POSTERS

Let's look at some sample costs for having your own poster printed. Assume you're going to print 1,000 posters on 100-pound, glossy stock. It will be a five-color printing job — basic four-color printing plus one extra color. You want just a simple design, and you won't need any retouching.

Color separation	$1,000
Printing	$2,000
Design and mechanical	$ 150
TOTAL	$3,150

The cost per poster works out to $3.15. This represents the first thousand posters. For another thousand, the cost would be about $500, which comes out to 50¢ per piece. Your biggest expenses — color separations, plates, artwork and any retouching — only occur once. That's why I suggest being conservative on the first printing and going back for more.

Bare winter branches, such as these framed against an emerald green river in Oregon, are beautiful in their subtlety and have a commercial appeal in the calendar or poster market. It sets a mood, momentarily sweeping us away to a tranquil setting. This is one of the purposes of nature photography: to remind us of inner peace through the natural world. This shot works for organizations such as the Sierra Club or the Audubon Society, who frequently publish nature's most subtle details. Many calendar companies, however, look for stronger color and bolder images. Some poster firms publish soft, comtemplative images, and this is the type of thing they look for.
Technical Data: *Mamiya RZ 67, 360mm lens, 1/2 second, f/16, Fujichrome 50D, tripod.*

As a wildlife and nature photographer, I find the entire spectrum of biology fascinating and love capturing it on film. Some subjects, however, are not widely appreciated. Creepy crawly things such as spiders and snakes may do well in the context of a textbook or in an editorial article, but they would never even be considered by a poster or calendar company. This Mexican tarantula has a face only its mother could love!
Technical Data: *Mamiya RZ 67, 180mm lens, 1/250, f/4.5, Ektachrome 100, hand-held.*

The number of posters you initially print is important because the more pieces printed, the less it costs per piece. For example, a run of one thousand may cost you (including the separation) three dollars per poster. If you ran five thousand, you might reduce the price to one dollar. On a larger order the price goes down even more. The dilemma is that the price per piece decreases with quantity, but the initial investment is significantly larger. With the above example, instead of laying out three thousand dollars, you'd spend five thousand dollars. Yes, you can make more profit with a larger investment, but you can incur a larger loss if you don't sell your inventory. Only you can decide how you should handle this, but my suggestion is

to be conservative. When you've sold your first thousand, order a larger print run. Ideally, if you can presell an order based on an 8 × 10 print of the photograph and get a deposit on, say, ten thousand posters, you can take advantage of the lower per-print cost. Tell potential buyers you're offering a "prepublished" price that will save them money.

Paper is expensive, but if your printer can print two posters on a single large sheet (this is called "two up"), you can save money. Posters that are 16 × 20 and 18 × 24 inches can be run two up. The overall size of the printing paper is largely determined by the type of printing press your printer uses, so consult with him or her on the dimensions. If only one poster is printed on a single sheet of printing paper, that waste costs *you* money. So consider the size of your poster carefully. The type of paper will also affect the price. I'd recommend a good quality, 100-pound stock for posters that will be mounted and framed. If you are rolling posters to be shipped in a tube, use 80-pound stock. The 100-pound stock will show roll impressions. If you use glossy paper stock, you eliminate the printing step of putting down a varnish coating on the paper.

Extra colors increase the cost of a job. The cost goes up with each additional color beyond the basic four. A typical full-color picture requires four color plates (cyan, yellow, magenta and black) of ink to be

produced. A matte or glossy varnish is considered a fifth "color," and a solid area, such as a border, frequently requires extra ink density, which takes another pass through the press. Printers use special Process Match System (PMS) colors to create colors not available through four-color printing. If you want a certain shade of peach, burgundy or aqua, you simply choose the number of the color from a sample book and the printer knows what to do. This means, however, another color and more money.

MARKETING STRATEGIES. The key to success in selling a product is marketing. There are dozens of ways to market a poster. Some will work, some won't. It's difficult to predict success or failure until you try. Therefore, increase your overall possibilities of success by trying everything you can think of.

Fall foliage is a popular subject in fine art photography. This image also has a delicate beauty that will enhance its marketability.
Technical Data: *Mamiya RZ 67, 180mm lens, 1/30, f/8, Fujichrome 50D, tripod.*

The simplest way to sell your poster is to sell it yourself. Offer the poster to as many retail outlets as possible. It's best to show a framed sample so the poster looks like a work of art—something customers would be proud to hang in their homes. You won't need a display rack for only one poster. If you develop several, you'll want to consider a convenient way for retail customers to look through your product line.

Don't be afraid to tell the store manager that you're new in this business. Many people will give new entrepreneurs valuable advice and contacts. In one of the stores I approached with a poster I produced, I spoke with a salesperson behind the counter. He told me how much the store marked up their inventory, how much quantity they buy if they like an item, who pays for the display racks, and so on. It was a very worthwhile conversation for me. If one person won't help you, hundreds more will. Keep asking questions until you have all the answers you need.

You will sell the poster at a wholesale price. Assume the retailer will double your price for resale, and make sure you don't overprice it. If your wholesale price is five dollars, the retailer will sell it un-framed for ten dollars, or perhaps $9.95. If you offer your poster mounted and framed, you must determine how much to charge. Study the pricing structure in poster and fine art shops to find out what the competition gets.

The major advantage to selling your poster yourself is that you can keep a larger percentage of the retail price. You don't have to depend on a distributor, and you maintain control over your work. The disadvantage is that you are only one person. You've got to do this store by store, one at a time. If a national distributor takes your poster, you'll have immediate exposure to a huge market. I don't know about you, but I'd rather let others do the selling while I take photos.

National and regional distributors specialize. Depending on the type of poster you produce, you must identify the market you're trying to reach. The best way to find the names of distributors is to go into the retail stores where you think your poster would fit in. Tell the manager or owner you're producing your own poster and you want someone to handle it, and ask for the names of the store's distributors.

If the distributor gives your poster good exposure, it could sell several thousand copies a year. While it's hard to hit the jackpot with just one poster, a real winner can gen-

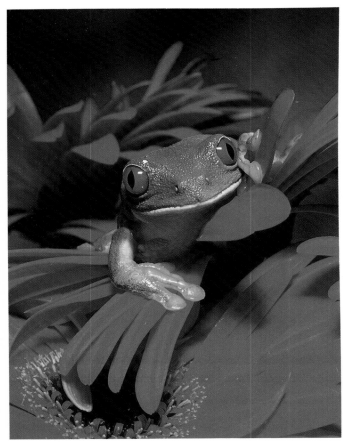

Humor sells. Whether you photograph animals in the zoo, in the wild, or in the studio, you will find dozens of places to sell the image if you capture a funny expression or an adorable interaction between animals. The poster and calendar markets are no exception. In this case, the unbelievable face of this red-eyed tree frog provides the humor. Everyone who saw it laughed, so I knew I had a winner. In addition, the brilliant colors are a strong attention-getter. The poster company that used this image wanted a caption to go with the shot, and I came up with "I only have eyes for you." This treatment takes this poster out of the high-end fine art market and targets the product for younger consumers, generally in the age range of twelve to eighteen years. The caption was added not to denigrate or cheapen the wildlife photograph, but to increase sales.

Technical Data: *Mamiya RZ 67, 110mm lens, #2 extension tube, flash, f/22, Fujichrome 50D, tripod.*

erate as much as ten thousand or twenty thousand dollars a year in sales. Even if you don't strike it rich, you can recover your investment and make at least a small profit if you sell at the right price. When you sell to a distributor, you can no longer work with a wholesale price. Working backwards, if the poster retails for ten dollars, the distributor must sell it to the retailer for five or six dollars. The distributor wants to pay a price that will give him or her a good profit. This figure is most likely to be around three dollars, but everything is open to negotiation.

Before you sell it for three dollars, be sure you'll make a profit at that price. If you've spent $3.15 per poster for one thousand posters (as with our example on page 121), this obviously is a losing proposition. However, if you have printed a very large quantity (remember, we're talking about national distribution) and spent only thirty-five cents per piece, you'd make a profit of $2.65 each.

These prices reflect posters that are sold in the fine art market. There is a less expensive grade of posters that retail for four or five dollars in discount stores and in swap meets. The difference between the two product lines is not only the quality of paper and art design, but the image itself and the way it is presented. For example, a shot I took of a red-eyed tree frog was printed as a low-end poster with a caption. The publisher and I decided the

frog's mass appeal would be increased with a clever concept. We used the phrase, "I only have eyes for you," which underscored the huge, brilliant red eyes of this frog.

This poster isn't really fine art. It's a poster that could sell tens of thousands of copies to kids, teens and adults with a sense of humor. In the above example, the poster was sold to the distributor for seventy-five cents. It cost thirty-five cents to print in quantities of ten thousand. I received 10 percent of this price, or 7.5¢ per poster. The distributor sold it wholesale for two dollars, and it retailed for around four to five dollars, depending on the store. Posters like this can have a life of several years. I can't give you the final figures on this particular image yet, since it's still selling, but for every one hundred thousand copies sold I receive seventy-five hundred dollars.

If, on the other hand, I became the publisher, investing my own money in the project, contacting the distributors and closing the deal, I'd make forty thousand dollars per hundred thousand posters sold. I tried this once but didn't like the business end. I want to remain a photographer. If I continue to take marketable pictures, I can easily make that same forty thousand dollars from selling five poster images and still love what I'm doing.

If you're business minded, you may prefer to take the financial risk by investing in yourself. You'll then reap all the rewards from the mass

Colors and color combinations are especially important in fine art photography because people hang the prints in the context of other tones in a room. Harmonious colors are more appealing than shocking or discordant hues. The deep burgundy of this sea kelp, seen against the gray/brown rock of a California tidal pool, is an attractive contrast that can add a dash of color to a monochromatic room or complement existing tones.

Technical Data: *Mamiya RZ 67, 50mm lens, 1/8, f/16, Fujichrome 50D, tripod.*

TRY, TRY AGAIN

You must always have a large number of images in the mail if you want to make a living from nature and wildlife photography. The potential is enormous, but to make it in this market your work must be seen constantly. My personal goal is to send one package per day, seven days a week. I don't always meet the goal—I may be out shooting—but I come as close to it as time permits. Many of these submissions are rejected, of course, but many others are sold.

Lacy patterns in plants imply a fragility, a delicacy, that appeals to fine art buyers. These colors, however, clash. Some people use bright accents of color to offset more traditional tones in a room. When you present your portfolio to a decorator, show that your vision, while unique, is diverse and that you are capable of supplying his or her clients with a wide range of nature images. Show them something subtle—and then hit them with some color.

Technical Data: *Mamiya RZ 67, 110mm lens, 1/8, f/22, Ektachrome 64, tripod.*

Monochromatic prints can easily go with any room. It may sound as if I am underplaying the intrinsic value of a photograph by viewing it as simply a color match for decor, but that's how many people, especially interior decorators, buy images. When you show a portfolio, they will look at your sense of color.

Technical Data: Mamiya RZ 67, 180mm lens, 1/15, f/11, Fujichrome 50D, tripod.

distribution of your images. If you do well, you can hire others to oversee the business end of the operation while you get back to taking pictures.

PHOTO DECOR

Within the last twenty years or so, public perception of the intrinsic value of photography has profoundly changed. Residential and commercial interior decoration use more and more photography. Private collectors have increased the value of photographic prints by seeking out promising names in the field. Photography as a fine art has come into its own.

Interior decorators and interior designers are interested in seeing new concepts in decoration. The type of prints that tend to sell best in the photo decor market are landscapes with a powerful sense of design such as powerful ocean waves or the gnarled trunk of a bristlecone pine tree. Rich tones and saturated hues must be evident. If the image is wildlife, it should be a strong portrait of an animal in a beautiful environment.

MARKETING YOUR WORK

Make your sales calls in person, not through the mail. Begin with local professionals in the Yellow Pages. If your wildlife and nature images sell to this market, you can expand to other cities by personally calling on people. You can approach both decorators and designers with your portfolio. Prints should be 16 × 20, in 20 × 24 frames. If you show only small prints, a decorator will immediately request to see larger ones. Anything larger than 20 × 24, however, is awkward to carry to an interview.

Since photo decor is usually framed and hung on the wall, this is the kind of finished product you should show. Use custom frames and matching mats to complement each image. It is true that decorator frames are expensive. For a portfolio of ten prints you can easily spend one thousand to fifteen hundred dollars in frames alone. Good custom prints are another major expense. If you want to look professional, however, and give yourself the best opportunity for a sale, it's an investment that needs to be made.

If you've had some of your work printed as posters, by all means show them. This is an impressive way to say you're published, and you may end up selling more posters.

The return on your investment will come if you get your work seen by as many decorators and designers as possible. But this is a hard road for a photographer, because in-

TO EACH HIS OWN

The photo decor market was the very first attempt I made at selling my work. I mounted and framed prints in sizes from 8 × 10 to 20 × 24, and I rented space at art fairs and swap meets. Although I sold a number of prints, I didn't enjoy it at all. I got tired of people trying to match the colors in their living room couch with my images. Besides, I was bored at art fairs. And it wasn't as easy as I'd imagined. Setting up displays, investing in frames, and trying to choose images that would sell was a challenge. Many days, I wouldn't sell anything. It was very discouraging.

Since then, I've spoken to many photographers who make this method of marketing their life. They travel all over the country to major art and craft fairs selling their work. Some of them do very well and seem to enjoy this nomadic life.

stead of taking photographs in national parks you are acting as a salesperson. I did this when I first began in photography, soliciting professional decorators who sold art prints. I'd simply call for an appointment and show a portfolio of ten mounted and framed 16 × 20's. If the decorator had the facilities and the time, I'd offer to give a slide show of my work. Projected transparencies are so impressive, and I could show dozens of images without the costly investment in custom prints

and frames. This way, I got feedback from the decorators as to what kinds of images they felt were most salable. Instead of uneducated guesswork on my part, I could get the opinion of someone who was constantly selling artwork to monied clientele.

If you can establish a friendly rapport with a decorator, he or she will be happy to tell you about special projects where your work might be applicable. If the decorator doesn't volunteer this information, ask. Try to garner information that will give you insight into any special needs. Also, ask for referrals to any associates who may have use for your work.

One particular decorator stands out in my mind as being extremely helpful. After seeing my slide show, she liked my work enough to suggest a gallery showing. She had a friend who owned an art gallery in Detroit and arranged for my work to be shown there. That one evening alone I sold thirteen large framed prints and made forty-six hundred dollars after the fifty-fifty split with the gallery.

If you live in a small town, the opportunity to sell your work to decorators is limited—presuming there are interior decorators at all. Even in medium-sized communities, it will be hard to make a living at selling to decorators. You may be able to supplement your income, but the real opportunities lie in big cities where there are concentrations of wealth.

INNOVATIVE CONCEPTS

In every type of sales, the burden of proof is on the seller, who must show the potential client how to use the product. A work of art is somewhat different, however, with respect to usage. We don't use art; we appreciate it.

To sell photography, the photographer is wise to learn about an interior designer's or decorator's project, and try to find a visual concept that will complement the client's purpose. By thinking creatively and expanding your vision, you can sell innovative concepts and earn a reputation for skill in problem solving.

As an example, exclusive restaurants and bars are usually lit with great subtlety. Unless photographic prints have a spotlight on them, they won't be seen very readily. You might suggest, however, that a number of light boxes placed throughout the restaurant would give off their own light plus provide attractive decoration. A friend sold a picture of fall foliage taken against a blue sky for a large light box built into the ceiling of a health food restaurant.

Along the same lines, you might suggest dentists install a beautiful light box built in right above the dental chair. Dental patients are nervous, and a peaceful landscape or intricate macro shot of a flower would give the patient something calming on which to concentrate. Two dentists who saw my work displayed in a photo lab approached me with the idea. There was concern about how the color

Sometimes the colors in a photograph have more to do with its sale than its artistic or intrinsic value. This bothered me for years. I always thought it was obnoxious when people tried to match my prints with their living room color scheme. Now, I realize that their money is just as good as an art collector's who loves a photograph regardless of its placement in a room.

This shot taken in White Sands National Monument in New Mexico is stark and consists primarily of neutral earth tones. The color can fit in with many decorating schemes. The strong graphic shapes here also appeal to many decorators, so I always include this image in a portfolio when soliciting the fine art market.

Technical Data: Mamiya RZ 67, 50mm lens, 1/8,f/22, Fujichrome 50D, tripod.

given off by the light box might interfere with certain dental procedures, but this was solved by simply swinging a bright light in front of the patient to drown out the effect of the illuminated transparency.

APPENDIX

RIGHTS

When you sell photographs, you're selling the *right to use them*. You don't have to formally register each picture with the copyright office; you automatically own the rights by having taken it.

There are many different types of rights you can sell for your pictures. A record company may want exclusive rights for album covers. You may be dealing with Spanish language rights or book cover rights. You'll be asked to sell the particular rights each client needs.

Certain types of usages and rights bring higher fees than others. For example, world rights should bring you more money than United States rights. A picture used as a chapter opener in a book has more value than the same image reproduced within the chapter. A photo used on a calendar with fifty-one other images (one a week) will command a smaller fee than one used in a calendar with only eleven other images.

The most common usage will be *one-time rights*. This means that the client is entitled to reproduce your picture once for a specified usage. If they want to use it again, they must pay for any additional use(s). You can sell several rights to the same party (often termed *multiple rights*); for example, North American rights for both calendars and posters. The more rights in an image that you sell to a single buyer, the more money you should be paid.

Rights may be exclusive or nonexclusive. *Nonexclusive rights* means you can grant the same rights to another buyer without any restrictions. *Exclusive rights* mean that you can't sell rights to use a picture to any other client for a specified period. For example, a magazine will often request *first rights* to previously unpublished images so those images won't appear elsewhere before it can use them. In that case, you might grant exclusive magazine rights for six months to that publication—agreeing not to sell it to any other magazine during that period.

When you sell a picture for a calendar, the calendar publisher usually wants to make sure no other calendar uses the same image in that calendar year. You would therefore agree to sell them *one-year calendar rights*. For example, a company wants to use one of your images in a calendar next year. You agree not to sell the rights to use that image in any calendar that will be published next year.

My stock agency, as do many others, asked me to sign an exclusive agreement with them, which would keep me from submitting my work to another stock agency. I consented to those terms because I felt they would do an excellent job of promoting my photography. You can, however, often arrange to grant limited exclusivity to a stock agency when they won't represent your work in certain markets or if they don't handle some types of images. Some agencies may handle only nature and wildlife but not travel/tourism images; in this case you could negotiate an agreement to have one agency handle your nature and wildlife while another represented you for travel/tourism.

A *licensing agreement* is one in which you give a company the right to sell a particular photo under certain conditions and terms. I granted a company a license to reproduce my photo of a red-eyed tree frog (see page 124) as a poster with a specific caption ("I only have eyes for you!"). Our contract stated that either party could terminate the agreement after one year.

In structuring the poster deal, I had the option of a *buyout* or a *royalty agreement*. In the buyout, the company would pay fifteen hundred dollars for the United States poster rights. I would not participate in any future profits, even if the poster were a huge success and they made millions of dollars. Under a royalty agreement, I would receive a 10 per cent royalty based on the wholesale cost of the poster (if each poster was sold at wholesale for one dollar, I'd get ten cents for every poster sold) as long as the poster continued to sell. I decided to gamble that the royalties would exceed the fifteen hundred dollars buyout figure because the image has always been so popular with friends and clients.

Occasionally you may be presented with a *Work for Hire* arrangement. In this scenario, you agree to take pictures of a particular situation for a specified per diem fee, and the client owns all rights to the pictures. The client pays for all your film and processing, transportation, and any other expenses incurred during the shoot. In turn, everything you photograph is owned by the client. But unless your agreement with them specifically states otherwise, everything you shoot on that trip is their property.

In nature and wildlife photography, work for hire (or assignment photography) isn't a common situation, but it does happen. I don't especially like to work with this type of agreement because it limits my potential for future sales. However, if the per diem is large enough I will consider an assignment.

Tech Talk

Although all the photographs in this book were taken with either the Mamiya RB or RZ camera systems and 120 (ten pictures) or 220 (twenty exposures) film, which produce transparencies or negatives in 6 × 7cm (2¼ × 2¾ inches), you can also get good results with 35mm camera systems.

I prefer the larger format because it needs less enlargement to fill an area than 35mm does and, therefore, appears to give a sharper picture. On the other hand, 35mm camera systems are much easier to use and offer more accessories than do medium-format cameras. Many successful professional wildlife and nature photographers use 35mm.

Film Recommendations

I use many different types of film in my photography, depending on what I want to accomplish. All the films I use are available in both medium format and 35mm. I use only transparency films, not negative emulsions. With very few

exceptions, publications do not use prints or negatives to reproduce your pictures. They make color separations from transparencies. The following is a list of color films I use, with some of their characteristics noted.

Fujichrome Velvia 50 (RVP): This is my favorite, because it's a very sharp film with extremely intense colors. It can turn a dull, smoggy blue sky into a rich-toned beautiful blue. However, it is very contrasty, often forcing shadows to go black. It's not a true ISO 50—it should be rated at ISO 40 and processed normally.

Fujichrome 50D (RFP): This is a very sharp film with saturated colors, yet it is not as contrasty as Velvia. The grain structure is very tight.

Fujichrome 100D (RHP): When I need to shoot in low light levels and still want fine grain, I use this film. It is very similar to RFP, except that the grain isn't quite as fine.

Fujichrome 400 (RHP): When the light level is very low, I am forced to use a faster emulsion with its inherent large grain structure, lower contrast and lower resolution capability. I don't like it, but when it is a choice between getting the shot or missing it, I use Fuji 400.

Agfachrome 1000 (RS): There are some situations when I use a very grainy film to achieve an artistic effect. I like Agfacrhome because I can easily push it one stop to 2000 or two stops to 4000. It is characterized by low contrast, muted, almost sepia-like colors, and large grain.

Ektachrome 100 (EPN): I sometimes use this film when I want to minimize the contrast in a scene. When I want to hold shadow details in contrasty lighting, such as midday sunlight, this is a good choice.

Ektachrome 64 (EPR): For accurate skin tones and good

color, EPR is a good choice. It is fine grained, and the colors are not as exaggerated as Fujichrome. For those of you who don't like the intensified colors of Fuji Velvia and Fuji 50D, Ektachrome 64 is a good film.

Kodachrome: Although many photographers use Kodachrome 25 and 64, I don't shoot these films any more. Both are extremely sharp, but I prefer the colors I get with Fujichrome 50 and Velvia. I've also had some problems with processing Kodachrome, which tends to go magenta if not processed properly.

Query Letters

Query letters are important, the ice breaker—creating the first impression a potential client will have of you. It's vital, therefore, that the query be written in a professional manner.

A query letter must be succinct and to the point. Eliminate any information that has no direct bearing on the proposal. Don't include technical data about the pictures or stories about how you got the shots. If buyers want to know, they'll ask. Stay focused on the buyers' needs, describing the benefits of using your images or article.

Briefly explain the purpose of your submission at the beginning of the letter. If you're submitting your work to a magazine, is this a package of cover images or a photo/article package?

Appearances count! Always use attractive stationery. It

35mm Focal Length Equivalents for 6 × 7 Lenses

35mm	6 × 7cm
16mm fisheye	37mm fisheye
24mm wide angle	50mm wide angle
50mm and 55mm normal lenses	90mm and 110mm normal lenses
90mm medium telephoto	180mm medium telephoto
135mm medium telephoto	250mm medium telephoto
200mm telephoto	360mm telephoto
300mm telephoto	500mm telephoto

March 8, 1989

Mr. Roy J. Reiman
Editor/Publisher
Country
5400 S. 60th St.
Greendale, WI 53129

Dear Mr. Reiman:

Would you please consider the enclosed 6×7cm color transparencies for cover material or for other editorial purposes.

If you require additional caption information, I will be happy to provide whatever is needed.

Thanks very much for your courtesy in reviewing my work. I've supplied a SASE for your convenience.

Best regards,

Jim Zuckerman

Enclosures: 24 6×7cm color transparencies, SASE

May 19, 1989

Jennifer Clark, Art Director
Gibson Greetings, Inc.
2100 Section Rd.
Cincinnati, OH 45237

Dear Ms. Clark:

Please find enclosed 28 6×7cm color transparencies for your consideration in the various paper product lines you design and produce. I have a large stock of images, so if this submission coincides with the vision of Gibson Greetings, please let me know and I'll be happy to send you more material on a regular basis.

The fee for one-time usage rights can be negotiated upon acceptance of any of the images.

I've provided a SASE for your convenience. Thanks very much for the courtesy of reviewing my work.

Best regards,

Jim Zuckerman

Enclosures: 28 6×7cm color transparencies, SASE

January 16, 1990

Ms. Vanessa Kelling
The Animal's Voice Magazine
Compassion for Animals Foundation, Inc.
P.O. Box 341347
Los Angeles, CA 90034

Dear Vanessa,

Please find enclosed 40 medium format color transparencies. As I mentioned on the phone, I've included a few shots that may tie in with your feature "Animals as Slaves," including elephants working in the jungles of Thailand.

The other images, I hope, will be appealing to you as cover material or for other features that may run in the near future.

When you wish to review shots dealing with animal rehabilitation, give me a call. I have a number of photos showing people working to save raptors.

In this submission, I included only one photo of an oil-covered bird. I have a series of pictures showing the efforts of a small community working to help the sea birds devastated by an oil spill in December '88 on the Washington coast. Let me know if you can use this material.

Thanks very much for your courtesy in reviewing this package. I've enclosed a SASE for your convenience.

Sincerely,

Jim Zuckerman
Phone: 555-1234 / Fax: same number

Enclosures: 40 6×7cm color transparencies, SASE

January 20, 1989

Mr. Gregg Olsen, Editor
Trailblazer Magazine
15325 SE 30th Place
Bellevue, WA 98007

Dear Mr. Olsen:

I would like to propose three article/photo packages for *Trailblazer Magazine*. They are: "Exploring Northern Rain Forests," "Houseboating on Lake Powell," "In Search of Butterflies."

The articles could be written in 1,500 to 2,000 words or per your specifications. I have enclosed for your review 12 medium format color transparencies that support each proposal, a total of 36 images.

The piece on rain forests would predominantly focus on Oregon and Washington. I could also touch upon the remarkable rain forests of southern Alaska, if you wish.

The Lake Powell manuscript would be an informative narrative on the best times of year to see the lake, spectacular land forms in the area, local history, and so on.

For the butterfly article, I would like to give some interesting information about the decline of butterfly populations as well as places throughout the United States where people can easily find them. The text could also include things your readers can do to help increase the numbers of these delightful insects.

I have been published for many years and am contributing editor to *Petersen's Photographic Magazine*. Previously published work is available on request.

Thanks very much for your courtesy in reviewing these proposals. I'll look forward to hearing from you soon. A SASE has been provided for your convenience.

Best regards,

Jim Zuckerman

Enclosures: 36 6×7cm transparencies, SASE

There are a number of special-interest zoos around the country, including Reptile World U.S.A. near Visalia, California, where I photographed this emerald tree boa. Although I photographed several unusual reptiles and amphibians in their enclosures by filling the frame with tight close-ups of their heads, I asked to shoot this snake outside in the sunlight because it was so beautiful. The staff agreed, and I set up this shot. Reptile World was doing a promotional poster, so the staff asked if they could get copies of the slides for it. I agreed, in exchange for shooting several other species using the lighting and backgrounds of my choice.

Technical Data: *Mamiya RZ 67, 180mm lens, 1/250, f/5.6, Fujichrome 50D, hand-held.*

doesn't have to be expensive, but it should look like you're in business on a long-term basis.

PROFESSIONAL FORMS

The following professional forms are used by photographers for two reasons. First, it's easier to have a written agreement upheld in court if there's a dispute. Second, there's less chance of misunderstandings if everyone has the terms (or whatever) spelled out in writing.

The Model and Property Releases increase the value of your photos by making them available for advertising and other promotional uses. Use the Delivery Memo not only to establish what you've sent to the buyer but also to spell out the agreed-upon terms for their eventual use — or that this is for examination *only* with terms to be established when a selection has been made. The Invoice itemizes what the buyer is using, the rights sold and the fee to be paid for those rights.

Delivery Memo: *Send this form with your transparencies to a client. It clearly spells out what you are sending and the terms that accompany the delivery. These terms include the length of time you are willing to leave the images, holding charges, if any, and a description of the photography.*

Invoice: *This is your bill once the client has decided to use one or more of your pictures. Most clients want at least thirty days to pay; this frequently can stretch to sixty or even ninety days. Offer a 2 or 3 percent reduction in price for payment within a shorter period of time, such as ten days.*

Model Release: *This form should be signed before you shoot any model — including friends, family or passing tourists. If the person is at all recognizable, you can't legally sell the rights to use the image without the consent in writing of that person. Make sure the person (or a minor's parent or guardian) understand what is being signed and the rights granted before signing. You should pay at least a token fee (some professional models will work in exchange for photos for their portfolios and some amateurs will accept copies of the pictures). Give a copy to your stock photo agency and any clients who use the pictures.*

Property Release: *A property release is necessary when any recognizable private home, office building, or commercial center is used for advertising purposes.*

DATE: March 23, 1988
SUBJECT: Bill per Purchase Order
PO NUMBER: 600-88
TO: Harcourt Brace Jovanovich, Inc.
 Orlando, FL 32887
ATTN: Patricia Vestal

– –

INVOICE

PHOTO DESCRIPTION — Monarch butterfly emerges from
 crysalid
USAGE — ¾ page, editorial, interior, nonexclusive, over
 40,000 printing, one-time U.S. and Canada English
 language rights only.
FEE — $245.00

Please remit within 30 days of above date. THANK YOU.

JIM ZUCKERMAN

P.O. Box 8505, Northridge, CA 91327

DELIVERY MEMO

TO: Bill Hurter, Editor Date: 11/13/90
 Photographic Magazine Client PO #
 8490 Sunset Blvd. AD:
 Los Angeles, CA 90069 Client: Petersen Publishing Co.

PHOTOGRAPHS TO BE RETURNED BY: After Publication

DESCRIPTION:
 Article: "Wide Angle Landscapes"
 20 6 × 7cm transparencies supporting article

TOTAL COLOR: 20
TOTAL BLACK & WHITE:

acknowledged and accepted by

Kindly check count and ·acknowledge by signing and returning one copy.
Count shall be considered accurate and quality deemed satisfactory for repro-
duction if said copy is not immediately received by return mail with all excep-
tions duly noted. This delivery memo is subject to all Terms and Conditions
on reverse side.

JIM ZUCKERMAN

P.O. Box 8505, Northridge, CA 91327

MODEL RELEASE

For valuable consideration, I hereby grant to _____,
their legal representatives and assignees, permission to copyright, sell, rent,
publish and/or use photographic portraits or pictures of me, in whole or part,
for advertising, trade, stock photography, editorial, educational or any other
lawful purpose whatsoever.
 I hereby waive any right that I may have to inspect or approve the finished
product or products or advertising or printed matter that may be used in
connection with this picture or the use to which it may be applied.
 I hereby release, discharge, and agree to hold harmless
_____ and any publication from any liability by vir-
tue of any blurring, distortion, alteration, optical illusion or use in composite
form of said photos.

 (Date) (Model's Name)

I am over 21 years of age _____ Yes or No.

 (Model's Signature)

Witnessed by: _____
 (Signature of Witness)

(If the model is under age, there should be a consent by parent or guardian)
 I hereby certify that I am the parent or guardian of
_____, the minor named above, and I ap-
prove without reservations the foregoing on behalf of the named minor.

Date: _____ Witnessed by:

(Signature of Parent (Signature of Witness)
 or Guardian)

PROPERTY RELEASE

For valuable consideration, I hereby grant to _____,
their legal representatives and assignees, permission to copyright, sell, rent,
publish and/or use photographs of my property located or described
as _____, in whole or part, for ad-
vertising, trade, stock photography, editorial, educational or any other lawful
purpose whatsoever.

I hereby waive any right that I may have to inspect or approve the finished
product or products or advertising or printed matter that may be used in
connection with this picture or the use to which it may be applied.

I hereby release, discharge, and agree to hold harmless
_____ and any publication from
any liability by virtue of any blurring, distortion, alteration, optical illusion or
use in composite form of said photos.

 (Date)

I am over 21 years of age _____ Yes or No.

 (Signature of owner)

INDEX